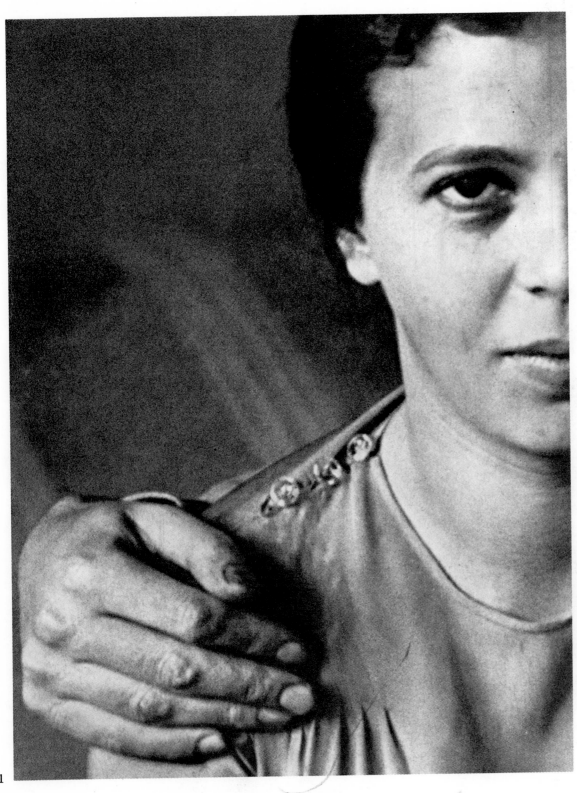

PENGUIN BOOKS

André Kertész

André Kertész was born in 1894 in Hungary, where he began taking pictures when he was sixteen. Self-taught and ignorant of photographic fashions in the rest of the world, he became the unintentional inventor of what is now called the "candid" manner, and went on to produce, during his service with the Austro-Hungarian army, some of his greatest masterpieces. In 1925 he moved to Paris, joining in the life of the cafés and the boulevards, meeting and photographing painters and writers, presenting (in 1927) the first one-man photographic exhibition ever held, and pioneering in photojournalism. He later said: "Paris accepted me. After my first one-man show I felt at home. This is the biggest thing an artist can have." His reception in America, where he moved in 1936, was different, if not positively hostile. In New York, editors told him, "Your pictures talk too much," and for more than twenty years he was obliged to earn his living as a free-lance magazine photographer. But though American recognition was slow in coming, it did eventually arrive, culminating in his 1964 one-man show at New York's Museum of Modern Art.

Kertész has published many books of photographs—among them, *On Reading, Washington Square,* and *J'aime Paris.*

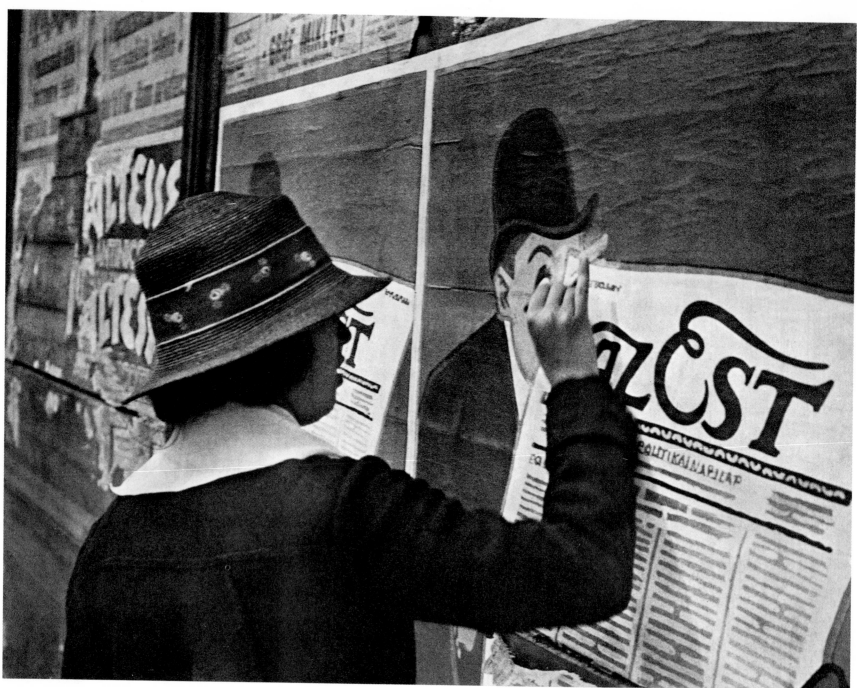

1920

André Kertész

Sixty Years of Photography

edited by Nicolas Ducrot

Penguin Books

To Elizabeth

ACKNOWLEDGMENTS
The author wishes to express his appreciation to
Elizabeth Kertész for her faith and partnership and
to Nicolas Ducrot for his understanding and spiritual
communion during the preparation of this book.

Penguin Books Ltd, Harmondsworth,
Middlesex, England
Penguin Books, 625 Madison Avenue,
New York, New York 10022, U.S.A.
Penguin Books Australia Ltd, Ringwood,
Victoria, Australia
Penguin Books Canada Limited, 2801 John Street,
Markham, Ontario, Canada L3R 1B4
Penguin Books (N.Z.) Ltd, 182–190 Wairau Road,
Auckland 10, New Zealand

First published in the United States of America by
Grossman Publishers 1972
Published in Penguin Books 1978

LIBRARY OF CONGRESS CATALOGING IN PUBLICATION DATA
Kertész, André.
André Kertész: sixty years of photography.
Bibliography: p. 6.
1. Photography, Artistic. 2. Kertész,
André. I. Ducrot, Nicolas.
[TR653.K47 1978] 779'.092'4 77-19082
ISBN 0 14 00.4744 1

Printed in the United States of America by
Halliday Lithograph Corporation, West Hanover, Massachusetts
Set in Linotype Caledonia

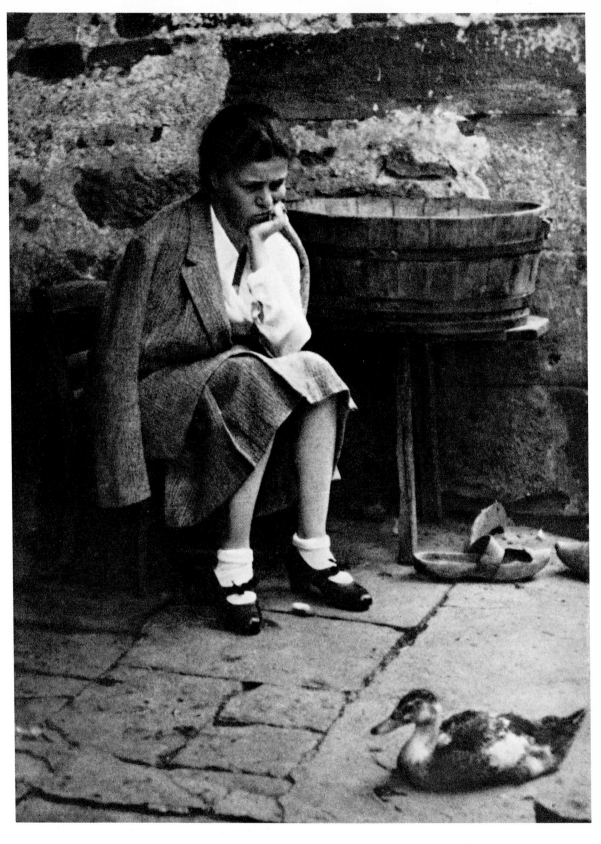

1933

Brother Seeing-Eye

Paul Dermée, the Dadaiste poet, wrote this poem as a Preface to the catalog for André Kertész's first one-man show at the gallery Sacre du Printemps in Paris in 1927. At the time, the Dadaists were handing out little stickers on which was written:

"You who do not see, please think of those who can."

The title is an allusion to a thirteenth-century home for blind friars and beggars where the monk in charge, the only man with sight, was named "Brother Seeing-Eye."

If only for the rhyme, Hamlet, you had to add:
There is more in nature than in works of art and literature!

Only discoverers and inventors create, enriching the public domain. It exists only through them, for which they are given grudging thanks.

To make continuous discoveries in the visual world one need only look with eyes whose retinas, with each blink, become virgin again—film endlessly unwinding.

All of you, do you not photograph nature on a plate that you have not changed since the day you were born!

Kertész,

Eyes of a child whose every look is the first,
which see the Emperor naked when he is clothed in lies;

which take fright at the canvas-draped phantoms haunting the quais of the Seine;

which marvel at the all-new pictures that create, without malice, three chairs in the sun of the Luxembourg Garden, Mondrian's door opening onto the stairs, eyeglasses thrown on a table beside a pipe.

No rearranging, no posing, no gimmicks, nor fakery.

Your technique is as honest, as incorruptible, as your vision.

In our home for the blind,
Kertész is a Brother Seeing-Eye.

Paul Dermée
TRANSLATED BY NICOLAS DUCROT

CHRONOLOGY

1894
Born July 2, Budapest, Hungary.
1912
Baccalaureate from the Academy of Commerce, Budapest.
Employed as a clerk in the Budapest Stock Exchange.
Buys his first camera (an ICA box camera using 4.5×6 cm plates) and begins shooting candid street scenes, genre subjects.
1913
Buys a new camera, ICA Bebe (4.5×6 cm plates).
1914–1918
Serves in the Austro-Hungarian army. Wounded in 1915. Photographs the war and the Commune as an amateur with Goërz Tenax (4.5 × 6 cm plates).
1916
Receives prize for satiric self-portrait from *Borsszem Jankó* magazine.
1917
First published photos in *Erdekes Ujsag* magazine (March 25; first cover June 26, 1925).
1925
Moves to Paris.
1925–1928
Does free-lance reportage for the *Frankfurter illustrierte, UHU* magazine, *Berliner illustrierte, Strasburger illustrierte, Le Nazionale de Fiorenze,* London *Times,* etc.
1927
One-man show, at Sacre du Printemps gallery, March 12.
1928
Buys his first Leica.
Selected to exhibit in the First Independent Salon of Photography.
Vu, edited by Lucien Vogel, begins publication; Kertesz is a major contributor.

1929
His photographs are purchased for the collections of the Staatliche Museen Kunstbibliothek, Berlin, and the Konig-Albert Museum, Zwickau.
1930
Art et Médecine begins publication; Kertesz is a major contributor until 1936.
Is awarded a silver medal at the *Exposition Coloniale.*
1932
Thirty-five prints in the exhibition of modern European photography at the Julien Levy Gallery, New York.
1933
Marries Elizabeth Sali.
Enfants, with text by Jaboune, is published.
1934
Group show at Leleu's, the noted decorator.
Group show at Galerie de la Pléïade, Paris.
Paris Vu par André Kertész, with text by Pierre MacOrlan, is published.
1936
Nos Amis les Bêtes, with text by Jaboune, is published.
October: Arrives in New York, under contract with Keystone Studios.
1937
Les Cathédrales du Vin, with text by Pierre Hamp, is published in Paris.
Terminates contract with Keystone Studios.
1937–1949
Free-lances for *Harper's Bazaar, Vogue, Town and Country,* the *American Magazine, Collier's, Coronet, Look.*
1944
Becomes an American citizen.
1945
Day of Paris, with text by George Davis, is published.

1946
One-man show at the Art Institute of Chicago.
1949
Signs exclusive contract with Condé Nast Publications.
1962
Terminates contract with Condé Nast Publications.
One-man show at Long Island University, New York.
1963
Is awarded a gold medal at the IV Mostra Biennale Internazionale della Fotografia, Venice, Italy.
One-man show at the Bibliothèque Nationale, Paris.
1964–1965
André Kertesz, Photographer, with text by J. Szarkowski, is published.
One-man show at the Museum of Modern Art, New York.
1965
Appointed honorary member of A.S.M.P.
Guest of Honor at the Miami Conference on Communication Arts, University of Miami, Coral Gables, Florida.
1967
Participates in the group show "The Concerned Photographer" at the Riverside Museum, New York.
1968–1969
"The Concerned Photographer" in Matsuya, Tokyo.
1970
Exhibits ten photographs at the U.S. Pavilion at the World's Fair Expo 1970, Tokyo, Japan.
1971
One-man show at the Moderna Museet, Stockholm.
One-man show at the Magyar Nemzeti Galeria Budapest, Hungary.
On Reading is published.
1972
One-man show at Valokuvamuseon, Helsinki, Finland.

1973
One-man show at the Hallmark Gallery, New York.
1975
Washington Square, with an introduction by Brendan Gill, edited by Nicolas Ducrot, is published.
Is awarded a Guggenheim Fellowship.
1976
Of New York, edited by Nicolas Ducrot, is published.

Distortions, with an introduction by Hilton Kramer, edited by Nicolas Ducrot, is published.
One-man show at Wesleyan University, Middletown, Connecticut.
One-man show at the French Cultural Services, New York.
Is honored with title of Commander of the Order of Arts and Letters from the French Government.

1977
One-man show at the Musée d'Art Moderne, Centre Beaubourg, Paris.
Is awarded Medal for Distinguished Achievement from the City of New York.

ARTICLES ABOUT ANDRE KERTESZ

Pierre MacOrlan. "La photographie et le fantastique social." *Les Annales*, Paris, March 1927.

Criticism of the exhibition at Sacre du Printemps gallery. *Comoedia*, March 12, 1927, Paris.

Montpar. "Photo Kertész." *Chantecler*, March 19, 1927.

Pierre MacOrlan. "L'Art littéraire d'imagination et la photographie." *Les Nouvelles littéraires, artistiques et scientifiques*, No. 37, 1928.

Pierre Bost. "Le Salon des Indépendants de la Photographie." *La Revue hebdomadaire et son supplément illustré*, No. 24, 1928.

Jean Gallotti. "La Photographie, est-elle un art? Kertész." *L'Art vivant*, March 1, 1929.

Jean Vidal. "En photographiant les photographes." Interview with Kertész. *L'Intransigeant*, April 1, 1930.

Carlo Rim. "Défense et illustration de la photographie." *Vu*, Paris, April 20, 1932.

Betrand Guégan. "Kertész et son miroir." *Arts et Métiers graphiques*, No. 37, 1933.

Carlo Rim. "Grandeur et servitude du reporter photographe." *Marianne*, Paris, February 21, 1934.

Pierre Malo. Criticism of the exhibition of photographers at Galerie de la Pléiade. *L'Homme libre*, Paris, November 20, 1934.

Alexander King. "Are Editors Vandals?" *Minicam*, 1939.

Arthur Browning. "Paradox of a Distortionist." *Minicam*, 1939.

John Adam Knight. "Photography." *New York Post*, December 31, 1942.

Maria Giovanna Eisner. "Citizen Kertész." *Minicam*, No. 10, 1944.

Bruce Downes. "André Kertész. Day of Paris." *Popular Photography*, No. 6, 1945.

———. "Day of Paris." *Minicam*, No. 10, 1945.

Elliot Paul. "A Mood from the Dim Past." *Saturday Review of Literature*, March 19, 1945.

William Houseman. "André Kertész." *Infinity*, No. 4, 1959.

Carol Schwalberg. "André Kertész, Unsung Pioneer." *U.S. Camera*, January 1963.

François Pluchart. "Un grand photographe: André Kertész." *Combat Paris*, November 16, 1963.

Brassaï. "My Friend André Kertész." *Camera*, No. 4, 1963.

Greistan Press. "Caricatures and Distortions." *Encylopedia of Photography*.

Maximilian Gautier. "Quand l'oeil a du génie." *Les Nouvelles littéraires*, November 28, 1963.

B. Girod de l'Ain. "André Kertész." *Le Monde*, November 29, 1963.

Alice Gambier. "André Kertész—Photographies." Bibliothèque Nationale, Paris.

George Regnier. "Un long regard amical à André Kertész." *Le Photographe*, December 20, 1963.

Tarcai Bela. "Fotofortenet André Kertész." *Fenykep Muveszeti Tajekoztato*, 1964. III-I.

Robert Kotlowitz. "A Great Photographer Has Spent a Lifetime in Pursuit of His Art." *Show*, March 1964.

L. Fritz Gruber. "André Kertész ein keinesfalls verschollener Altmeister." *Foto Magazin*, July 1964.

Anna Farava. *André Kertész*—Photographic series, Grossman Publishers, New York.

L. Fritz Gruber. "Die Gabel." *Die Welt*, July 3, 1964.

Anatole Jakowsky. "Le Royaume enchanté des naifs." *Beaux Arts*, October 7, 1964.

David Vestal. "André Kertész, Photographer." *Contemporary Photographer*, November 1964–1965.

Margaret R. Weiss. "André Kertész, Photographer." *Saturday Review*, December 20, 1964.

Beaumont Newhall. *"History of Photography: 1830 to the Present Day."* Dist. by N.Y.G.S. Museum of Modern Art.

François Pluchart. "Une définition du langage photographique." *Combat*, December 24, 1964.

"André Kertész—Originator." *Photography*, March 1965.

Dan Budnik. "A point de vue." *Infinity*, March 1965.

Recension of catalogue and exhibition at the Museum of Modern Art in New York. *Times*, London, March 25, 1965.

Ursula Czartoryska, "A Magyar Fotografia Mesterei," *Foto*, November 1965.

L. Fritz Gruber. "André Kertész, a un Piccolo Maestro," *Foto Magazin*, November 1965, Como, Italy.

ASMP Bulletin, November 1965. Report of Kertész's appointment as a member of honor.

Robert E. Hood. "André Kertész, Soldier and Candid Cameraman in World War I." *12 at War*, 1967.

Peter Pollack. *Picture History of Photography.* Abrams Publishers, 1968.

Bill Jay. "A. Kertész, Nude Distortion, an Incredible Experiment." *Creative Camera*, January 1969.

Bill Jay. "A. Kertesz, a Meeting of Friends." *Creative Camera*, August 1969.

Geoffrey James. "André Kertesz." *Vie des Arts*, No. Hiver 1969–1970.

———. "Major Portfolio." *Creative Camera*, September 1969.

Prisma Encyclopedie de la Photographie, Paris, 1970.

Frederick von Almete. "Descriptive Tradition." *Boston after Dark*, April 1, 1970.

Joseph Foldes. "To Become a Photographer." *Popular Photography*, March 1971.

Janet Malcolm. "On and Off the Avenue. *The New Yorker*, May 1, 1971.

Kurt Bergengen. "For alla med Kamera: André Kertész." *Aftonbladet*, May 1971.

Margaret R. Weiss. "Everyman's Reader." *Saturday Review*, July 3, 1971.

Manuel Glasser. "Portfolio Kertesz: Paris um 1930." *Du*, July 1971.

Zay Laslo. "Az Ember A Kep Es A Muveszet." *Foto*, No. 6, 1971.

"Ein Pioner der Fotografie und ihrer hochsten Vollender: André Kertész." *Die Welt*. September, 1971.

Bozoky-Maria. "André Kertész." *Fotomuveszet*, November 20, 1971.

"Les Nus Etranges d'André Kertesz." *Photo Magazine*, March 1972.

William Wilson. "Photos of André Kertész, Quickest Shutter in Town." *Los Angeles Times*, August 13, 1972.

Margaret R. Weiss. "Anniversary Salute to André Kertész." *World*, January 2, 1973.

Hilton Kramer. "Kertész Conveys Poetic Significance of Details." *The New York Times*, January 17, 1973.

Hilton Kramer. "Three Who Photographed the 20's and 30's." *The New York Times*, March 3, 1974.

Tom Albright: "Weird Magic and Drama." *San Francisco Chronicle*, 1974.

Lois Greenfield. "Kertész: Discovered at 70." *Changes*, April 1975.

Owen Edwards. "Zen and the Art of Photography." *The Village Voice*, April 5, 1975.

Nancy Stevens. "André Kertész." *New York Arts Journal*, December–March 1976.

Hilton Kramer. "Two Masters of Photography." *The New York Times*, March 27, 1976.

Leo Rubinfien. "André Kertész: French Cultural Services." *Artforum*, Summer 1976.

Mark Roskill and Roger Baldwin. "André Kertész's 'Chez Mondrian.'" *Arts Magazine*, January 1977.

John G. Morris. "Gentle Vision." *Quest*, January–February 1978.

NOTES TO THE PLATES

Half-Title Elizabeth, Paris, 1931
Title Page AZ EST, Budapest, April 27, 1920
Copyright The Duck, Savoie, 1933
7 Behind Notre-Dame, October 1925, Paris
9 My mother's hands, 1919, Budapest
10 Spring shower, 1921, Budapest

11 Hazy day, November 1920, Budapest
12 Ripples, May 11, 1913, Hungary
13 April snow, April 13, 1913, Budapest
14 Iskola Ter, February 19, 1920, Budapest
15 Downtown Esztergom, February 1, 1917, Hungary
16 Boskay Ter, 1914, Budapest

17 Rákos Patak, 1914, Hungary
18 Torok—Balint, August 19, 1922, Hungary
19 Tisza—Szalka, July 6, 1924, Hungary
20 HoldVilág Utca, May 9, 1916, Hungary
21 Cock fight, February 19, 1920, Hungary
22 Accordionist, October 21, 1916, Esztergom

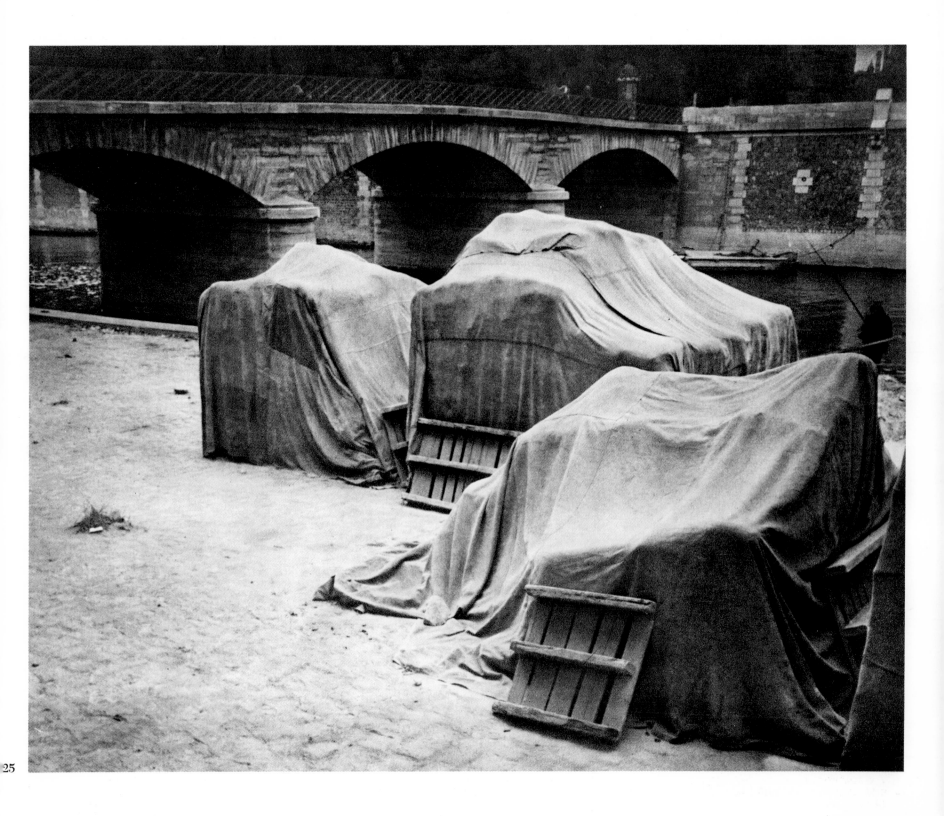

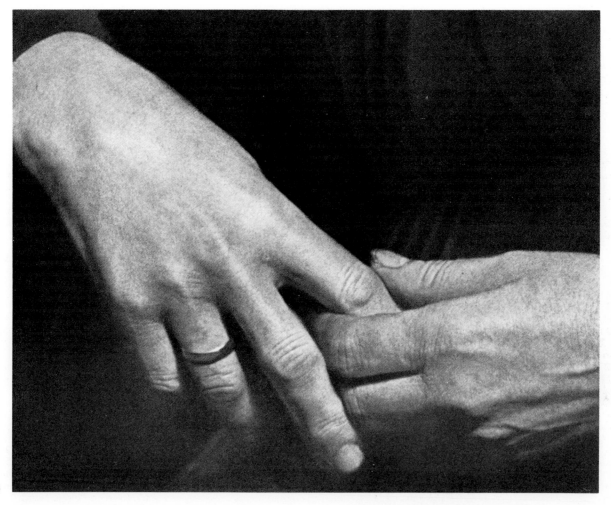

1919

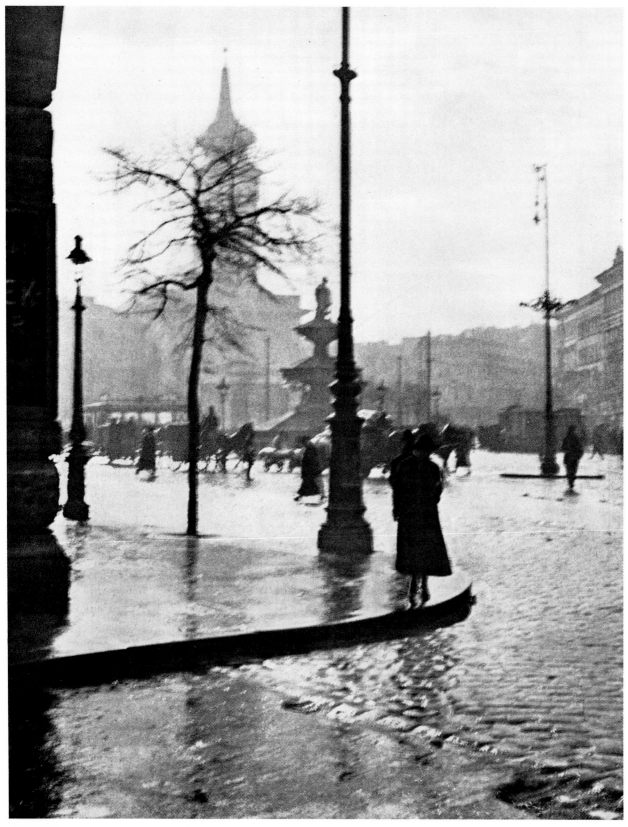

1921

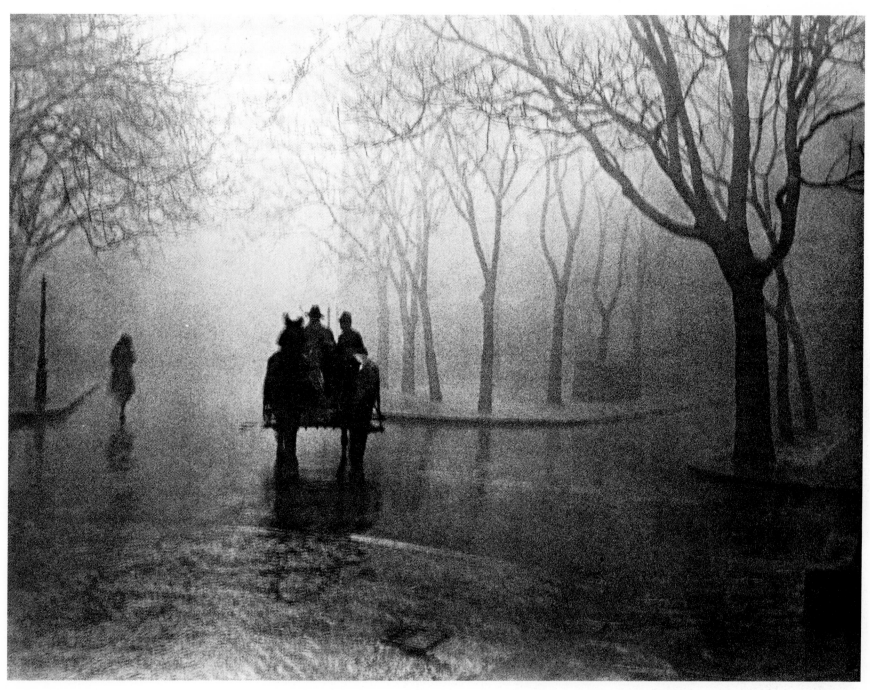

1920

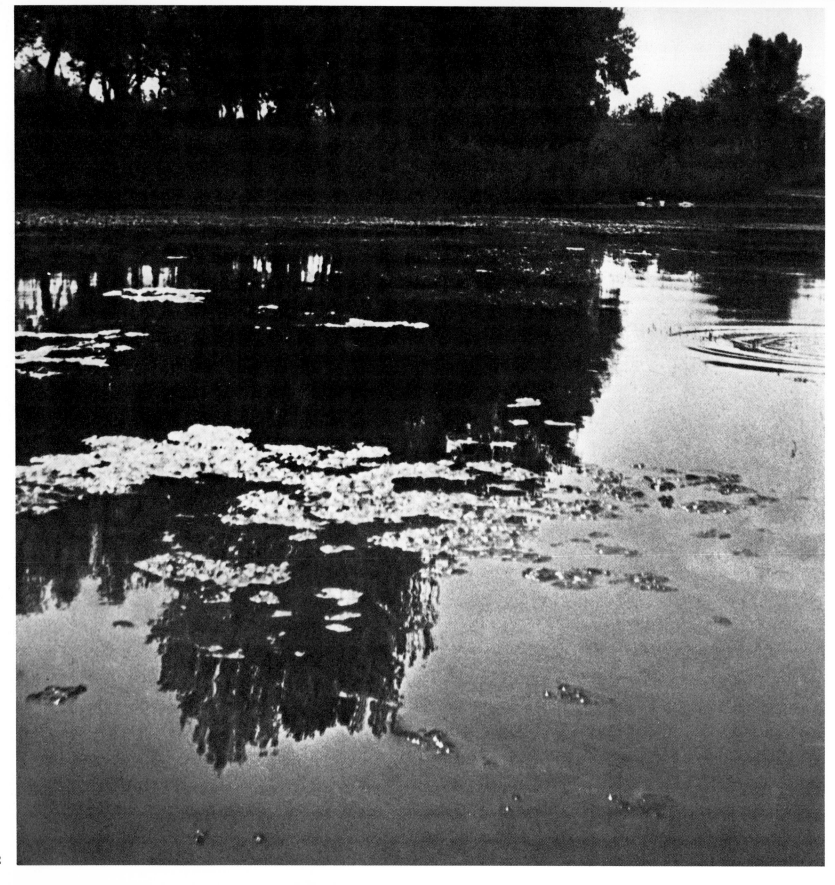

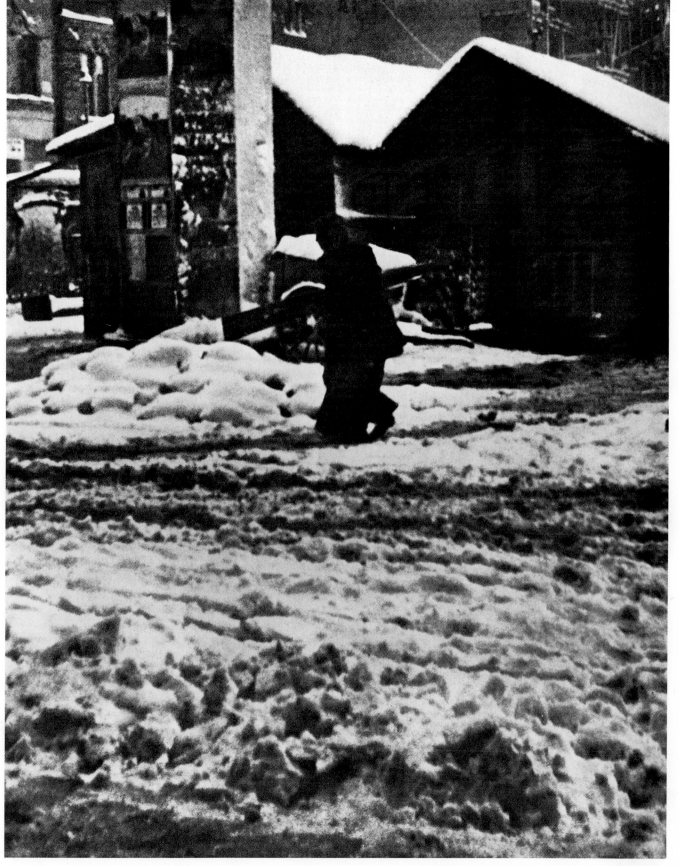

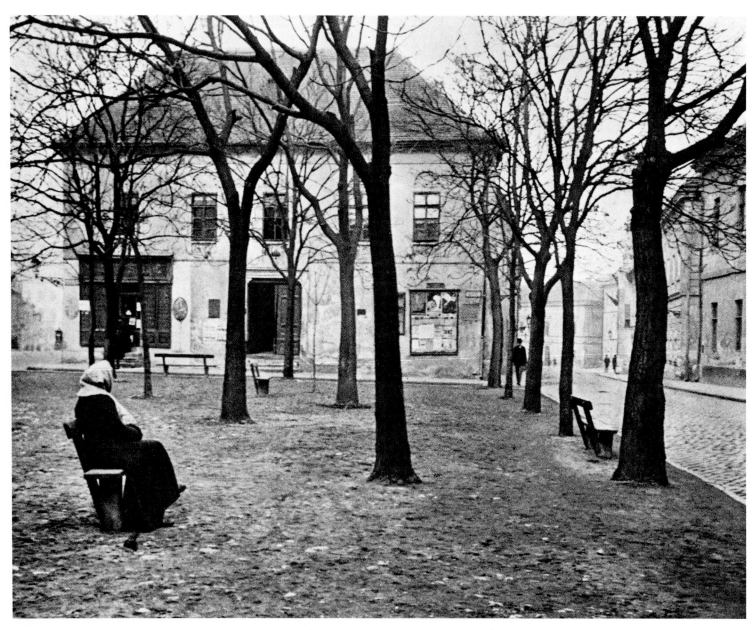

1920

14

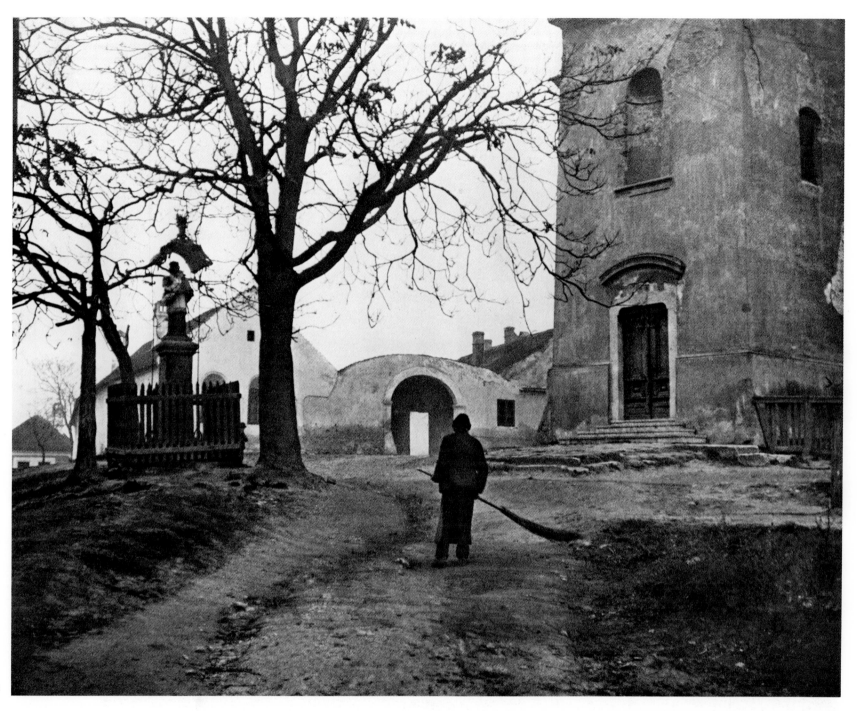

1917

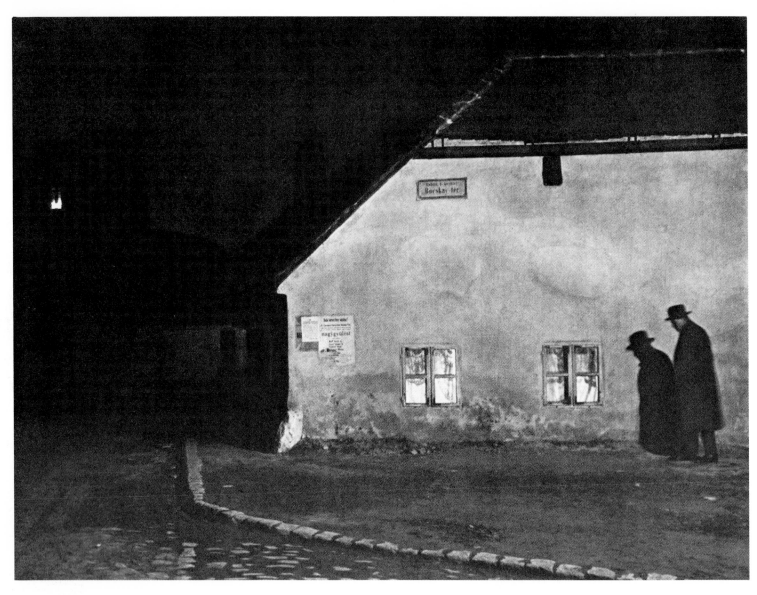

1914

16

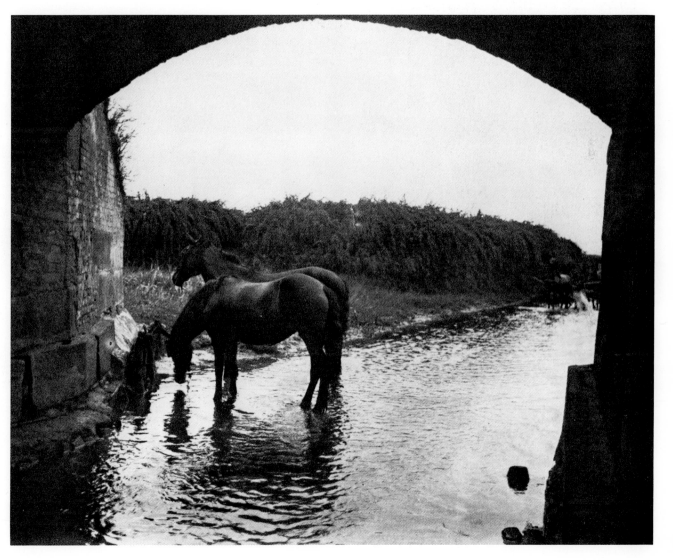

1914

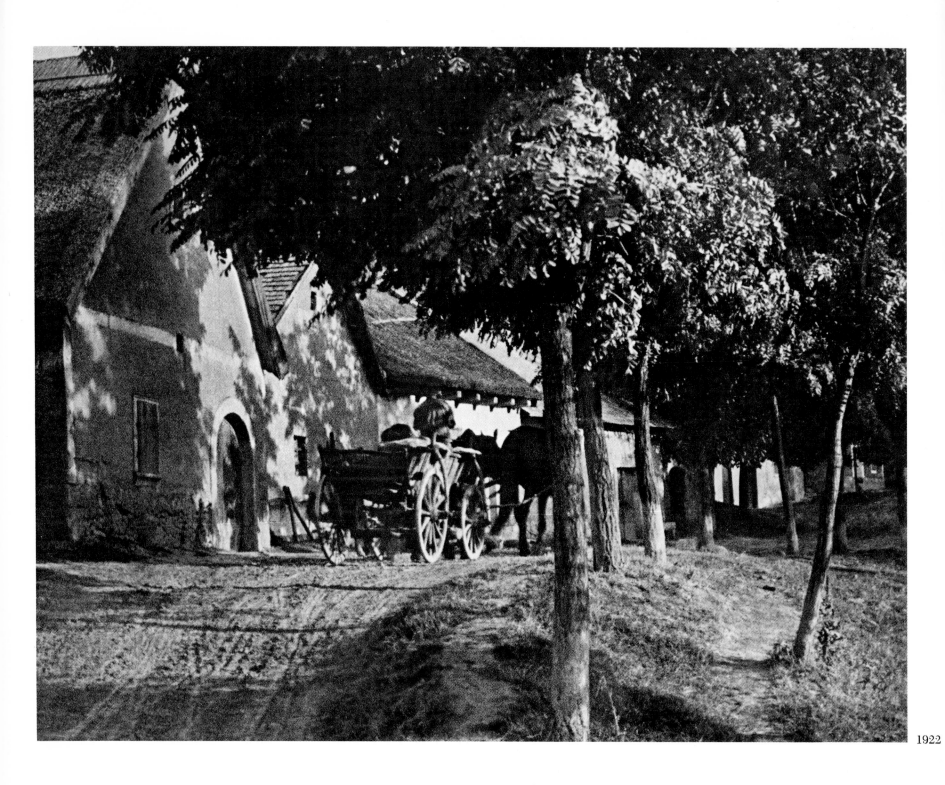

1922

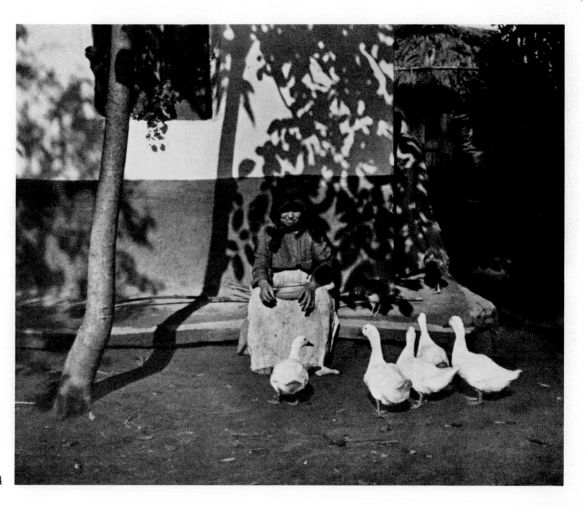

1924

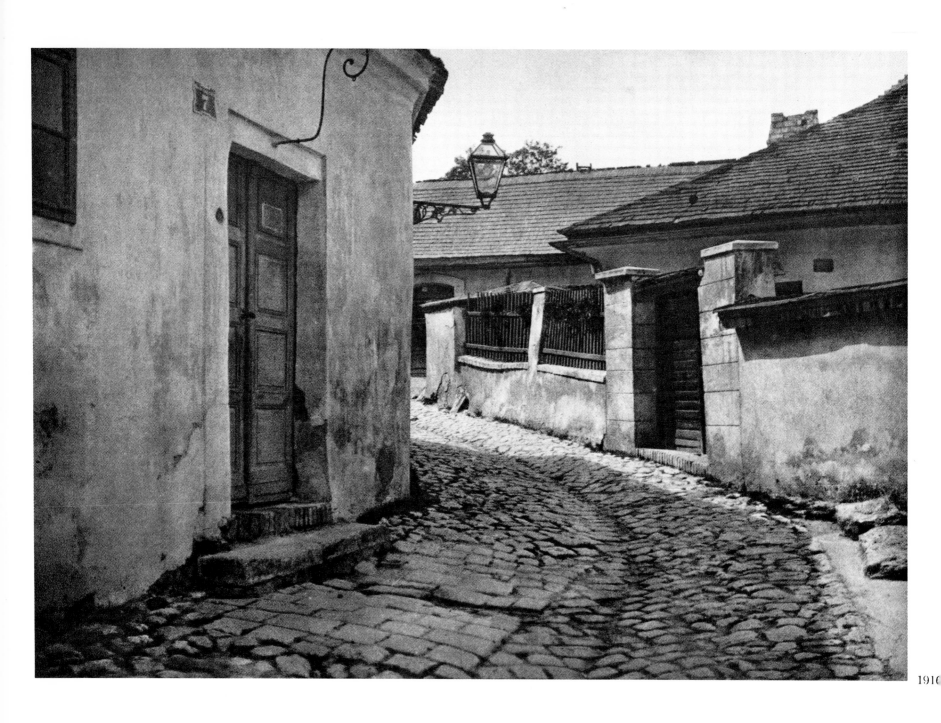

1910

20

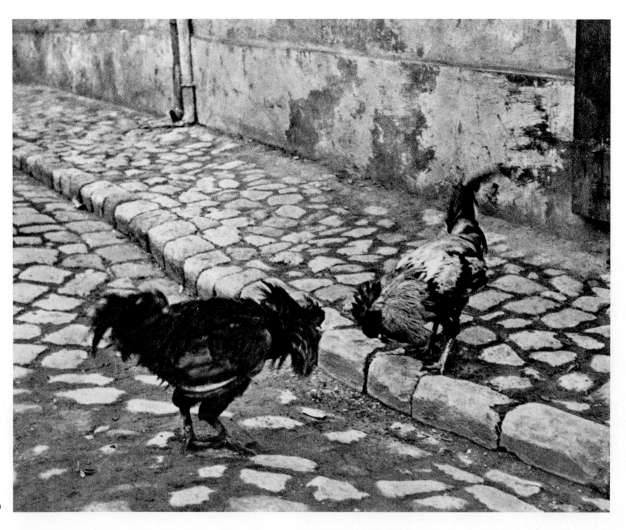

1920

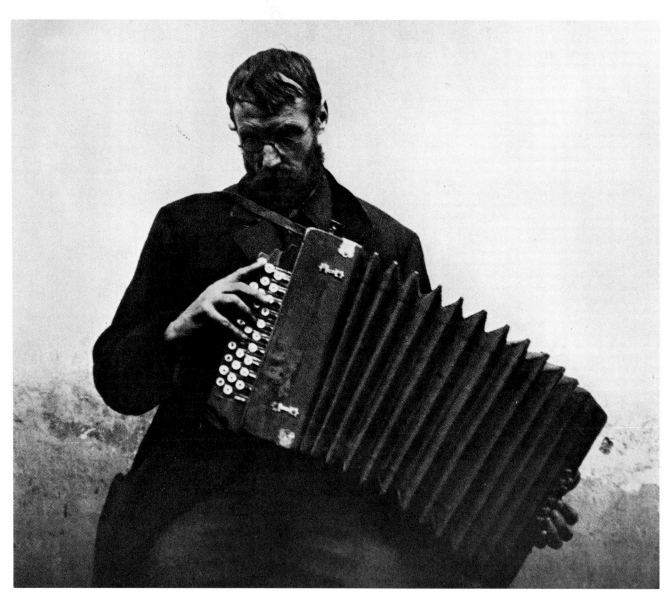

1916

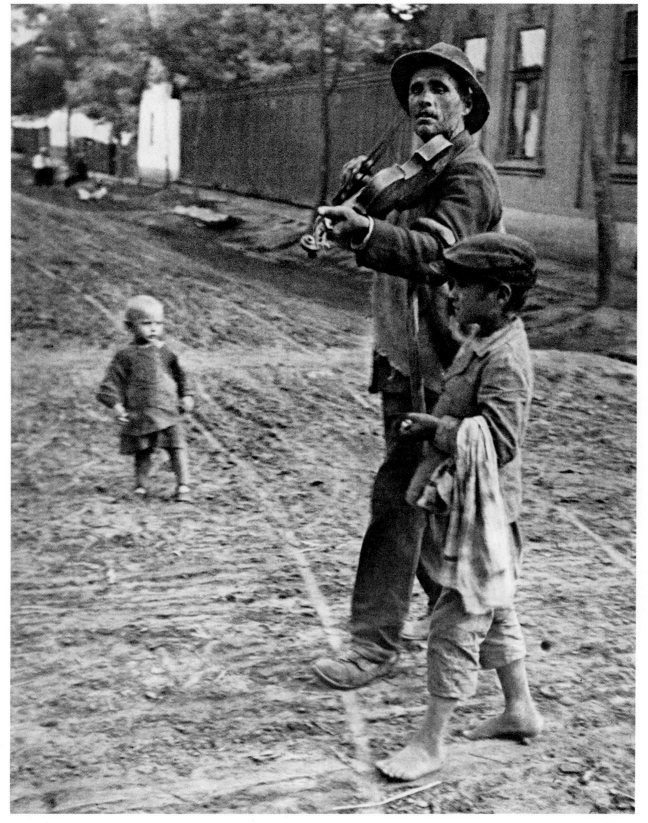

1921

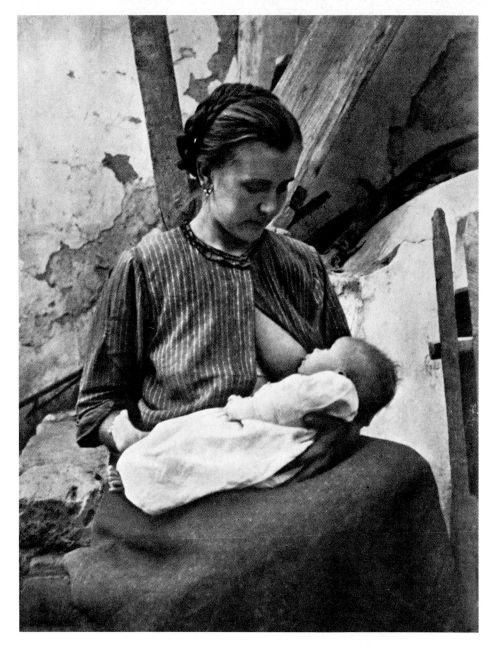

1920

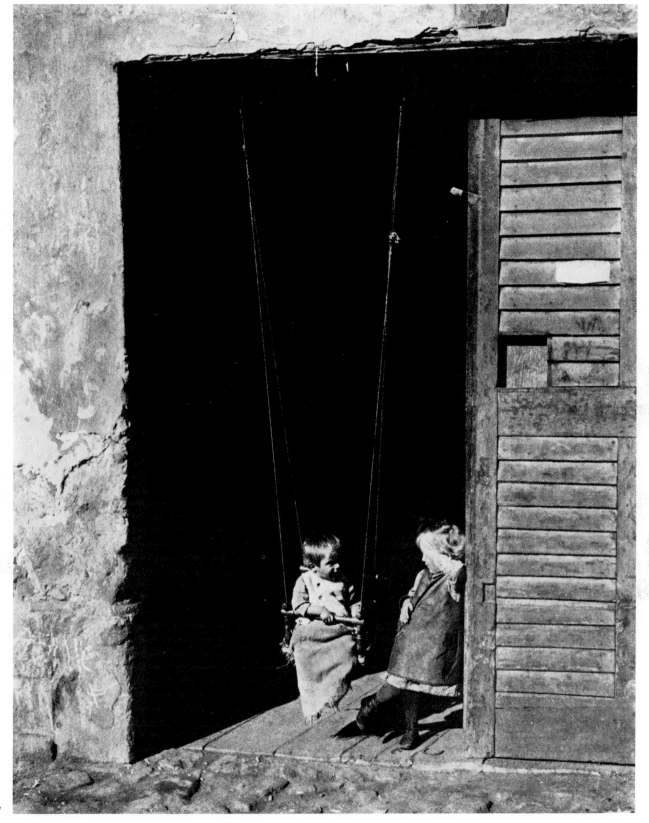

1917

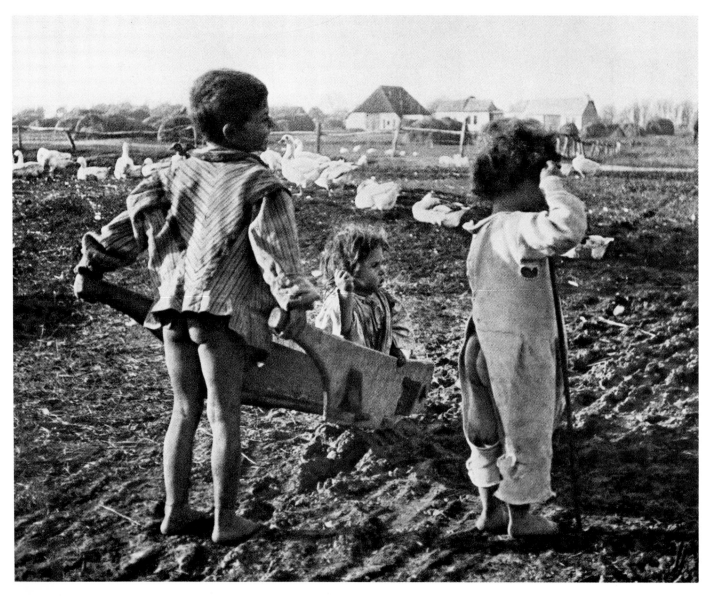

1916

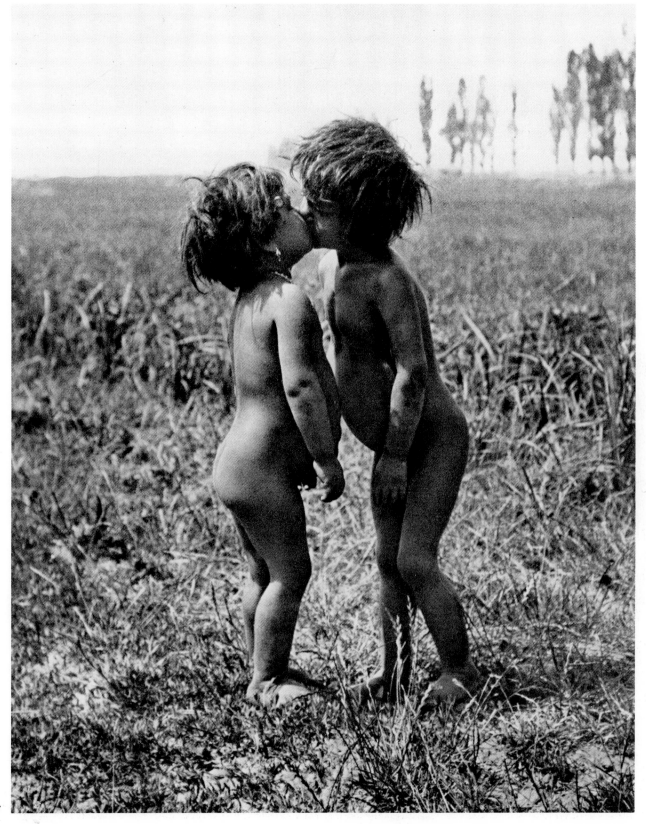

1917

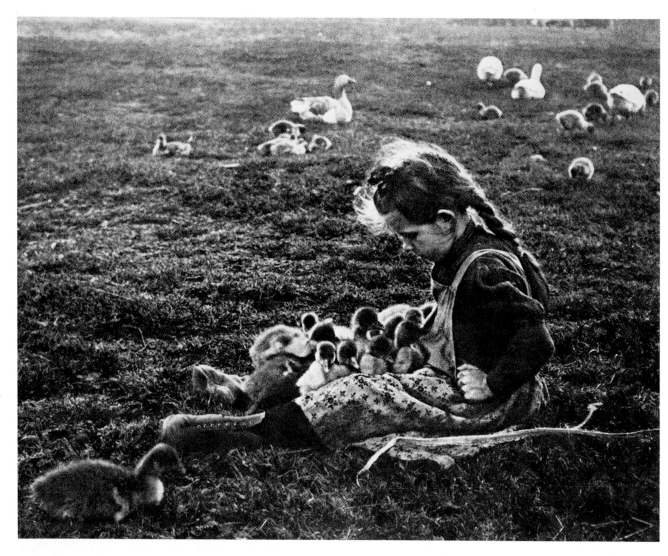

1918

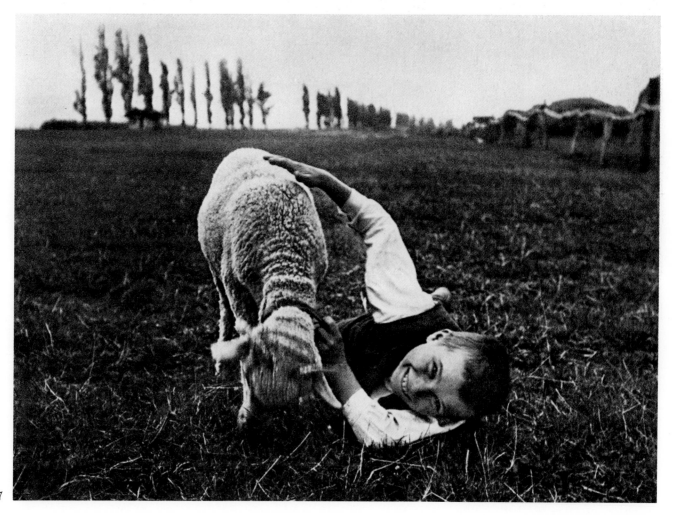

1917

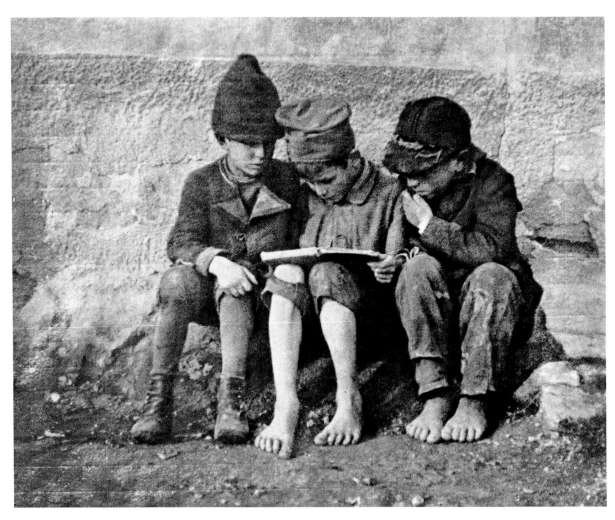

1915

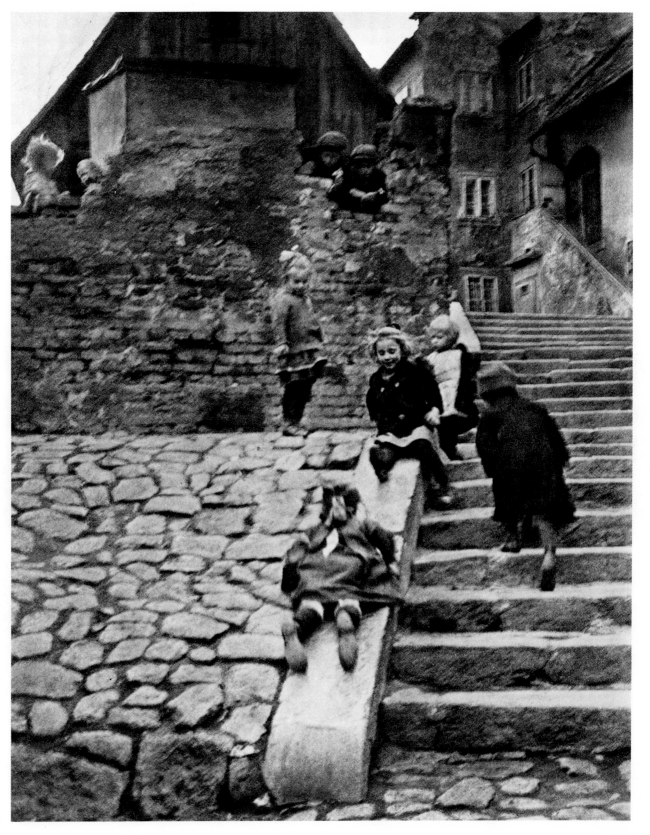

1916

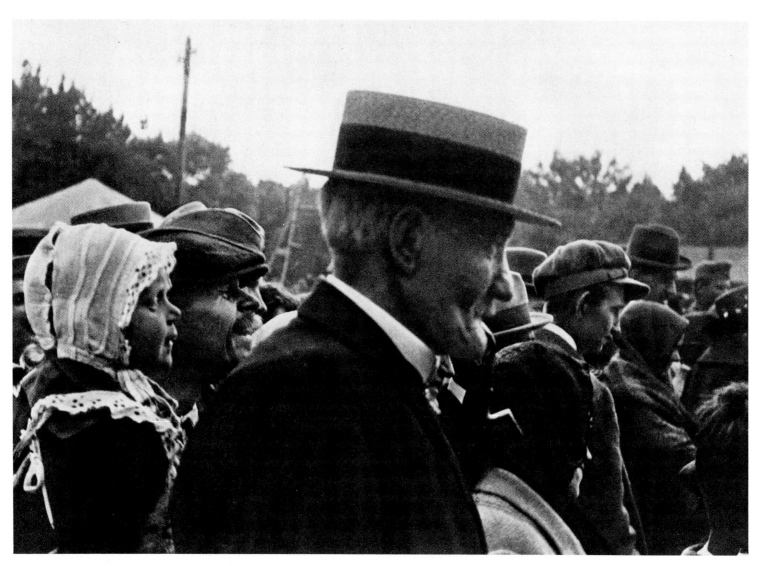

1920

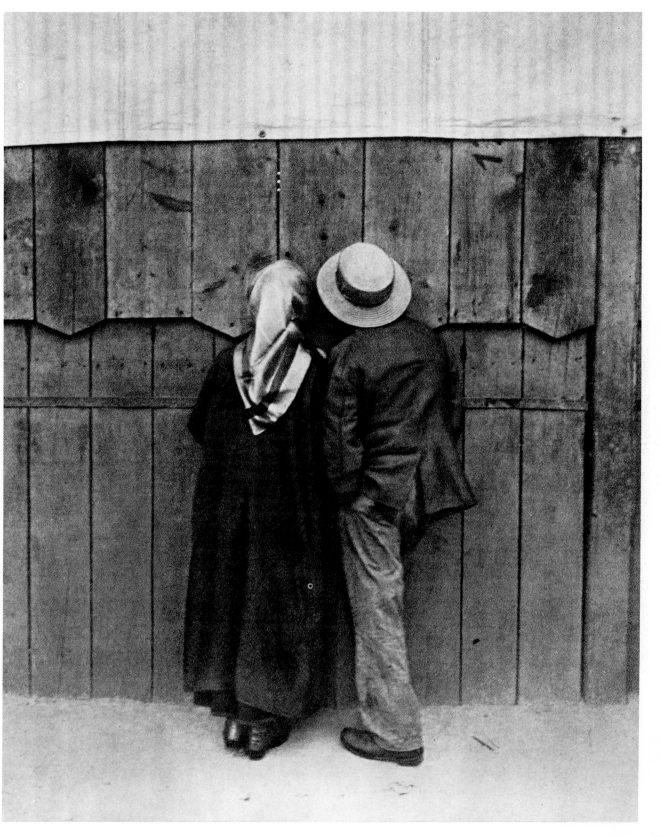

1920

33

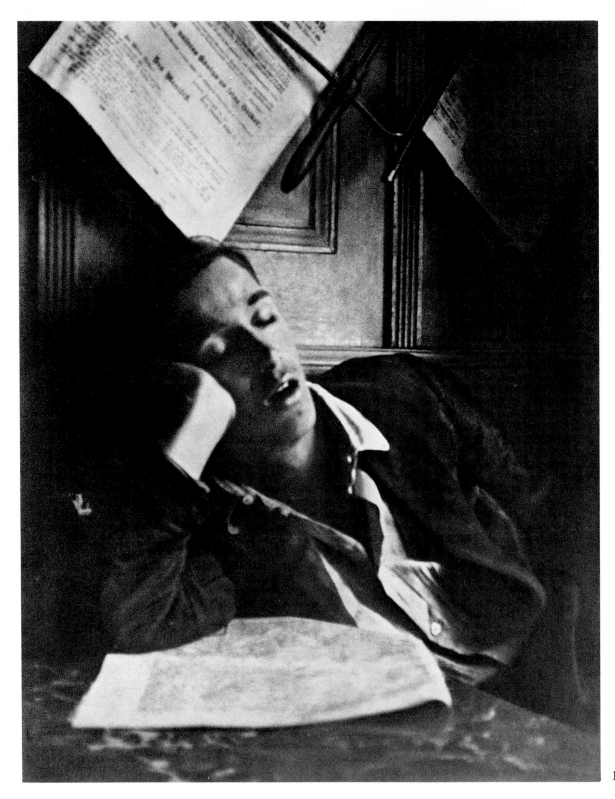

1912

34

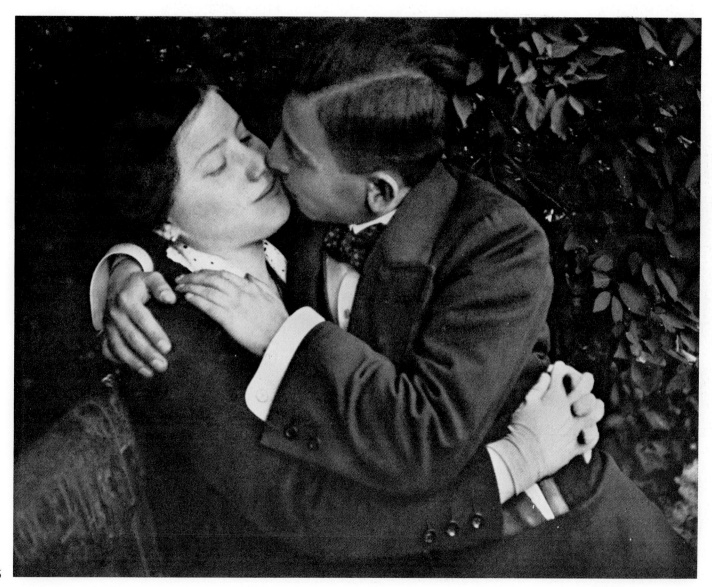

1915

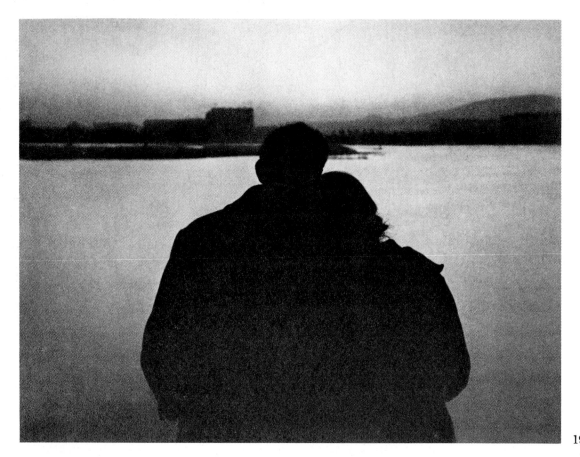

1920

1917

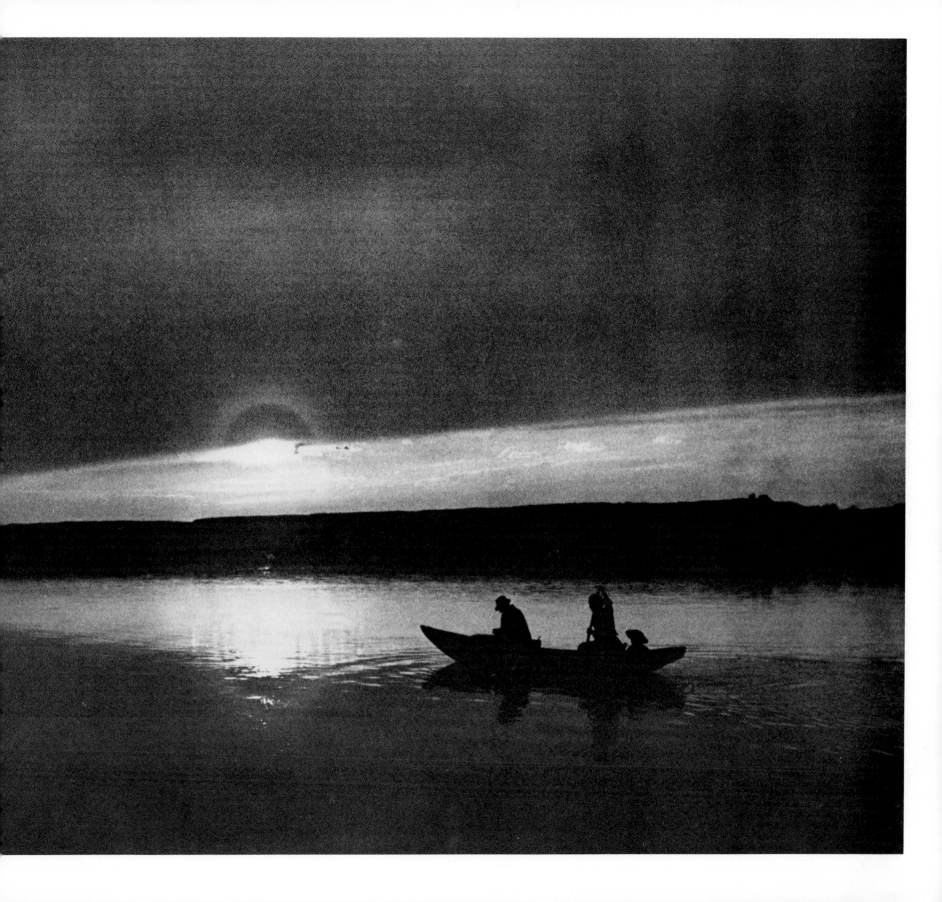

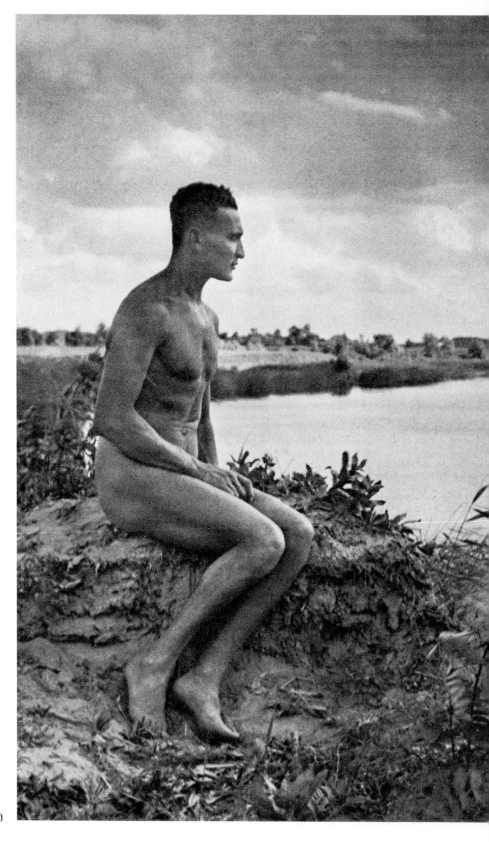

1920

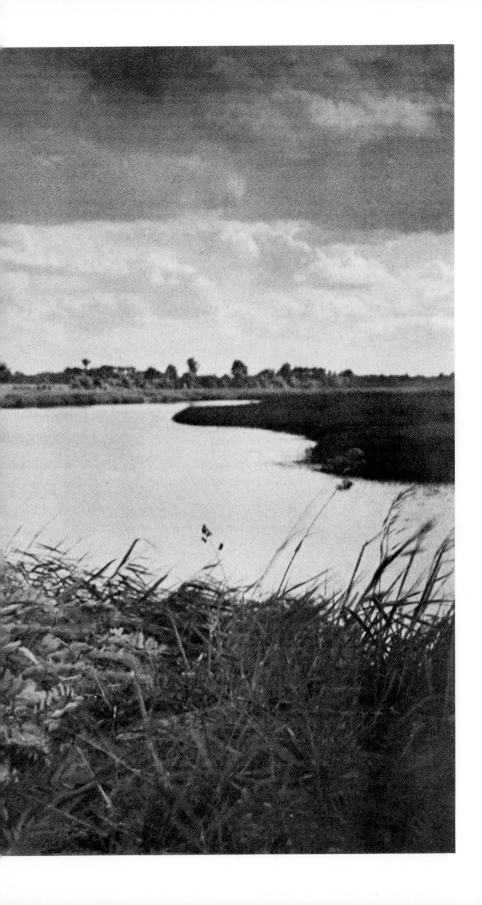

1919

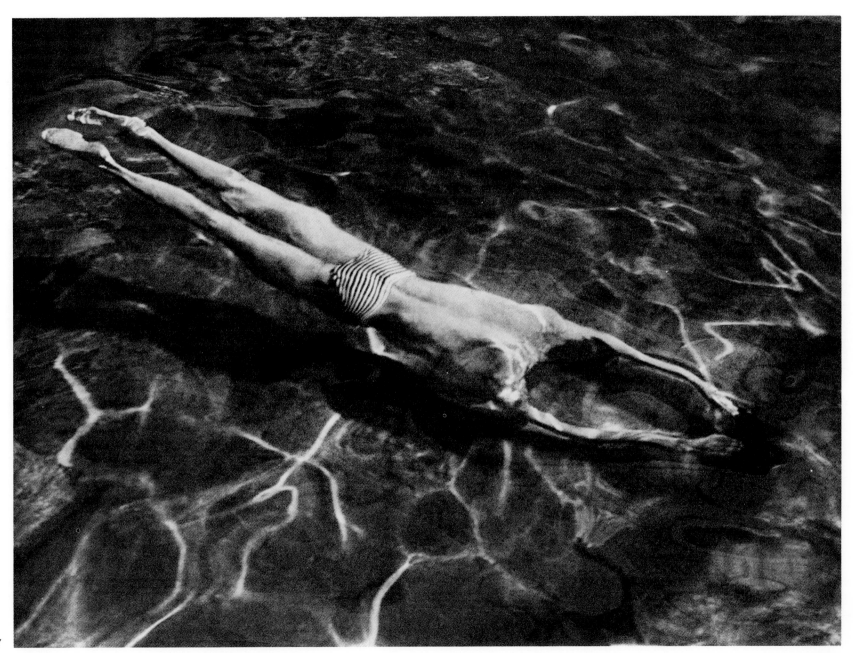

1917

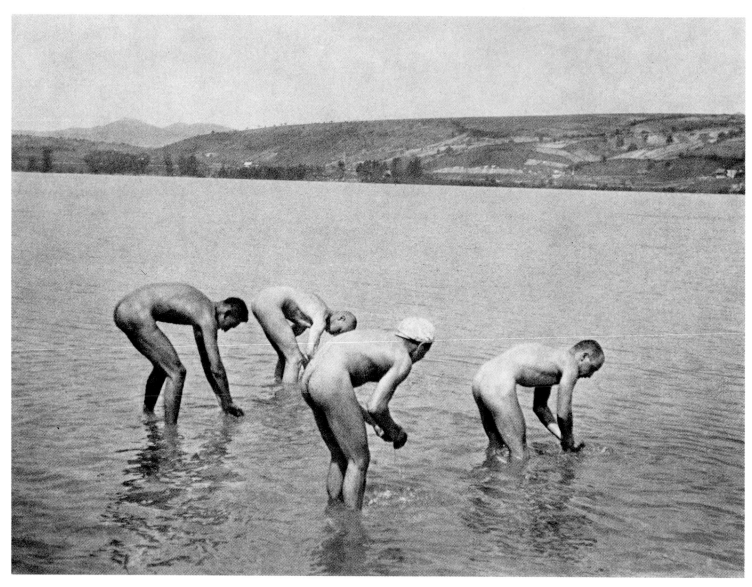

1915

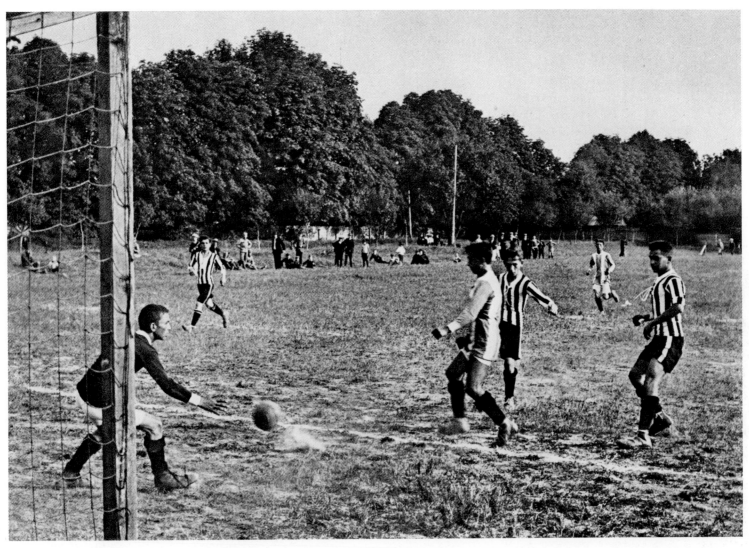

1917

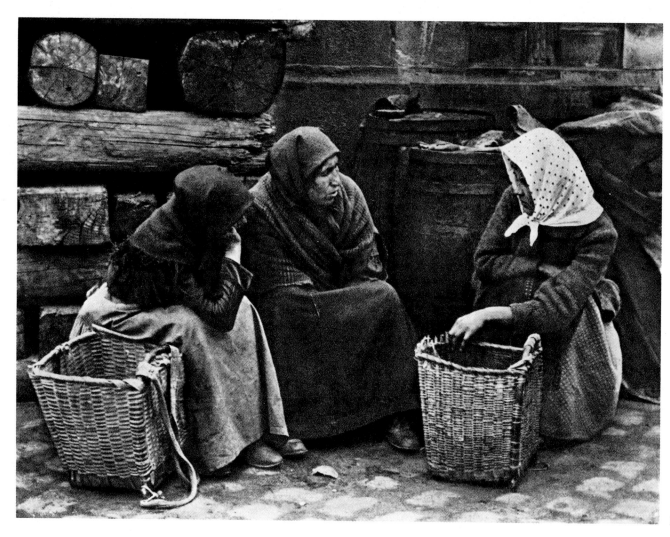

1919

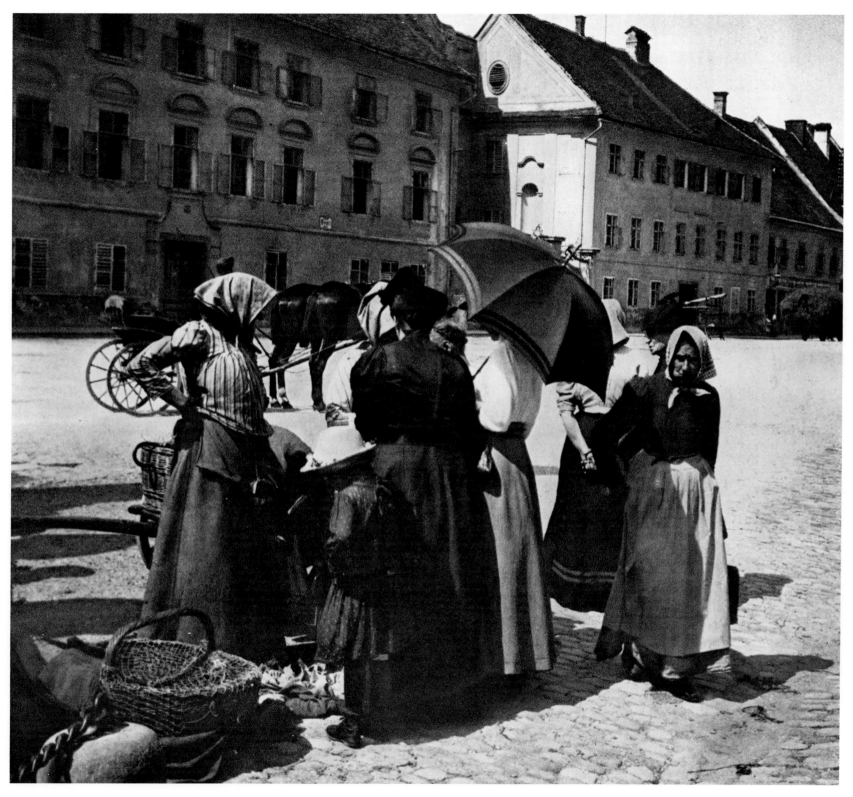

1917

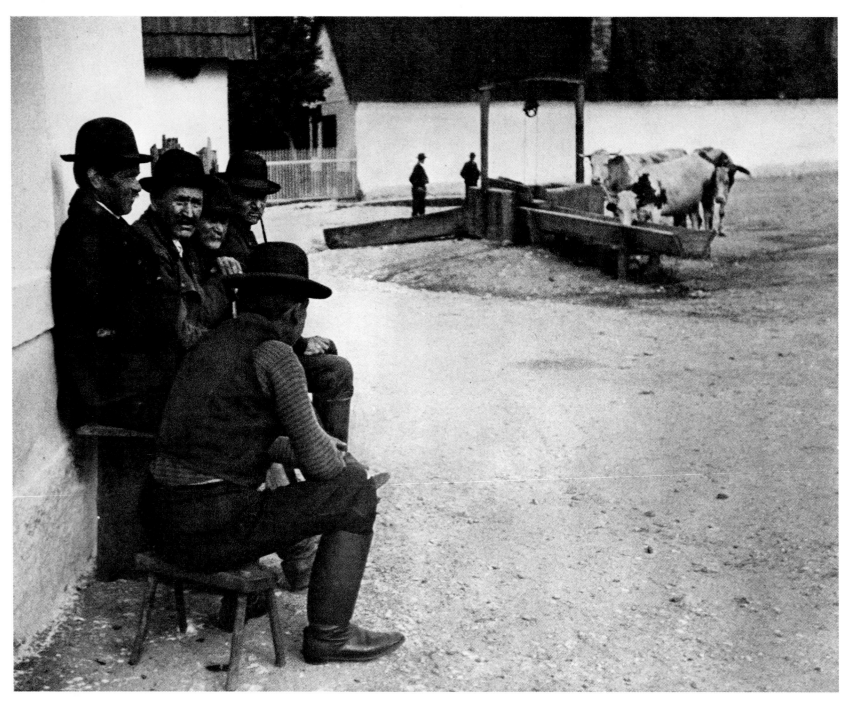

1916

46

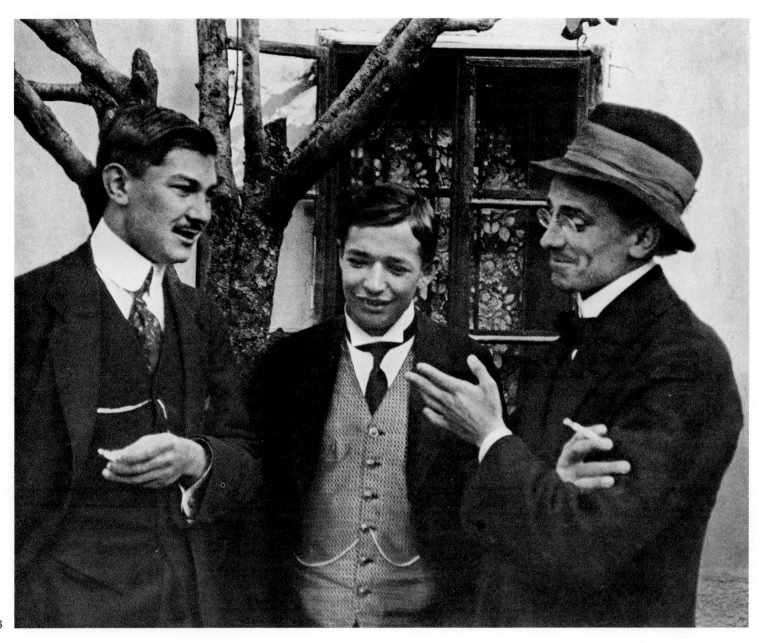

1916

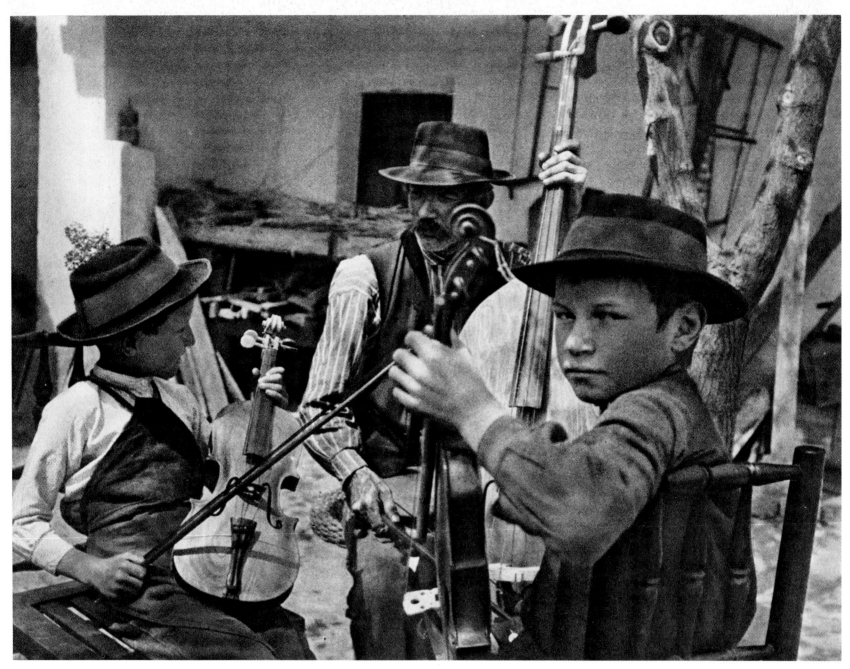

1923

48

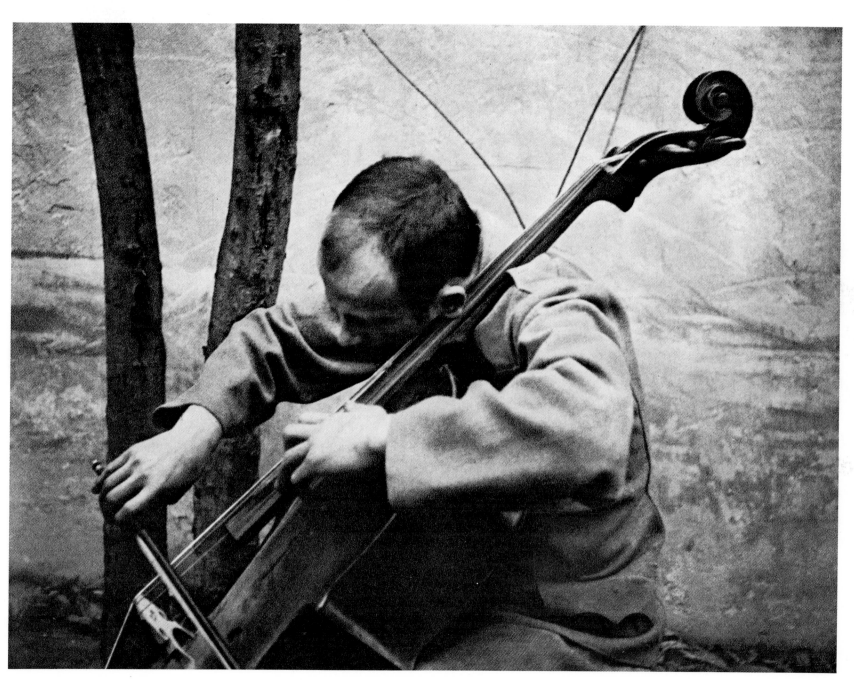

1916

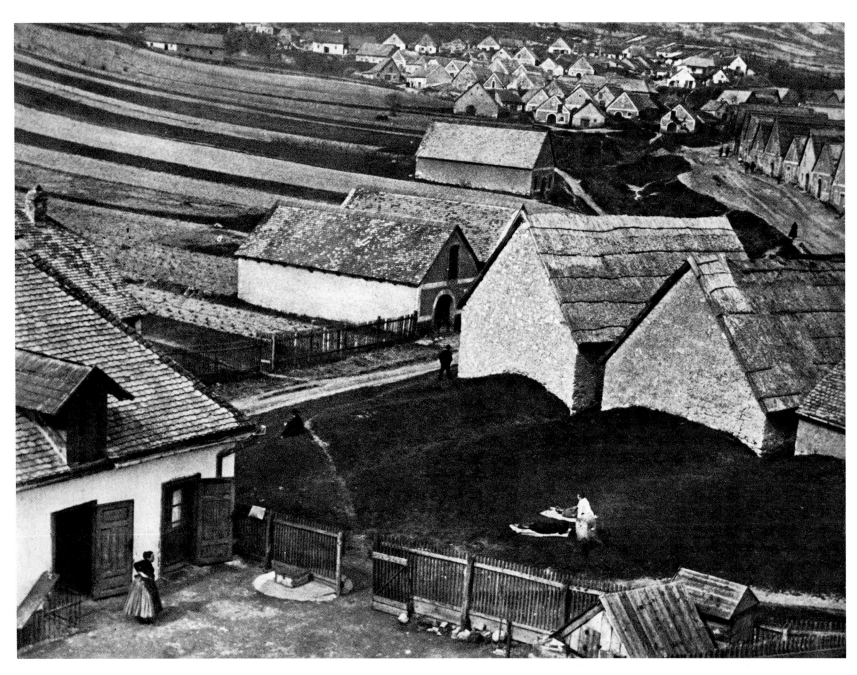

1919

50

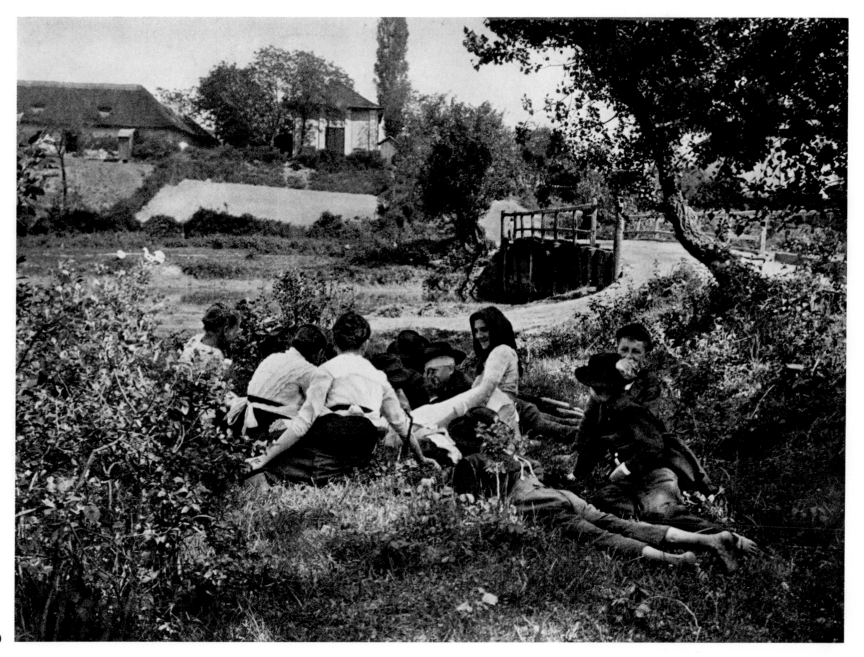

1919

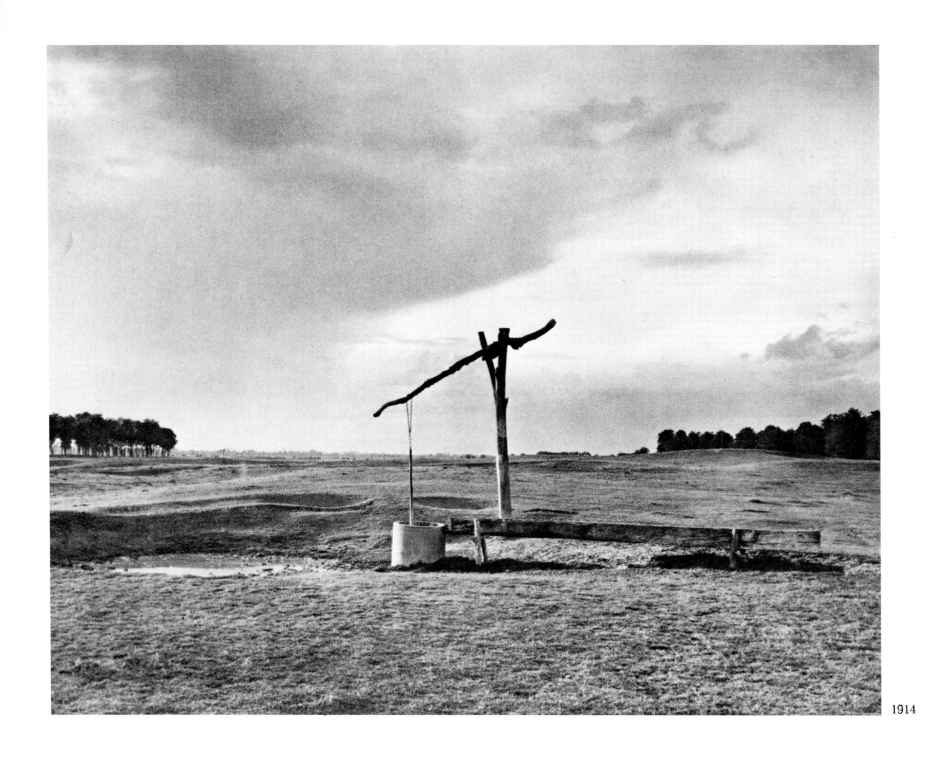

1914

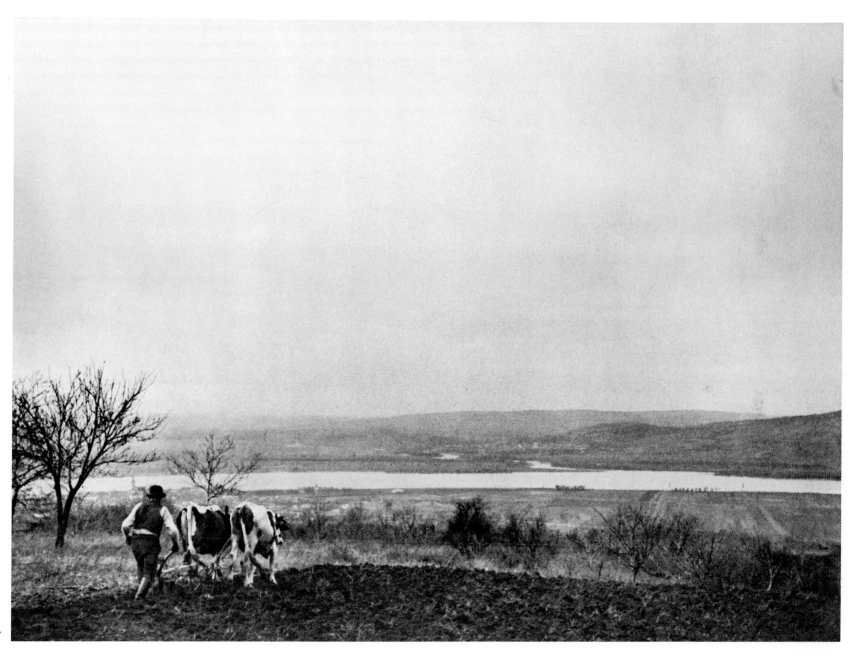

1917

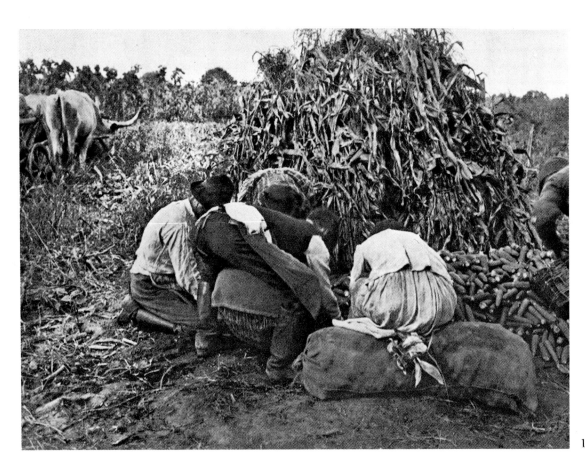

1924

54

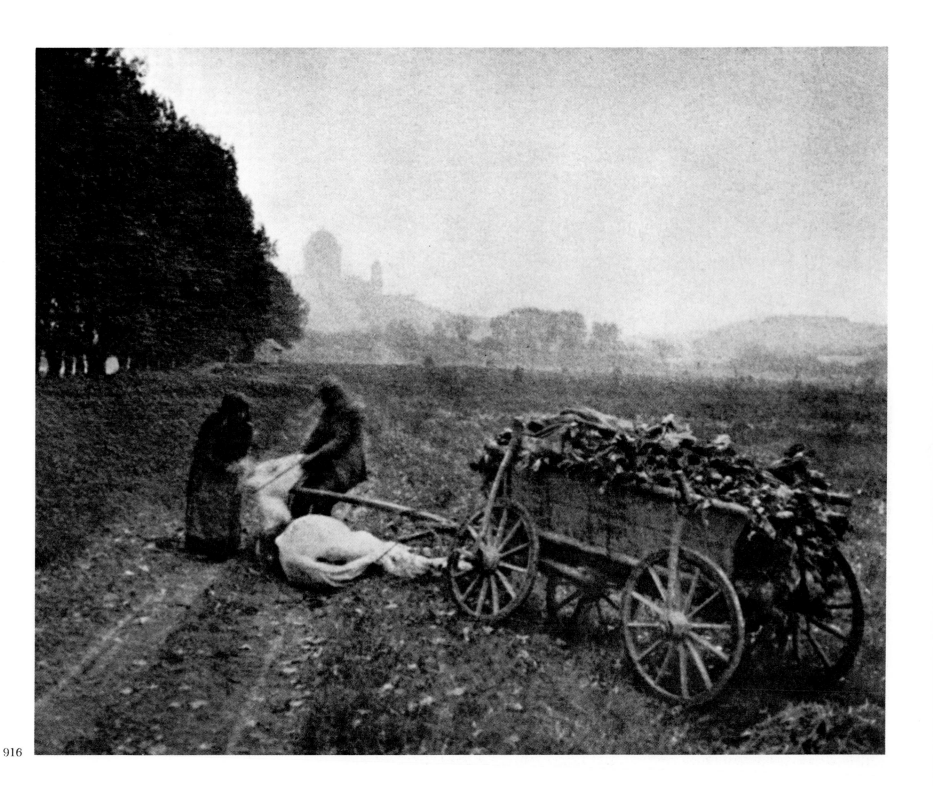

916

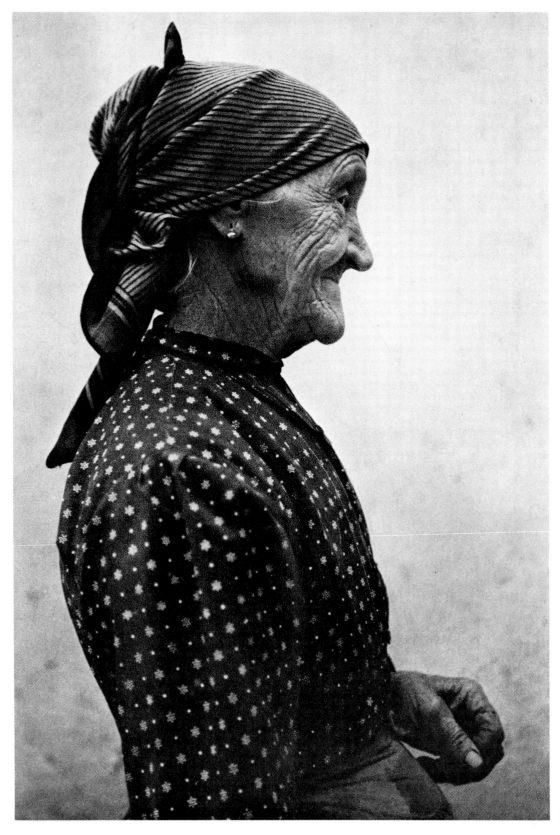

1919

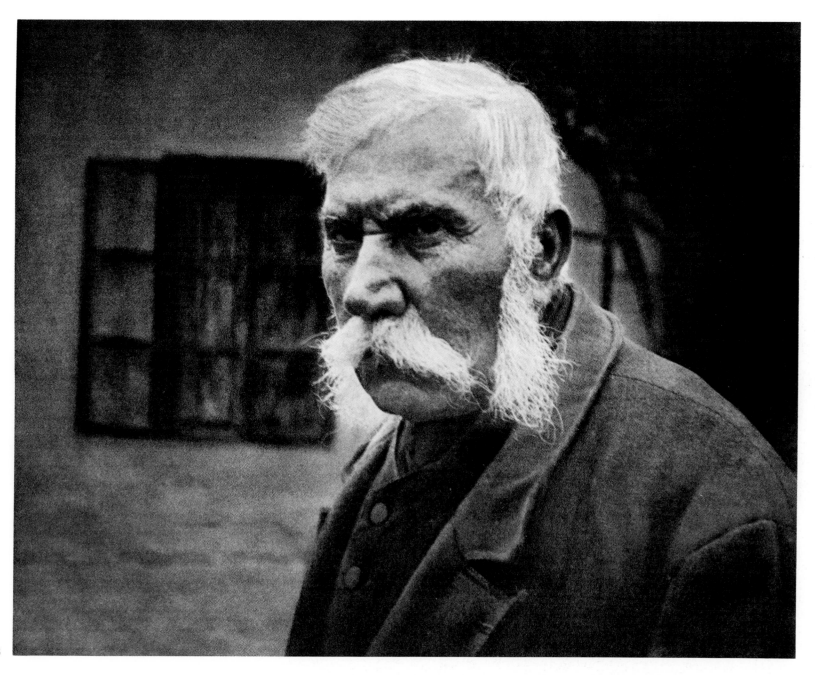

1916

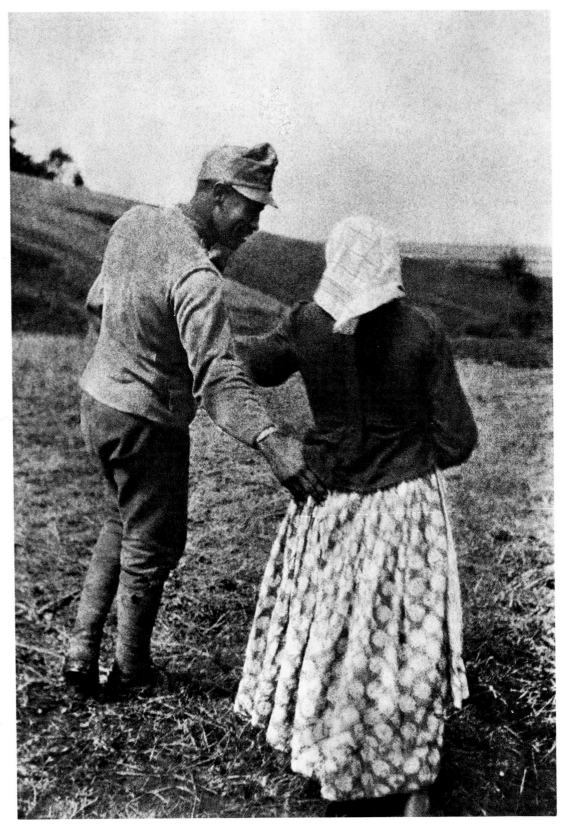

1915

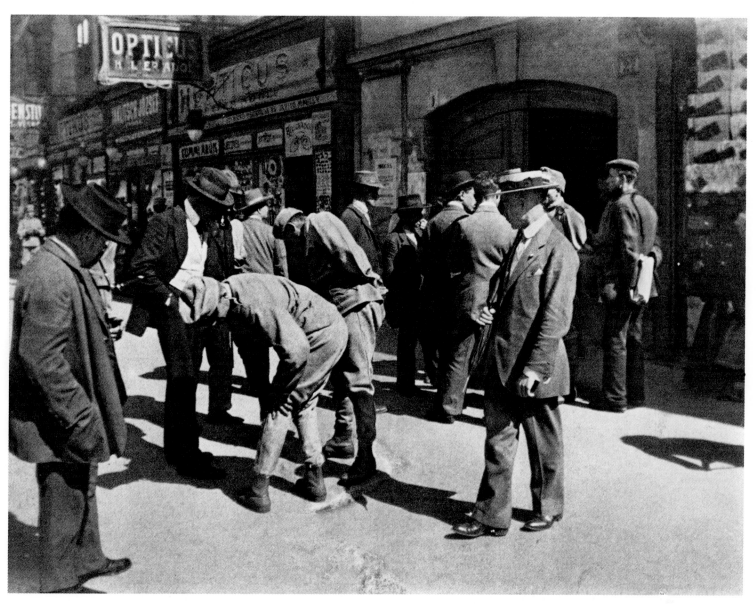

1914

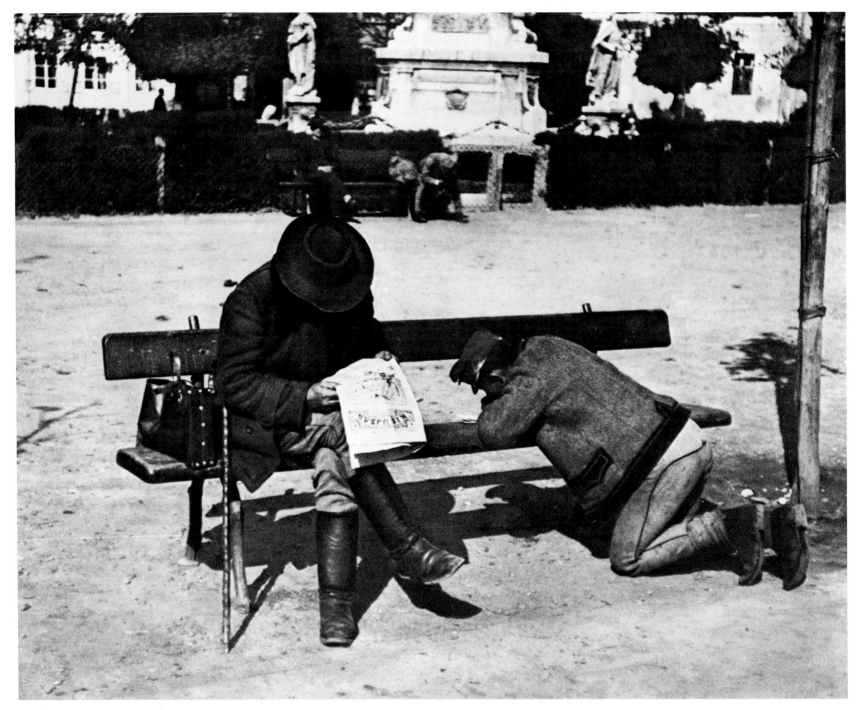

1916

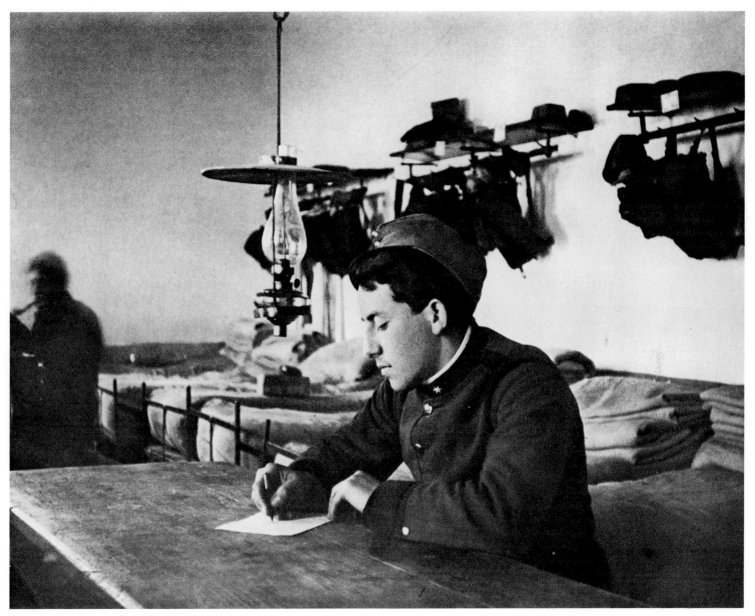

1915

61

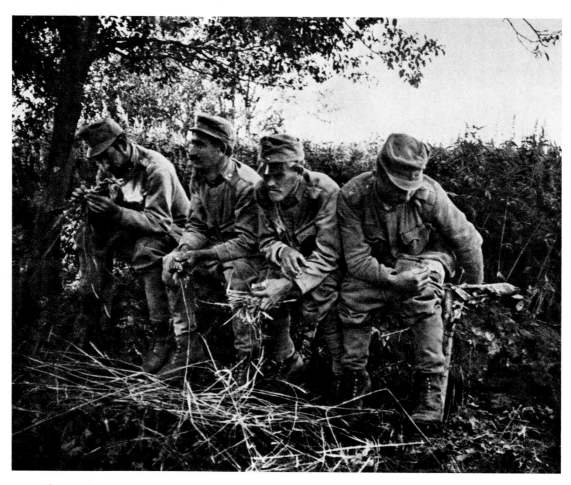

1915

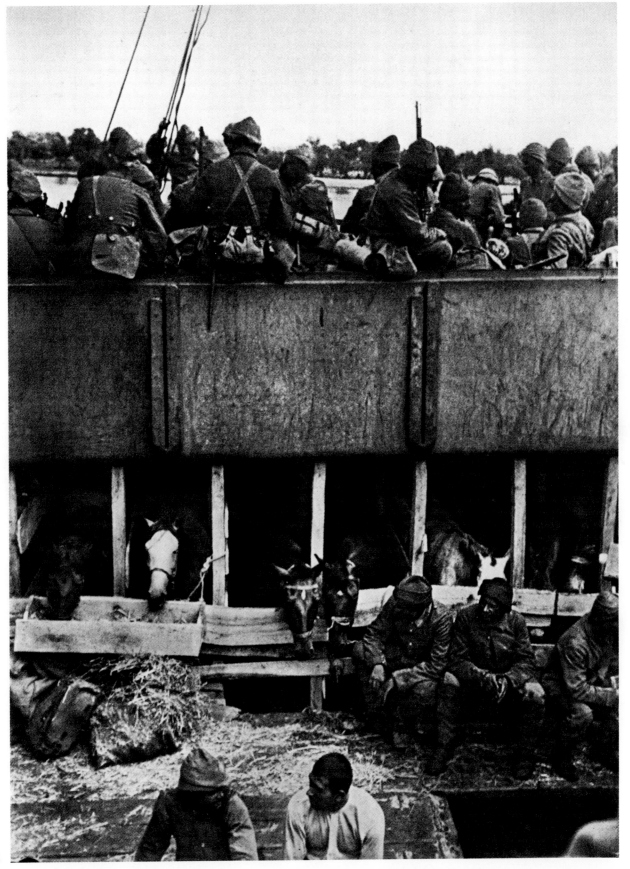

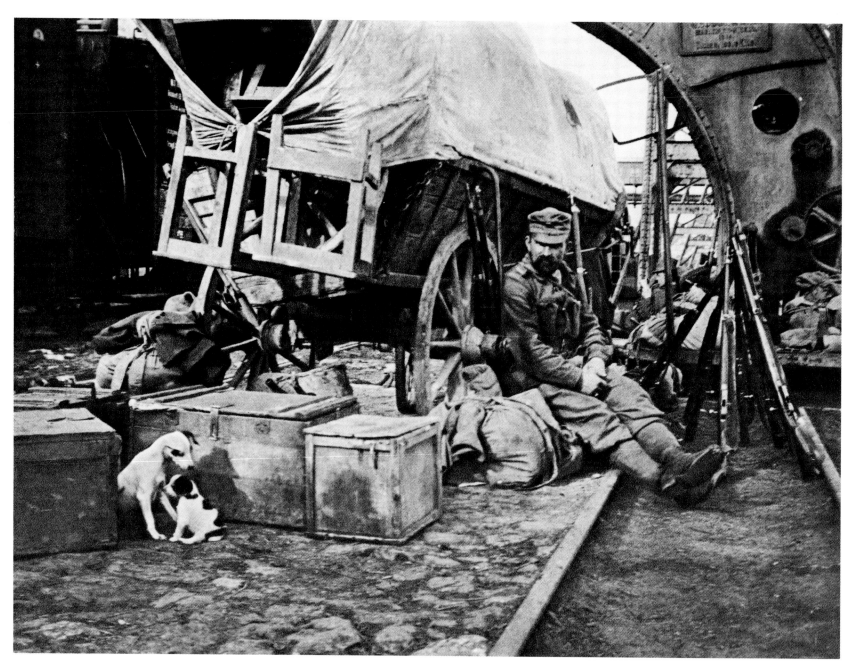

1918

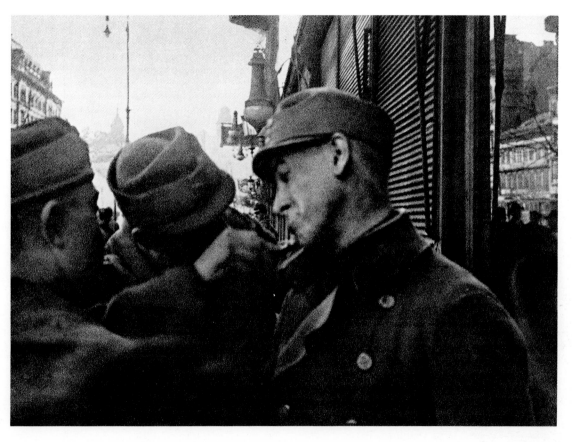

1919

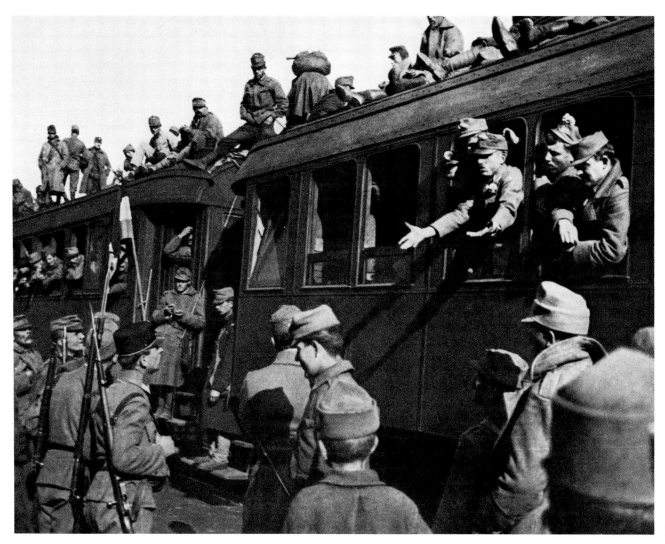

1918

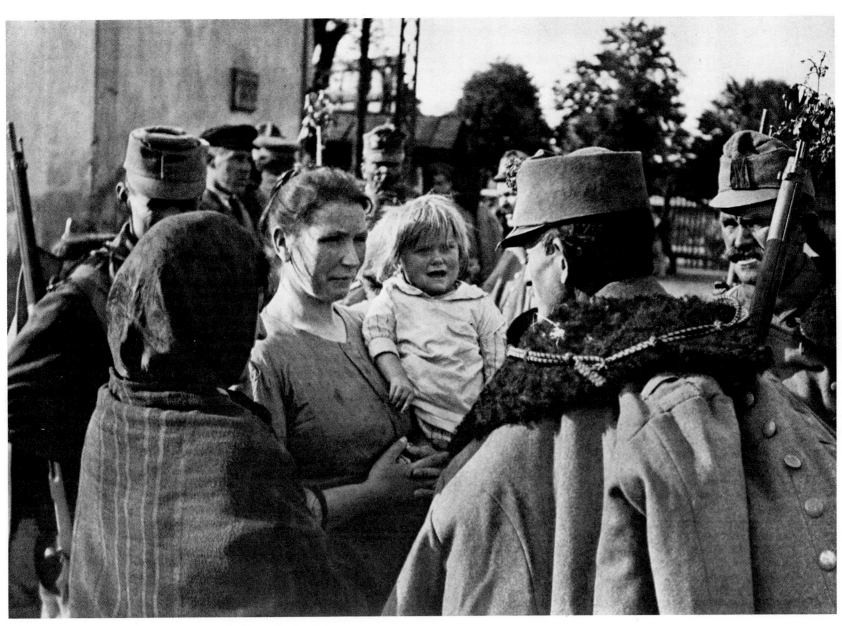

1919

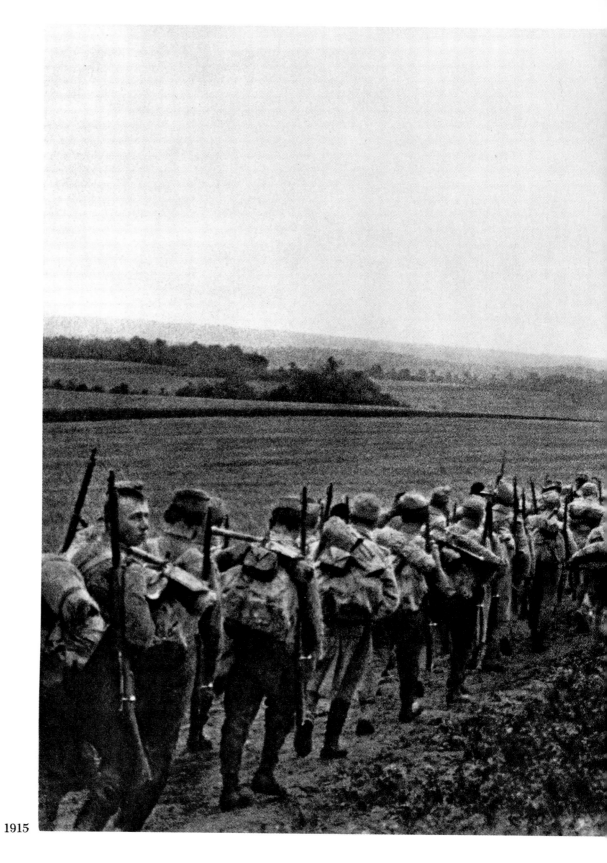

1915

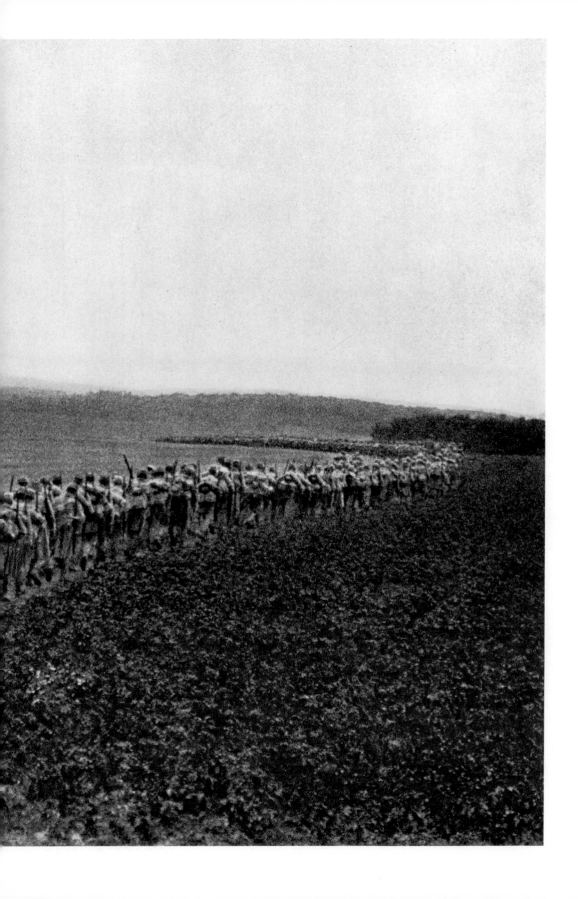

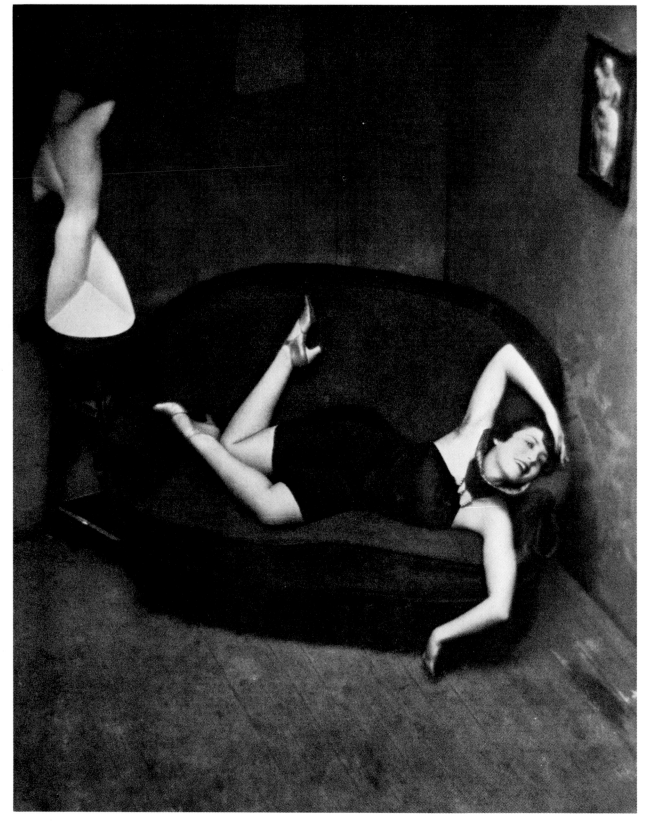

1926

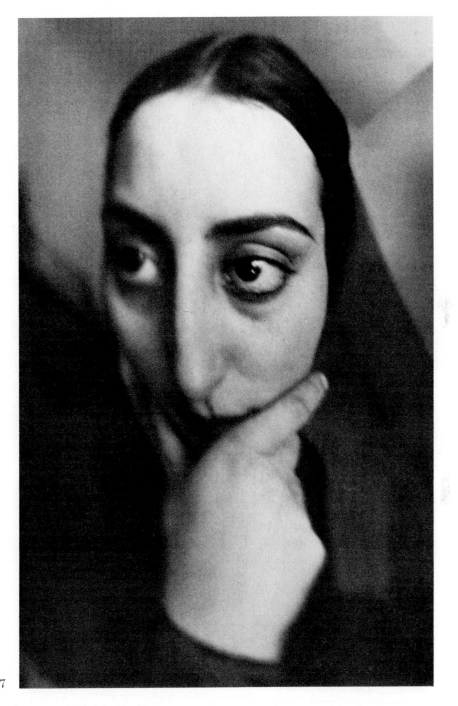

1927

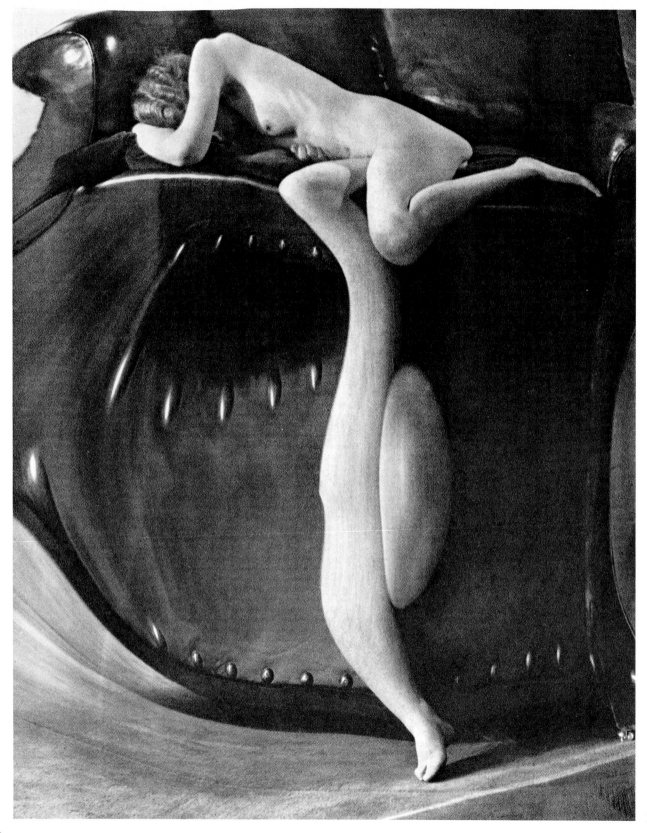

1933

72

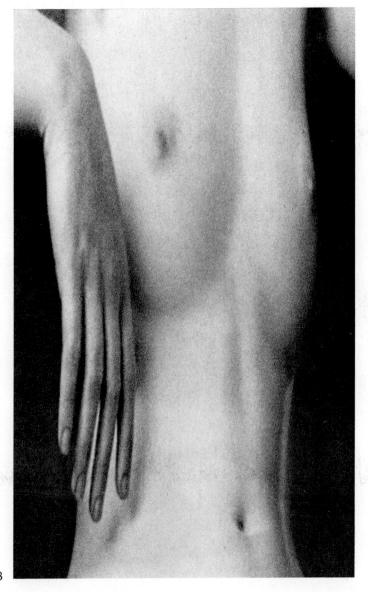

1933

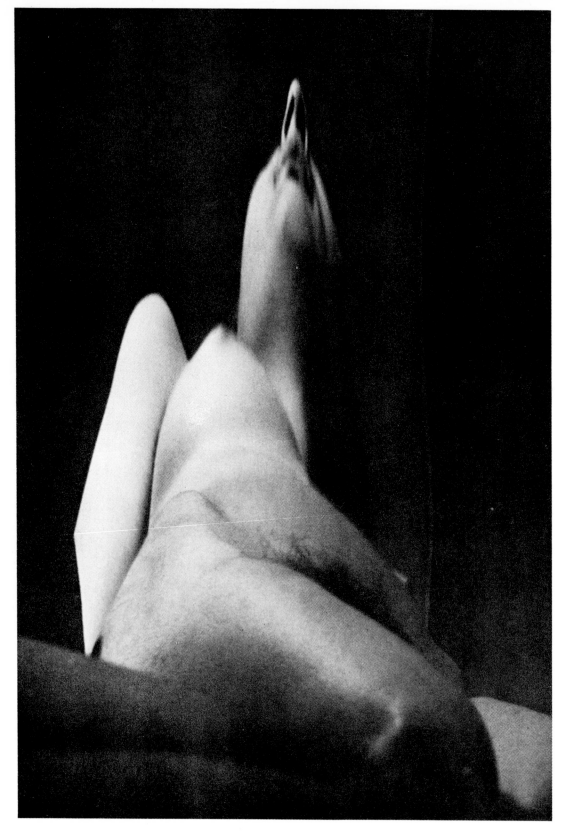

1933

74

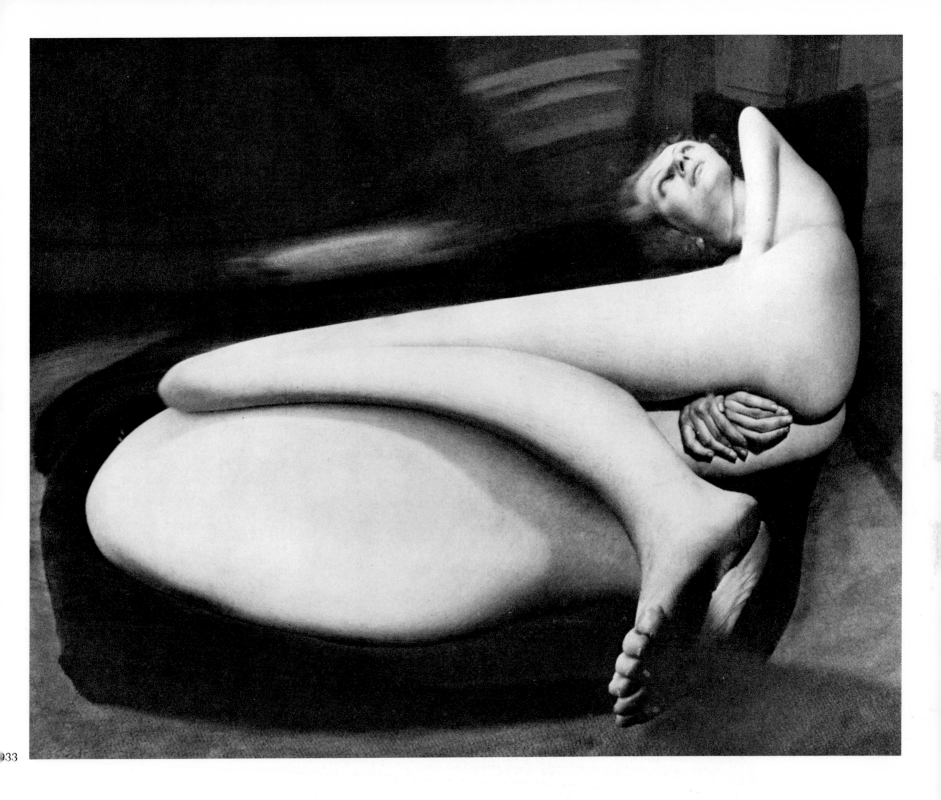

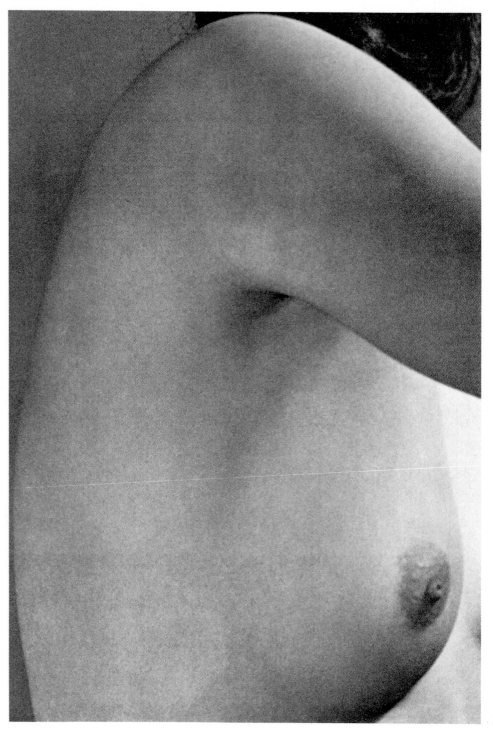

1941

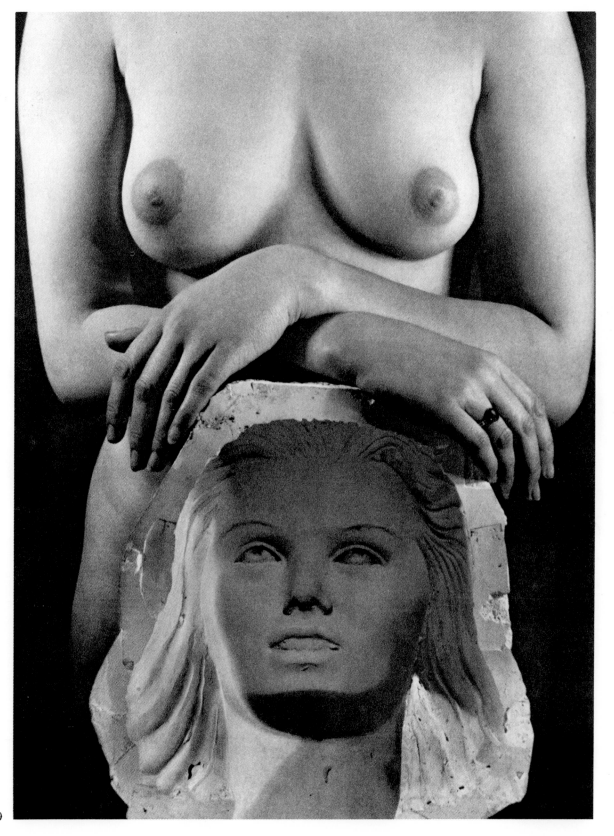

1939

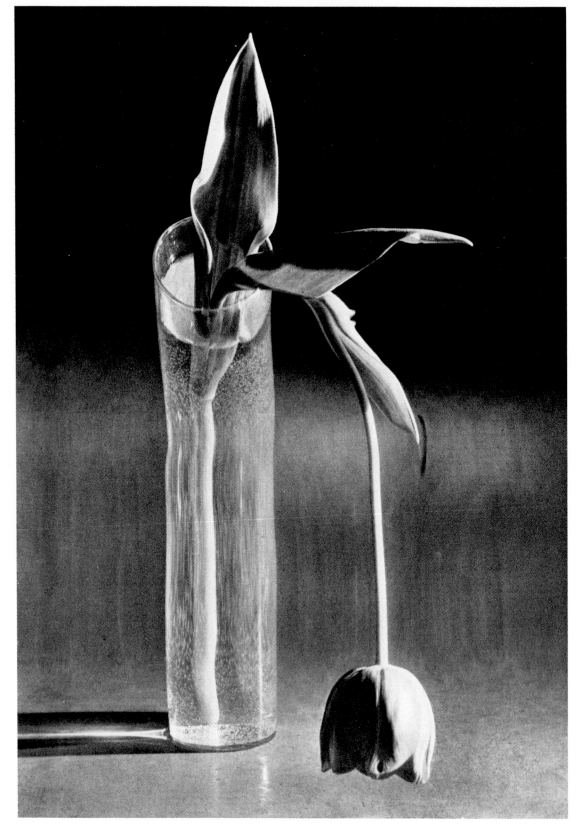

1939

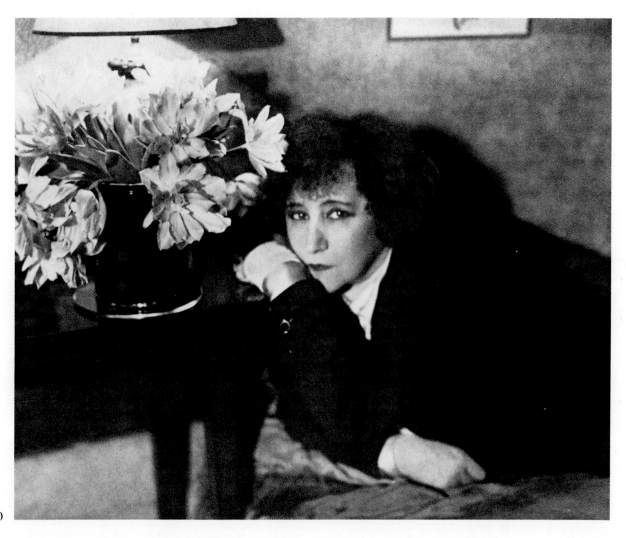

1930

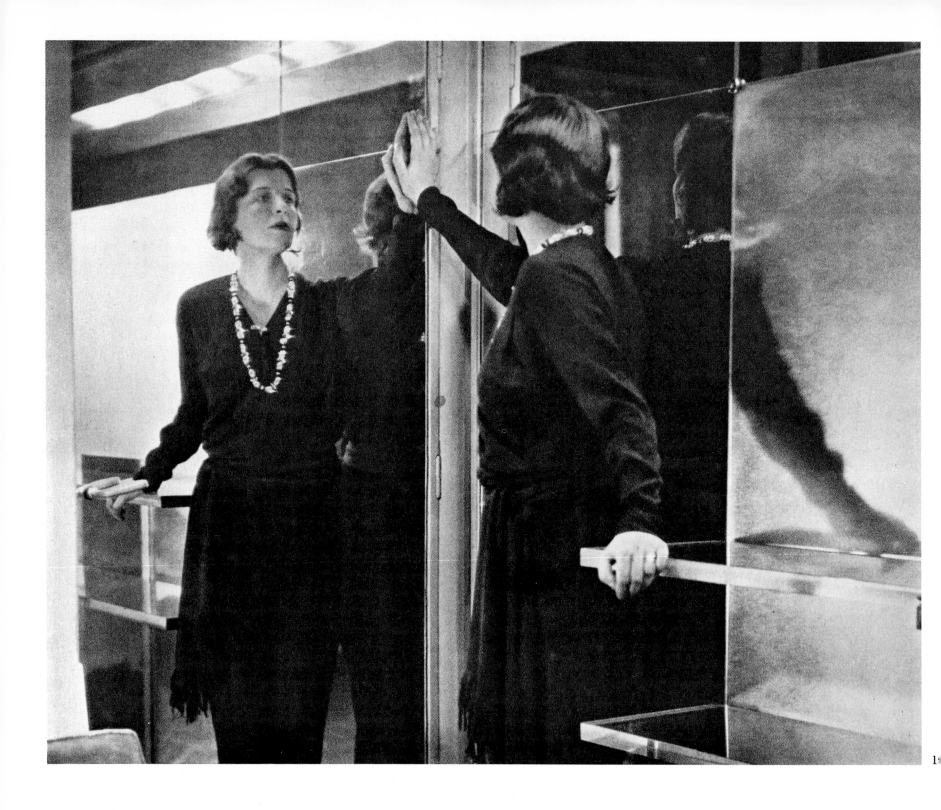

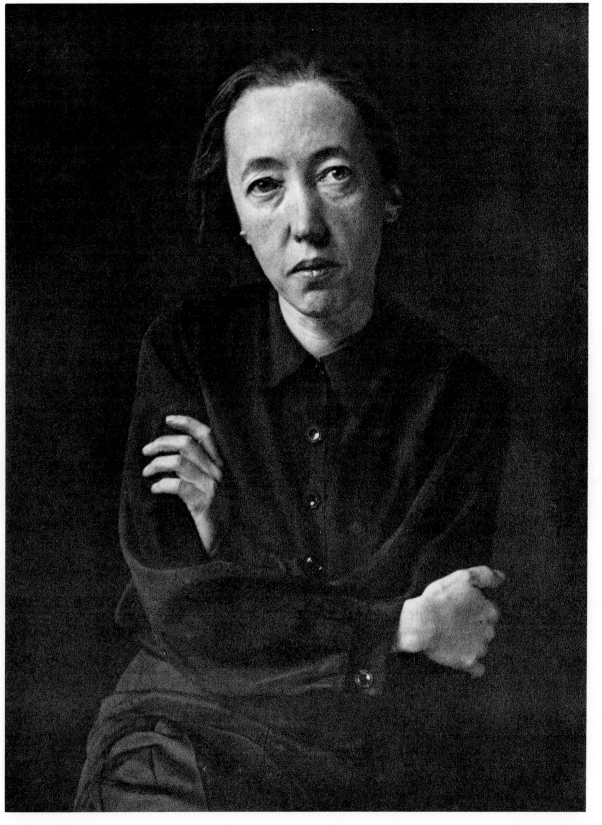

1926

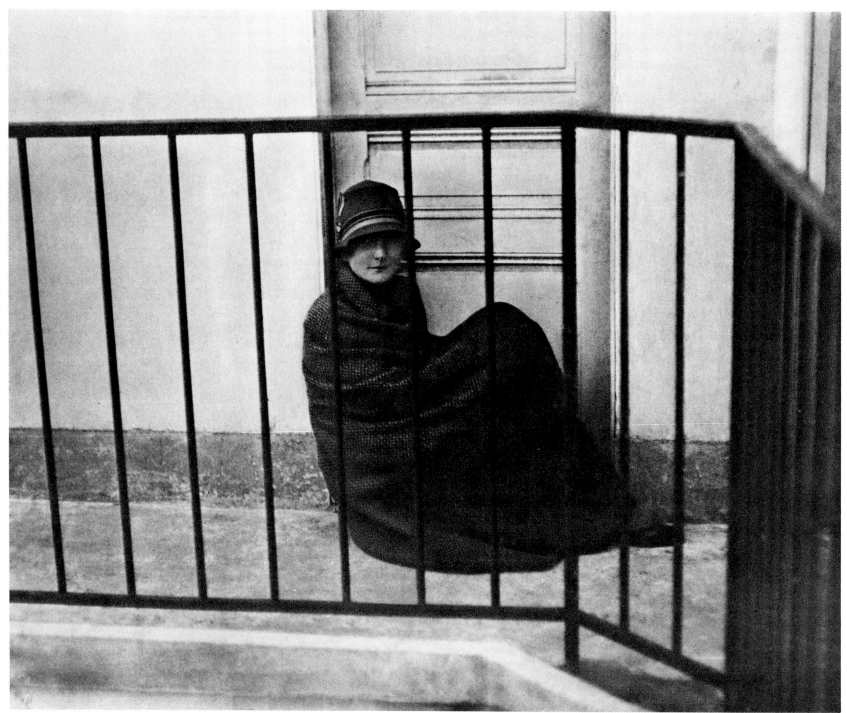

1927

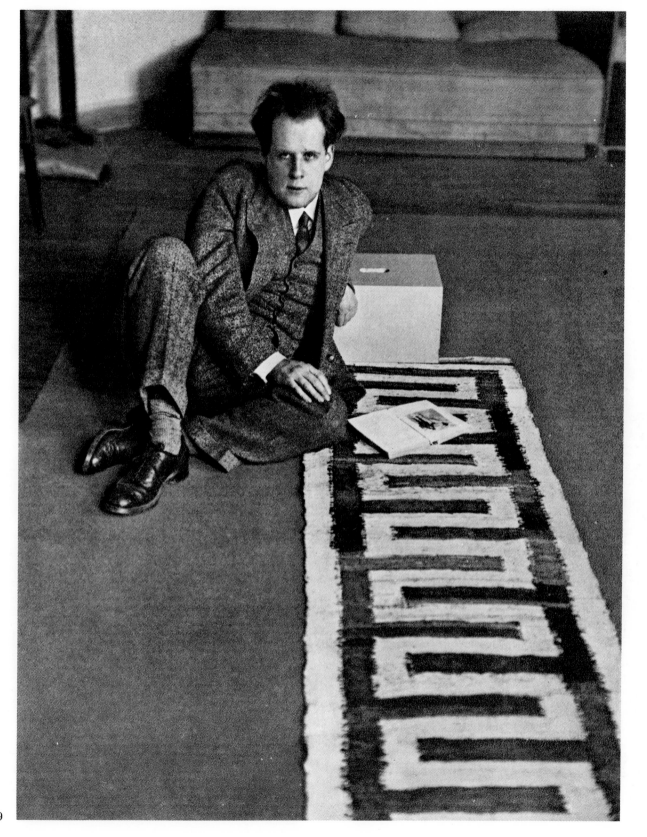

1929

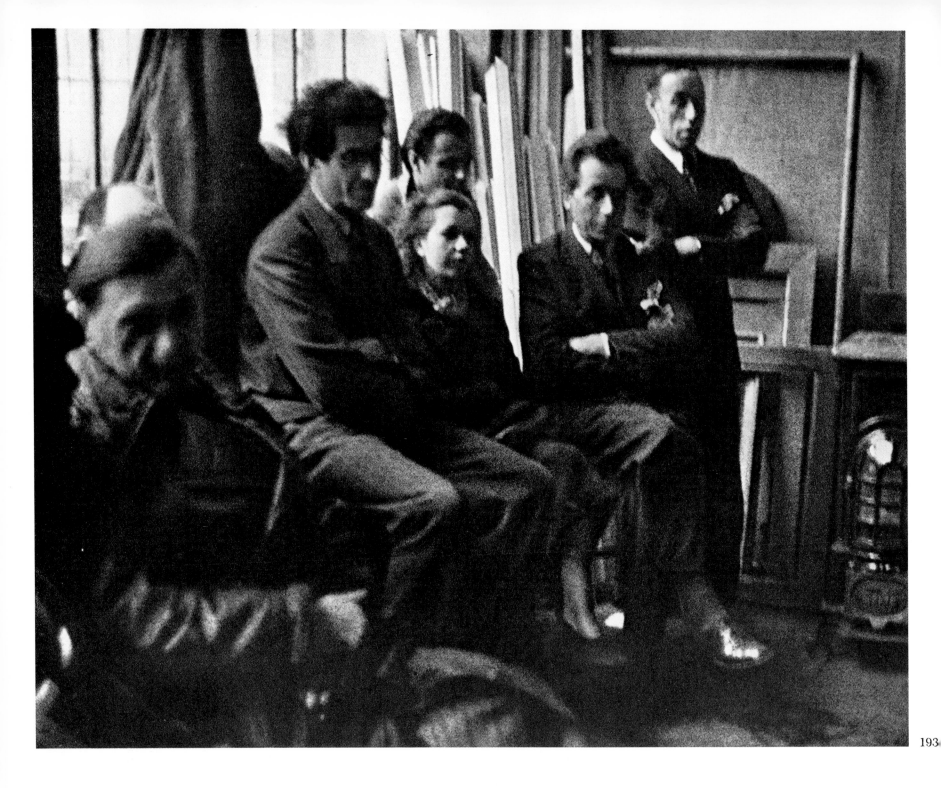

193

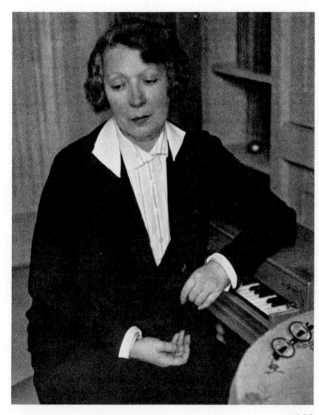

1930

1926

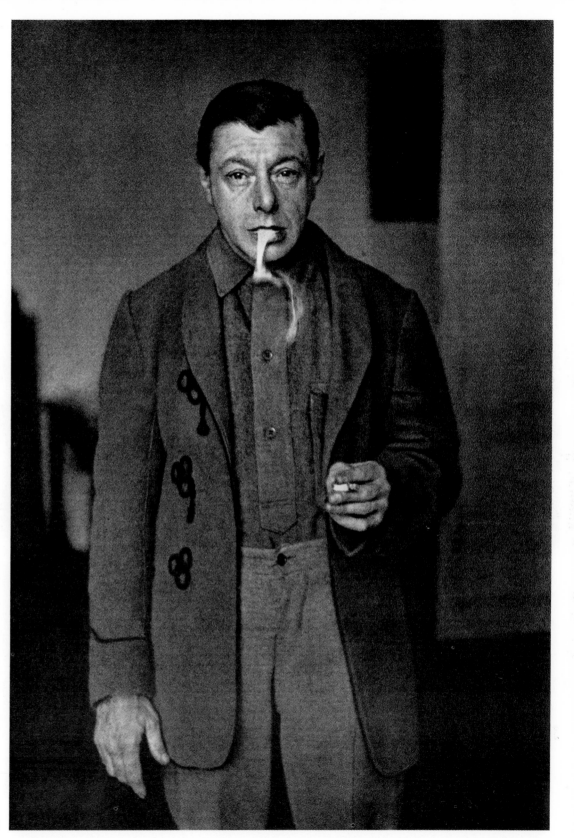

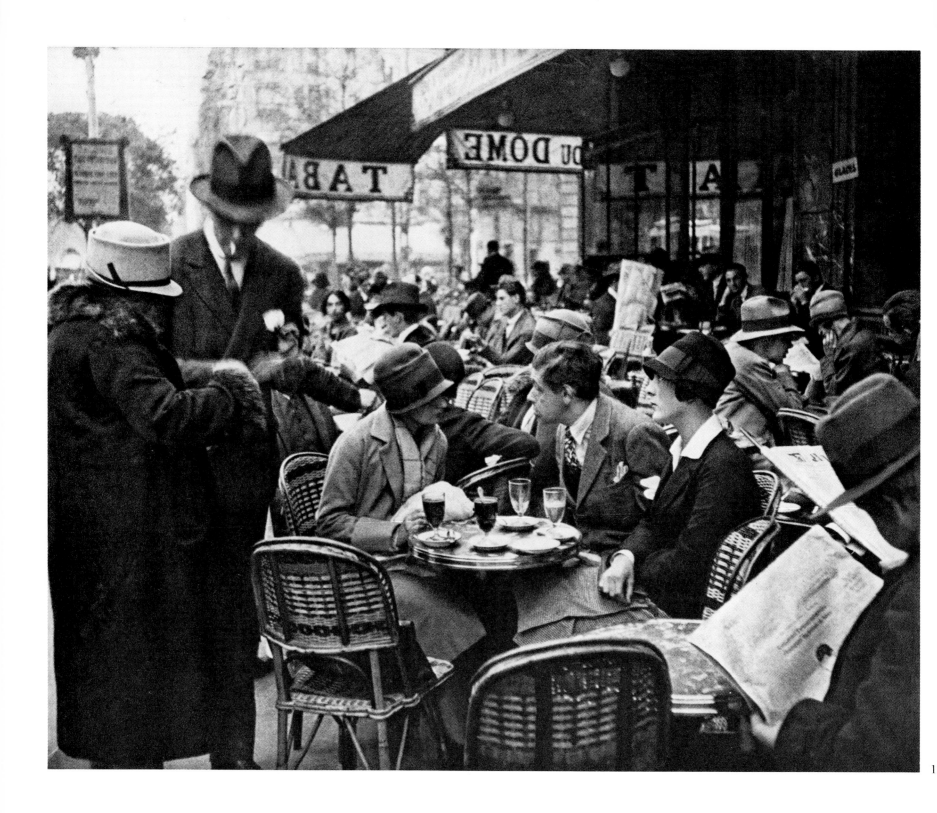

1

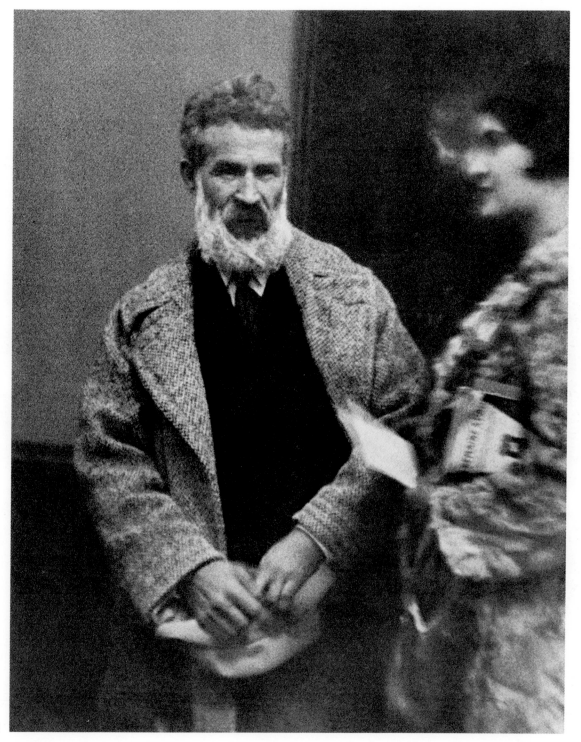

1928

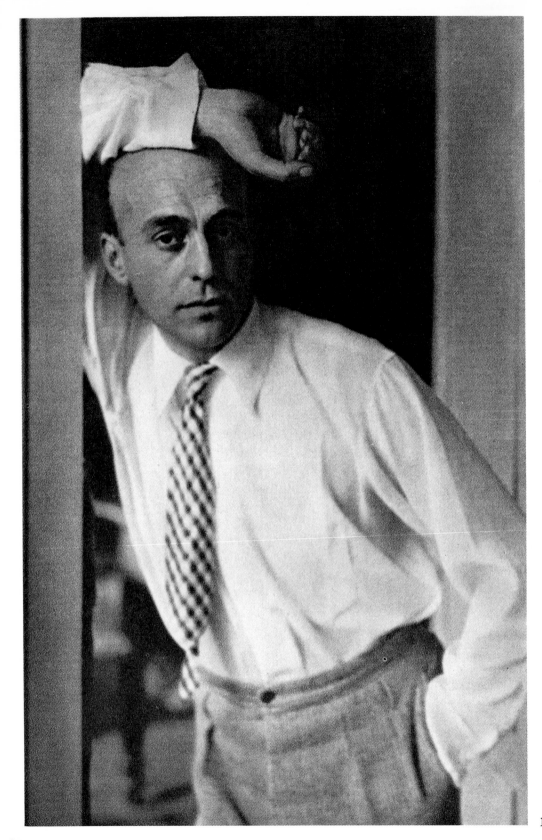

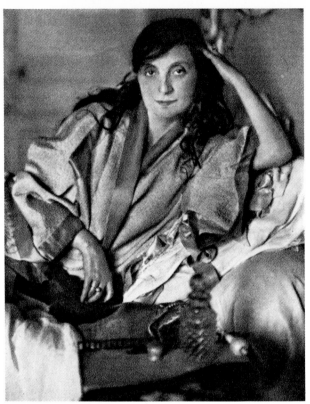

1931

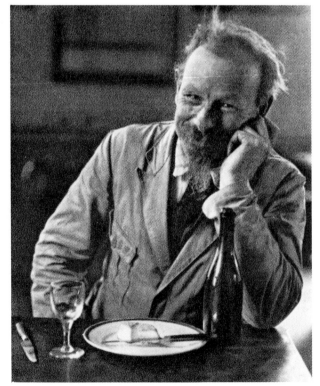

1928

1929

88

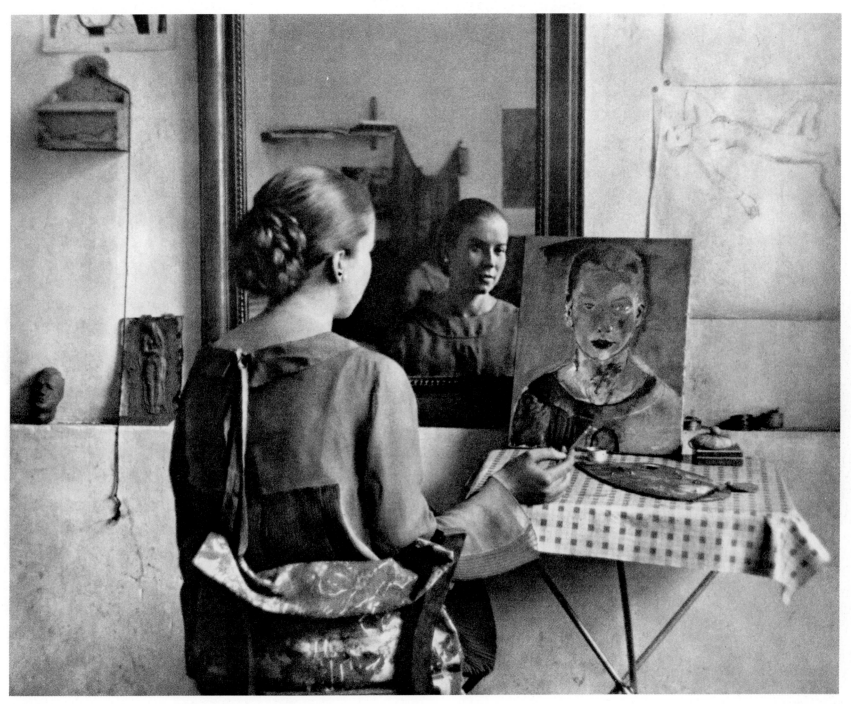

1926

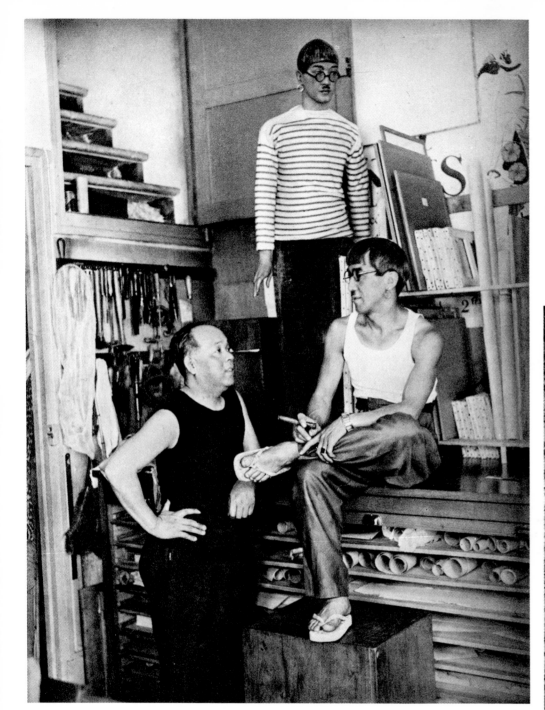

1928

1945

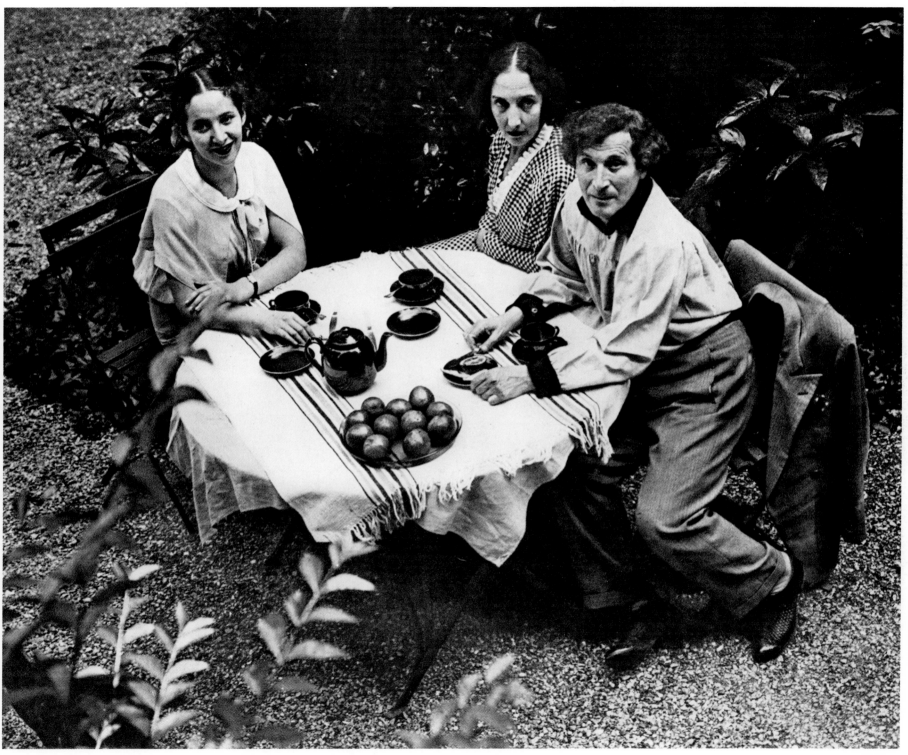

1933

1929

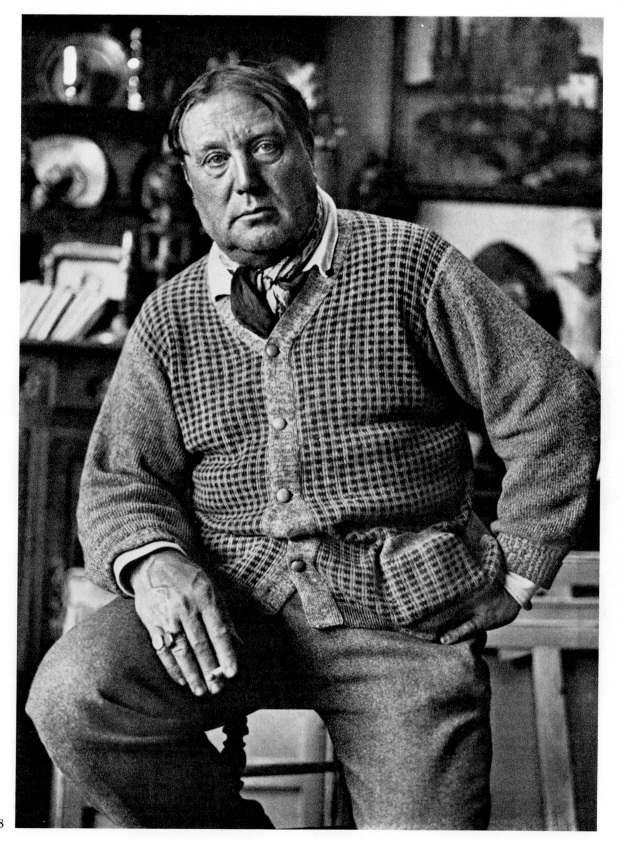

1928

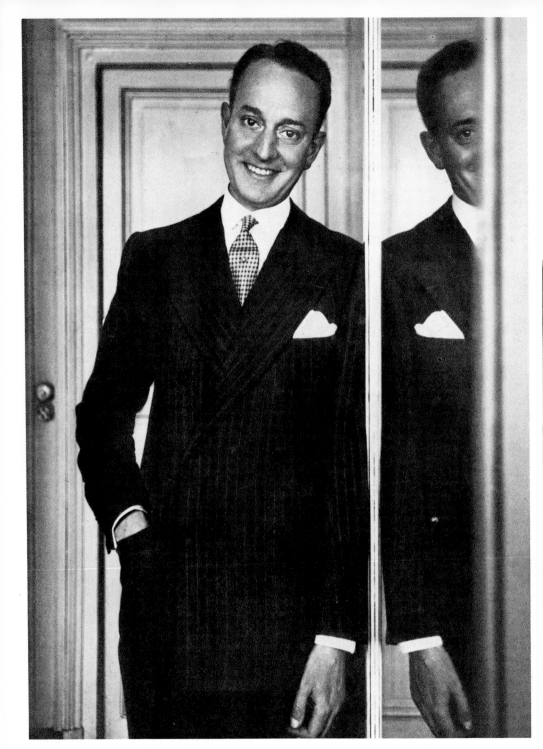

1927

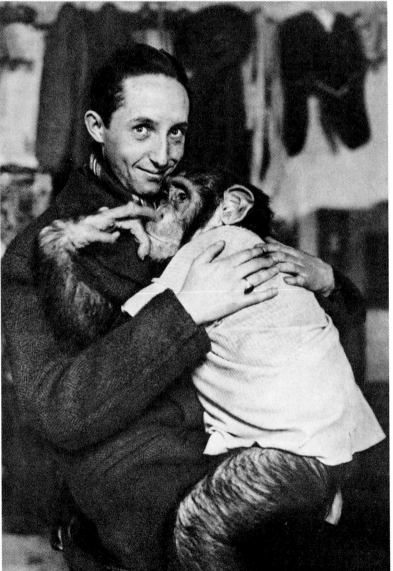

1928

94

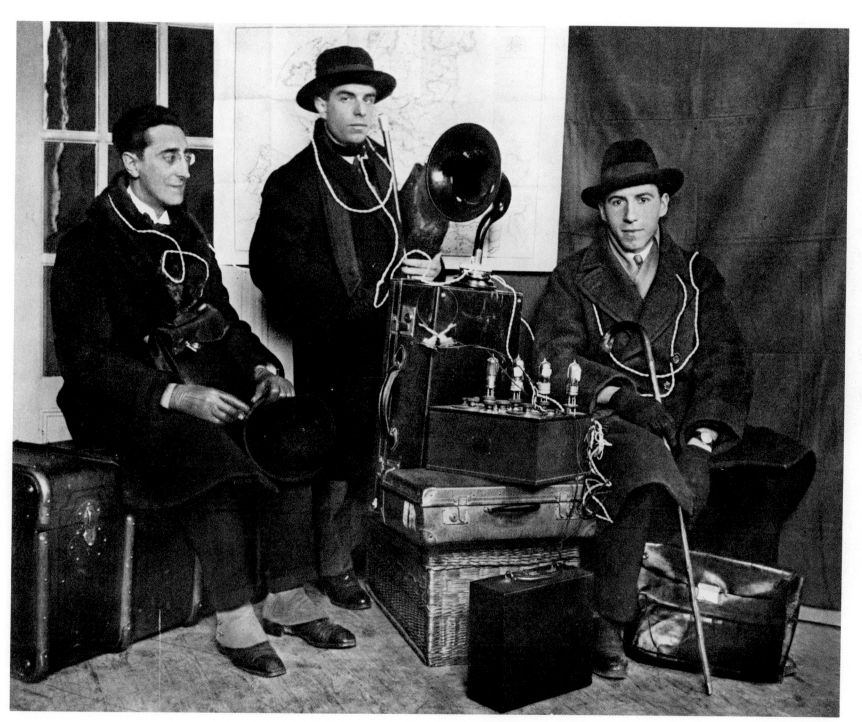

1927

19

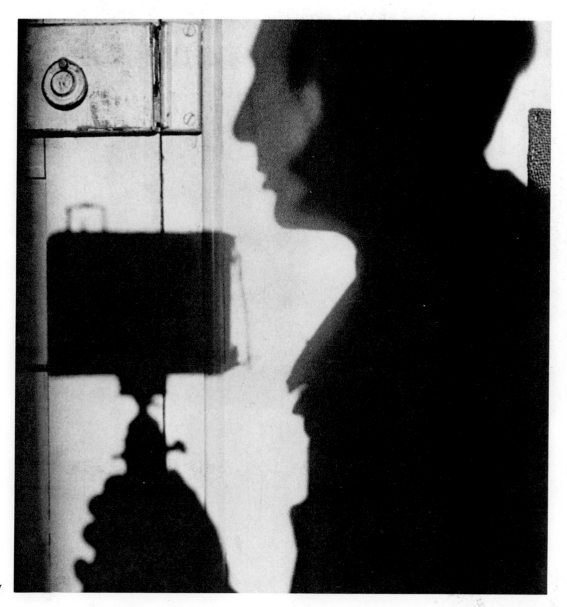

1927

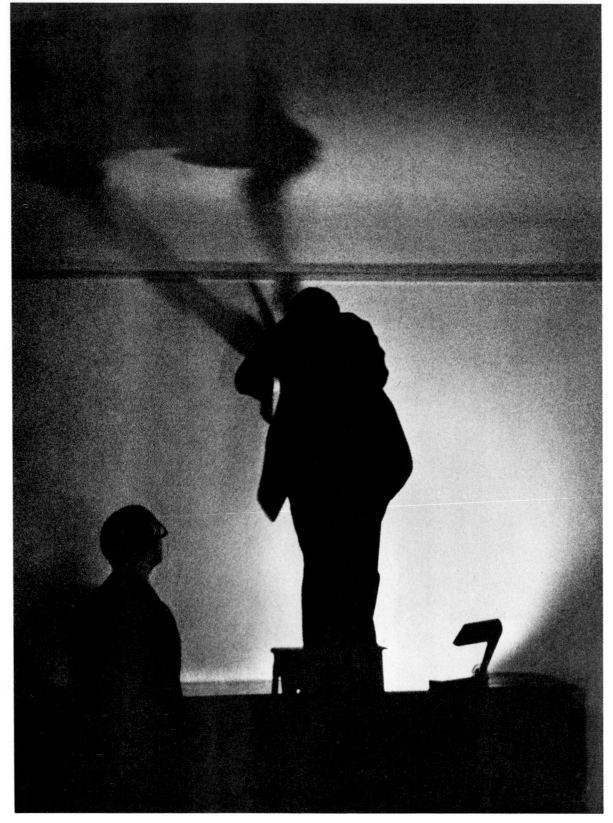

1928

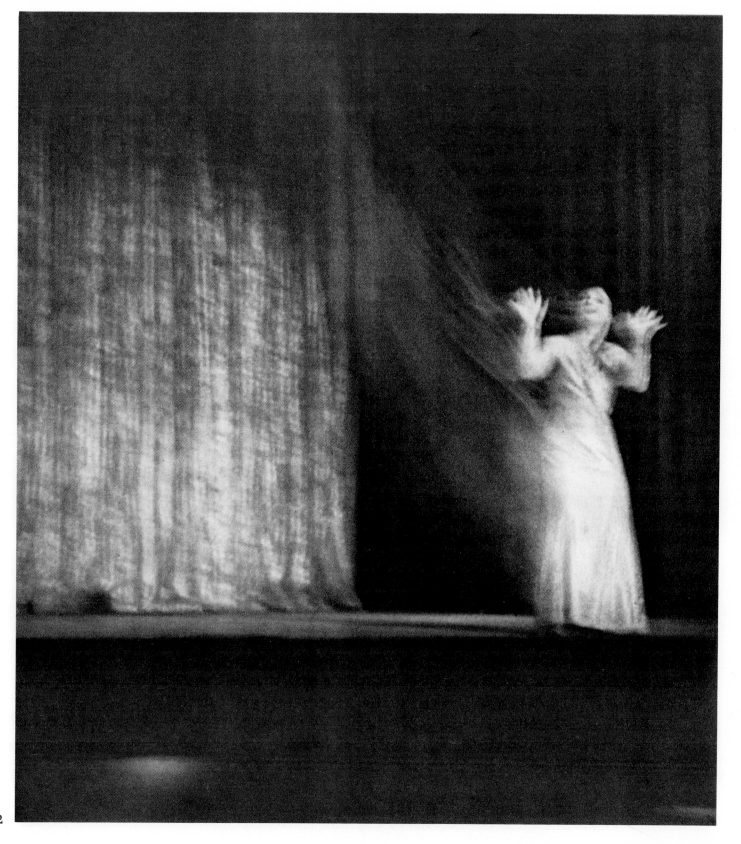

1932

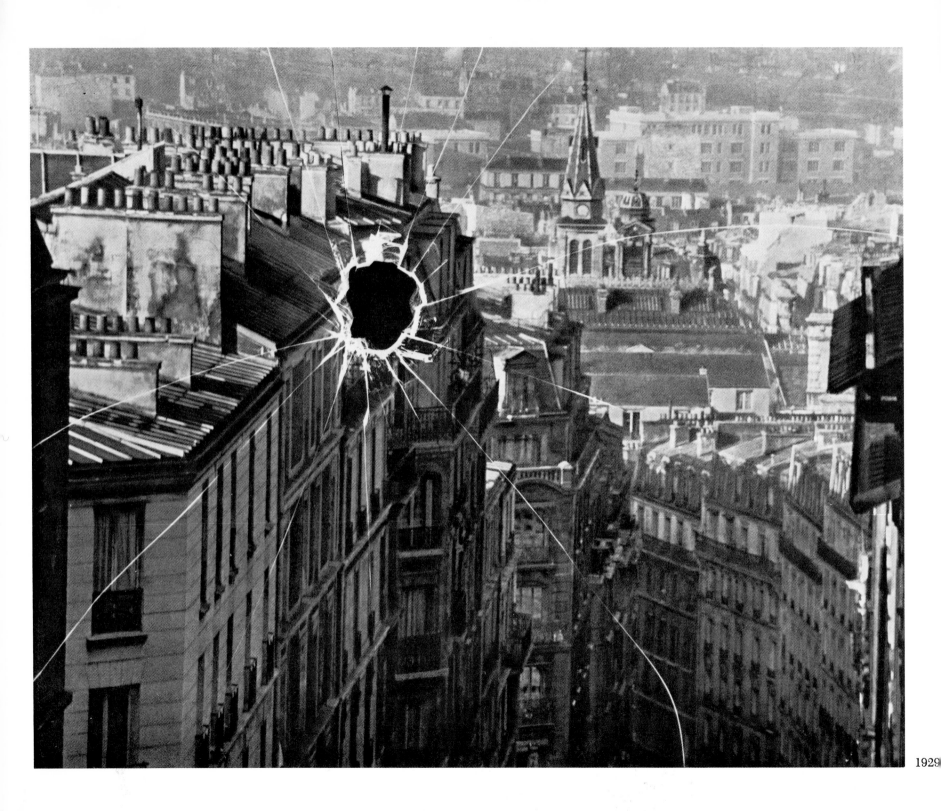

1929

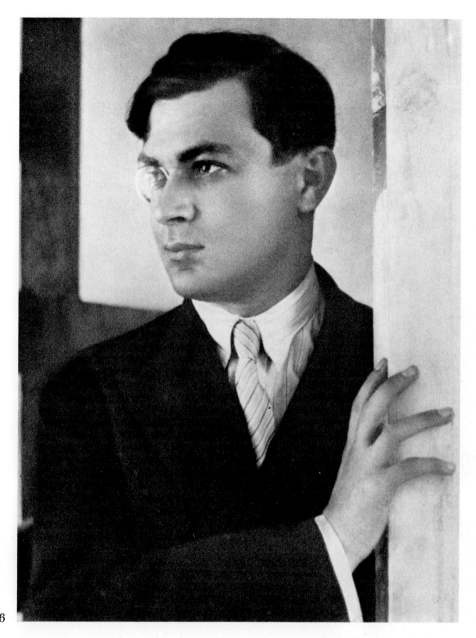

1926

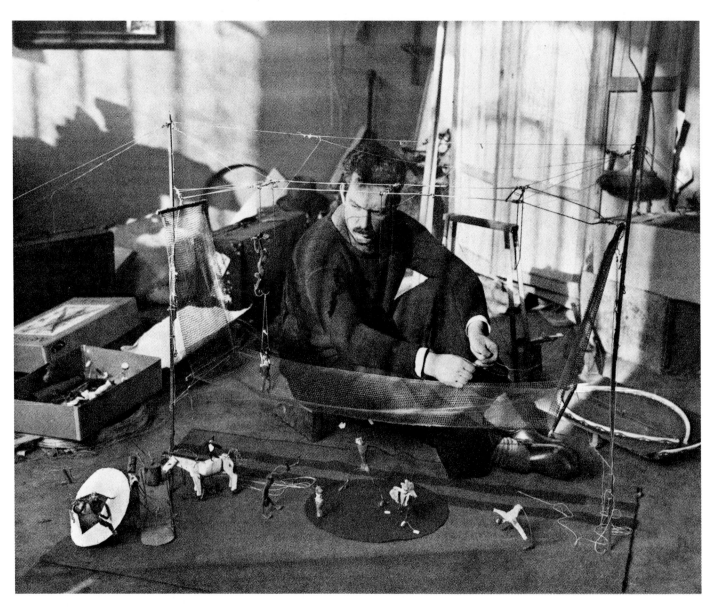

1929

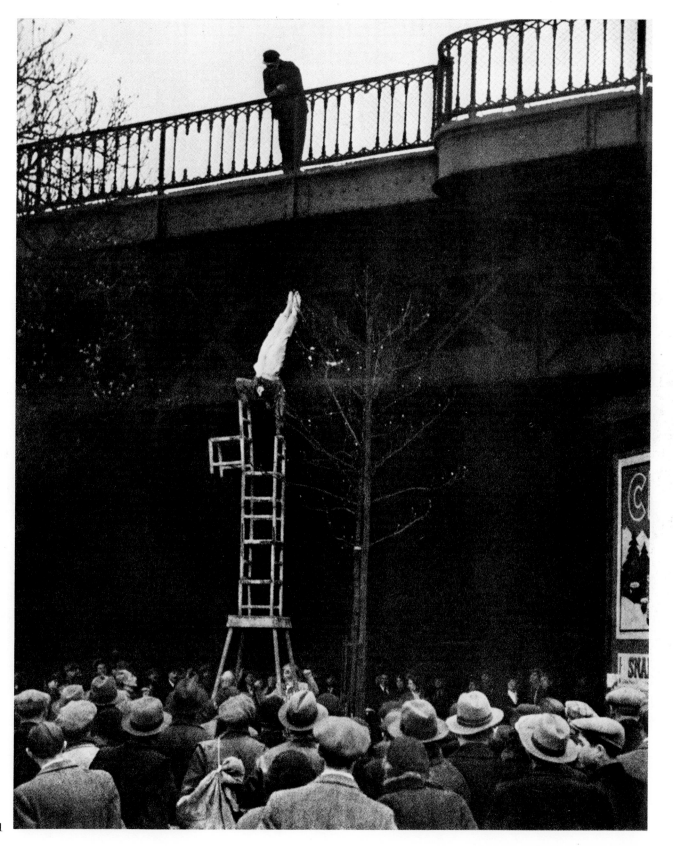

1931

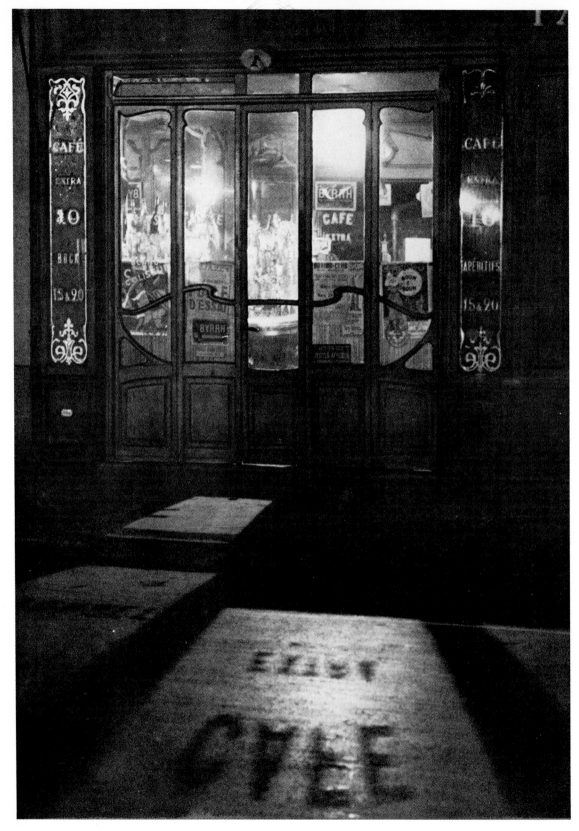

1927

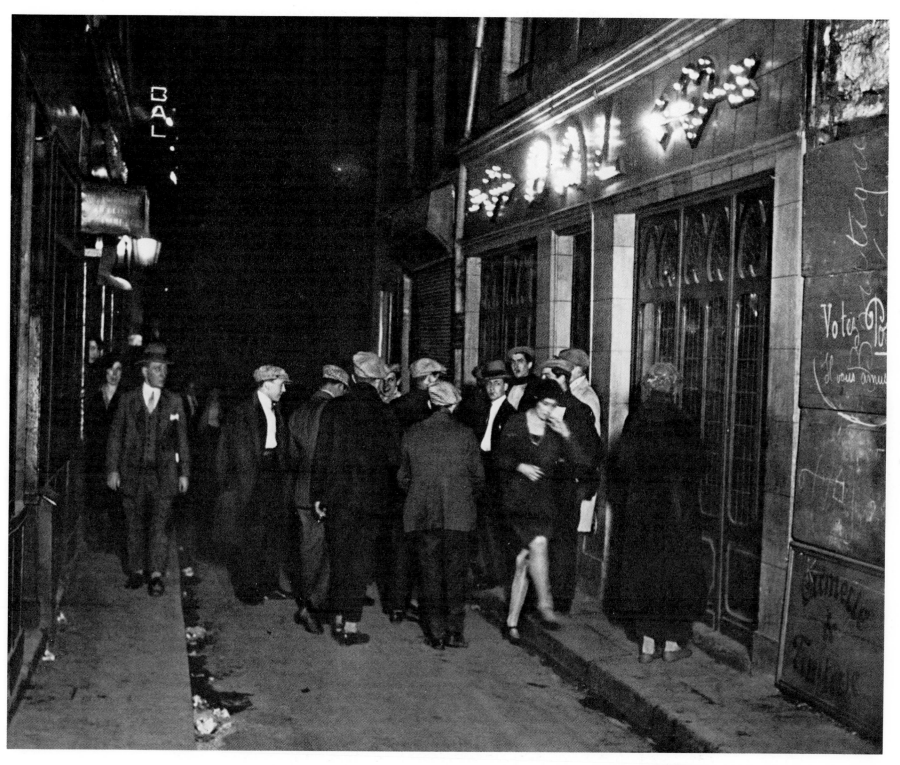

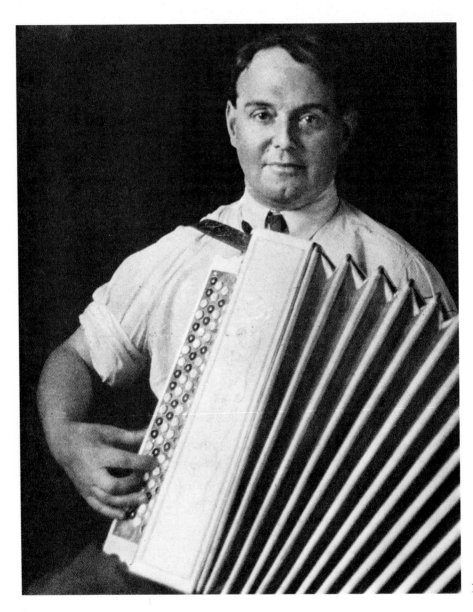

1927

106

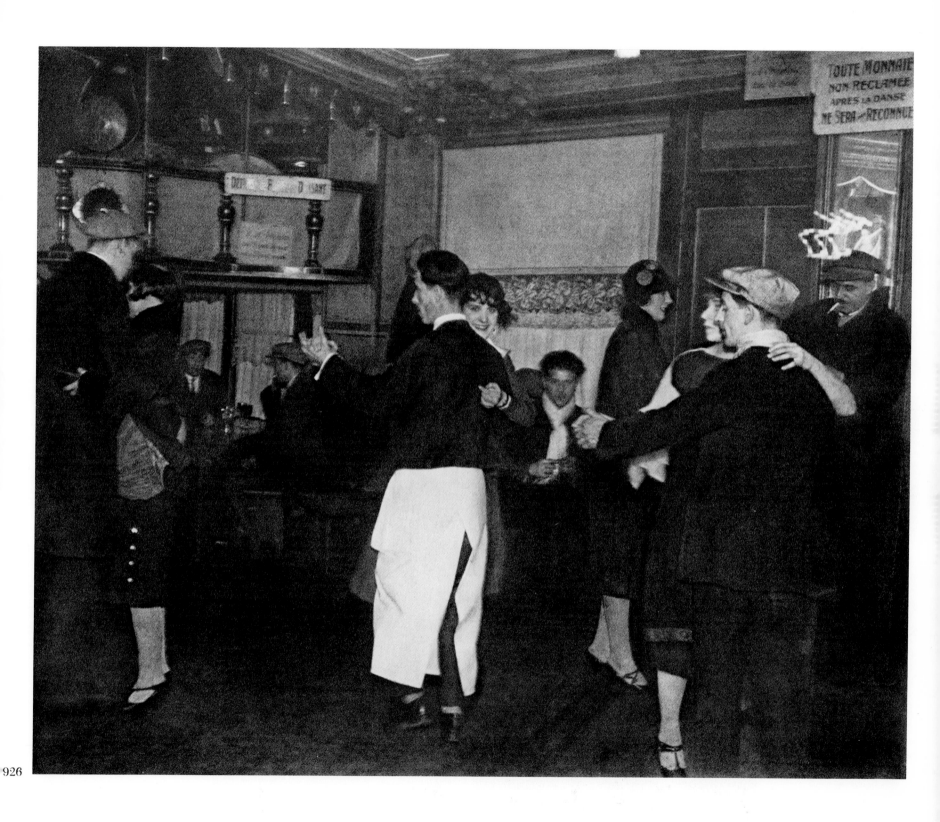

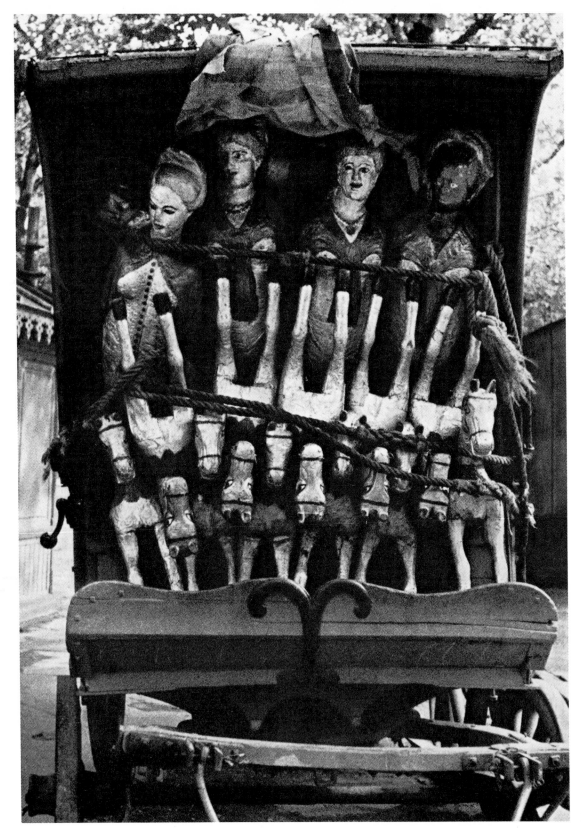

1929

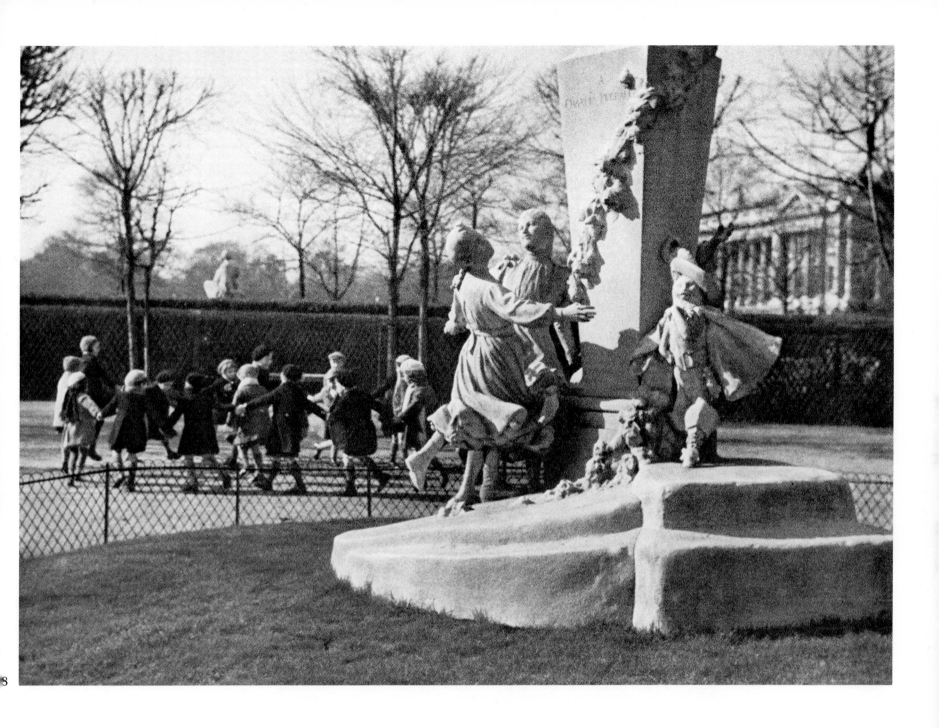

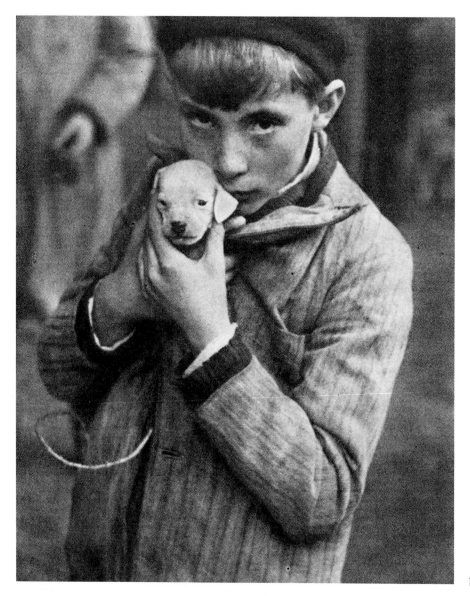

1928

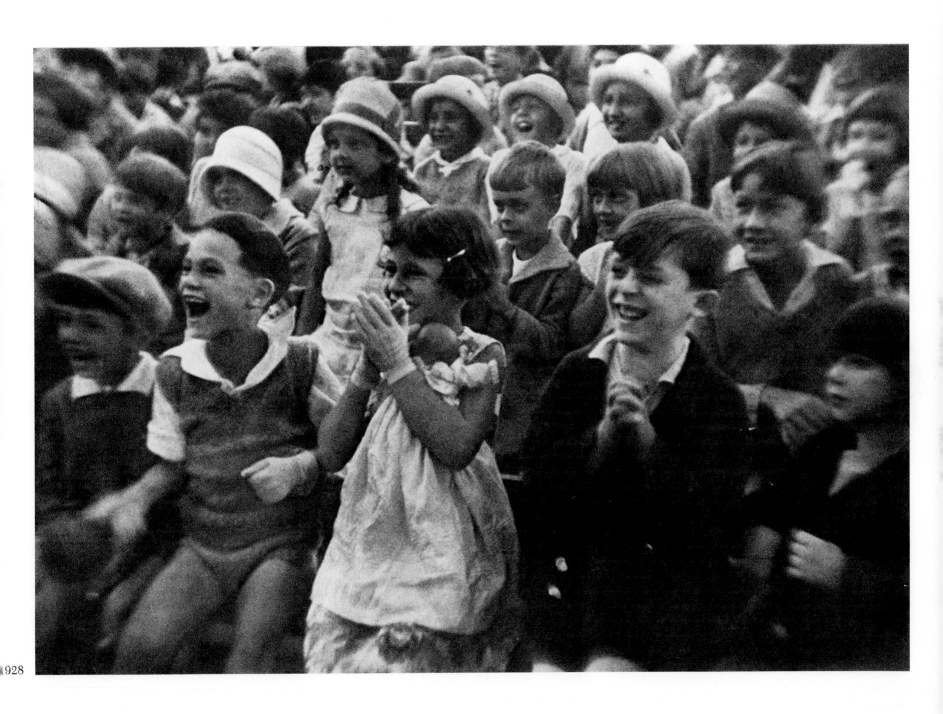

1928

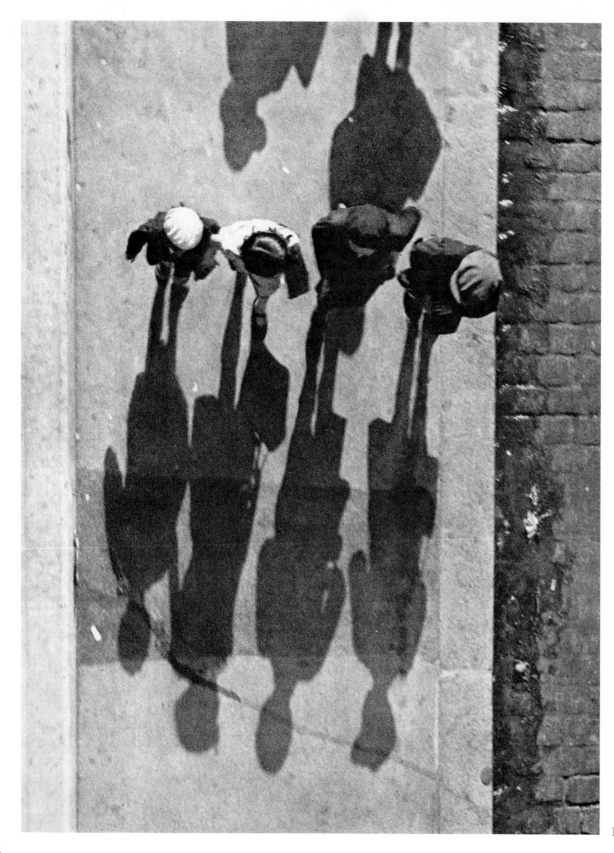

1931

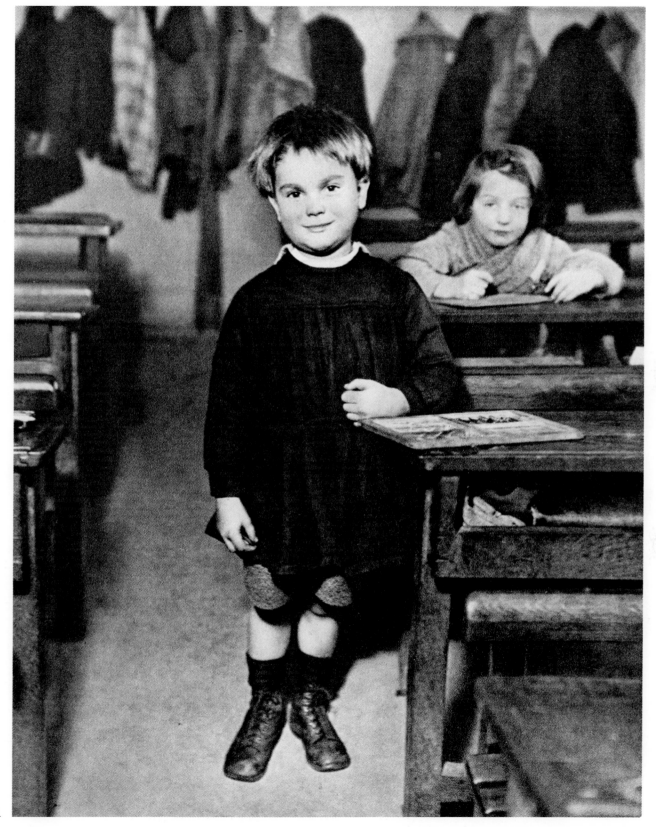

1931

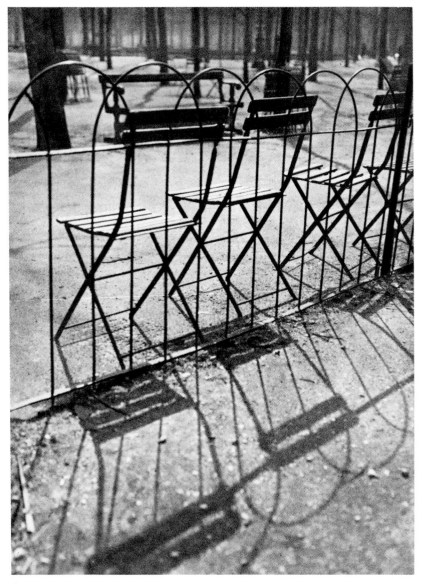

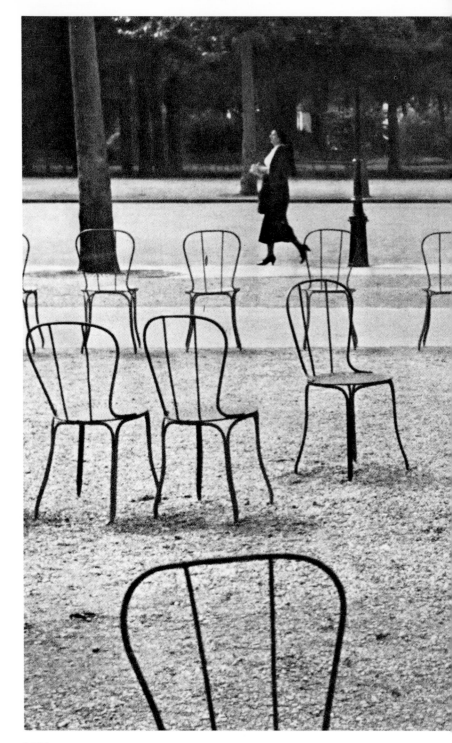

1927

1927

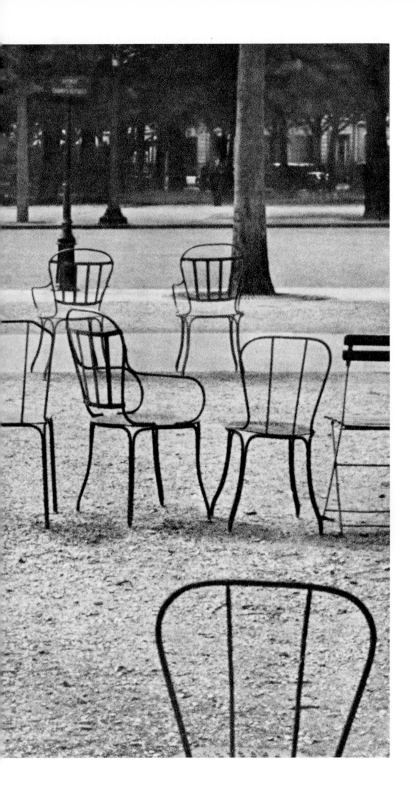

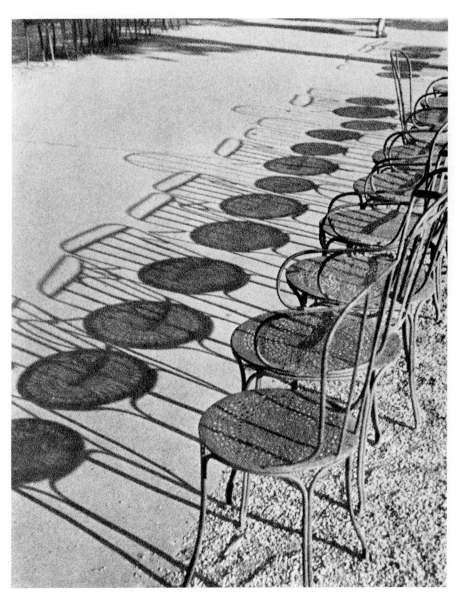

1929

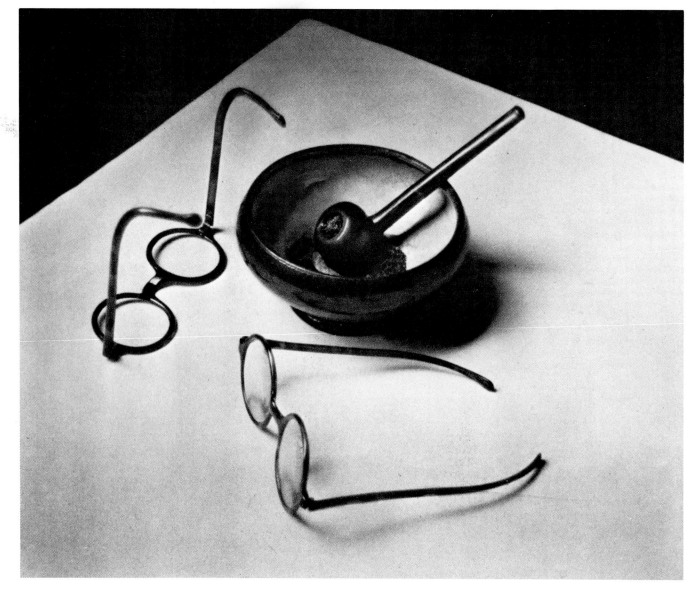

1926

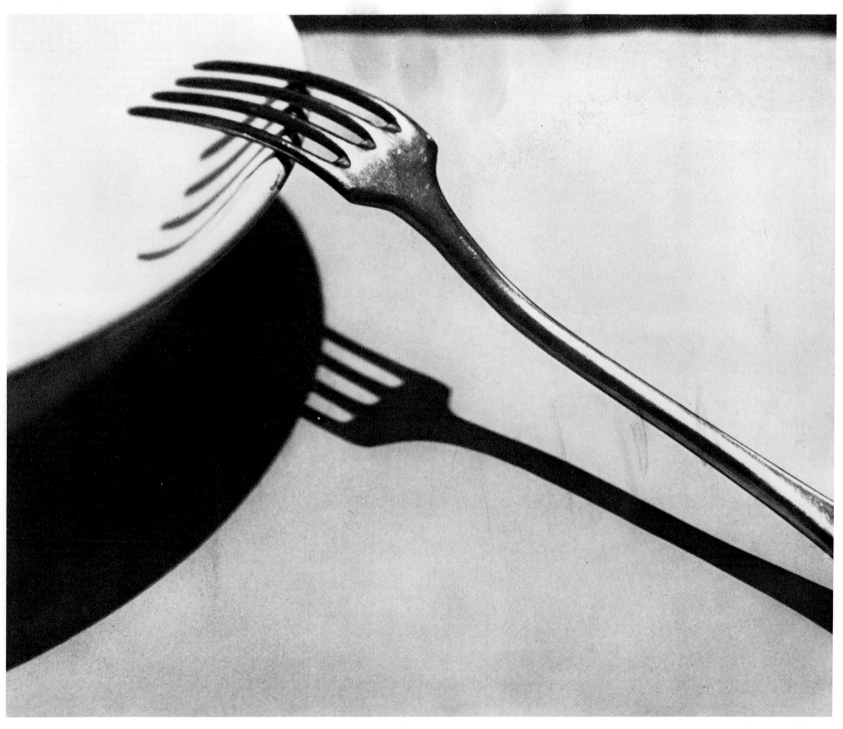

1928

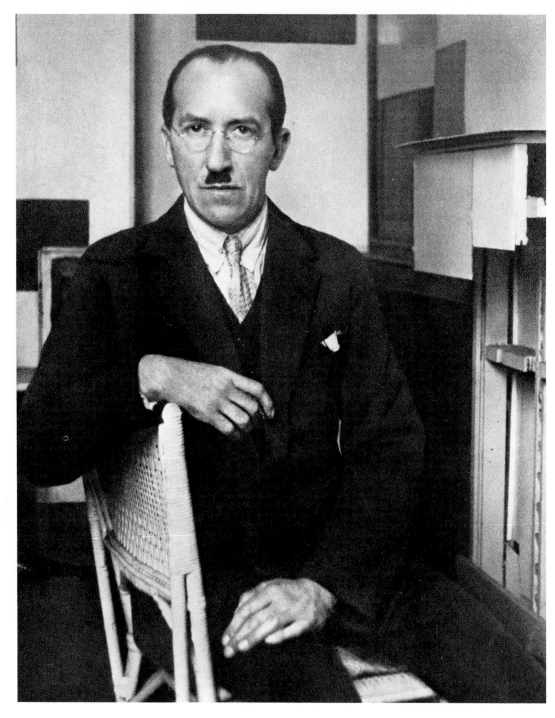

1926

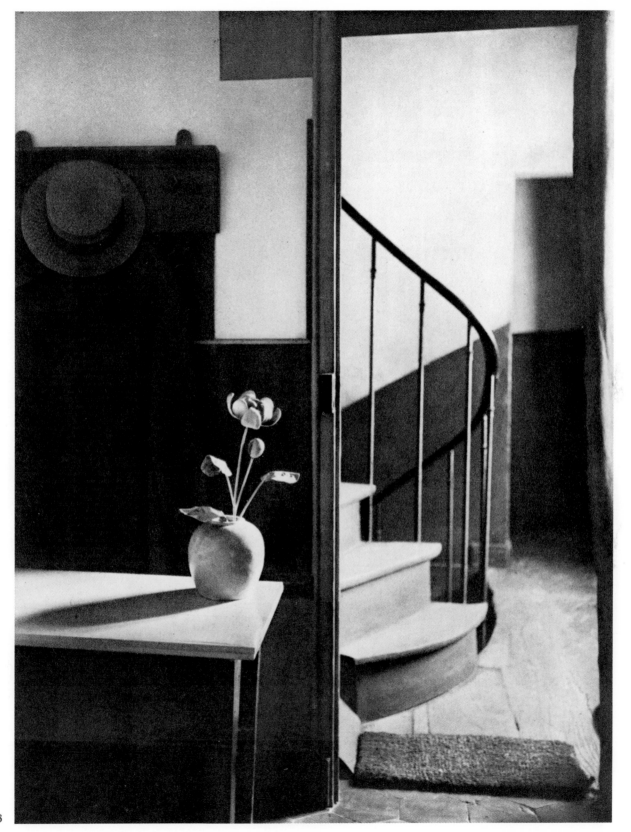

1926

1926

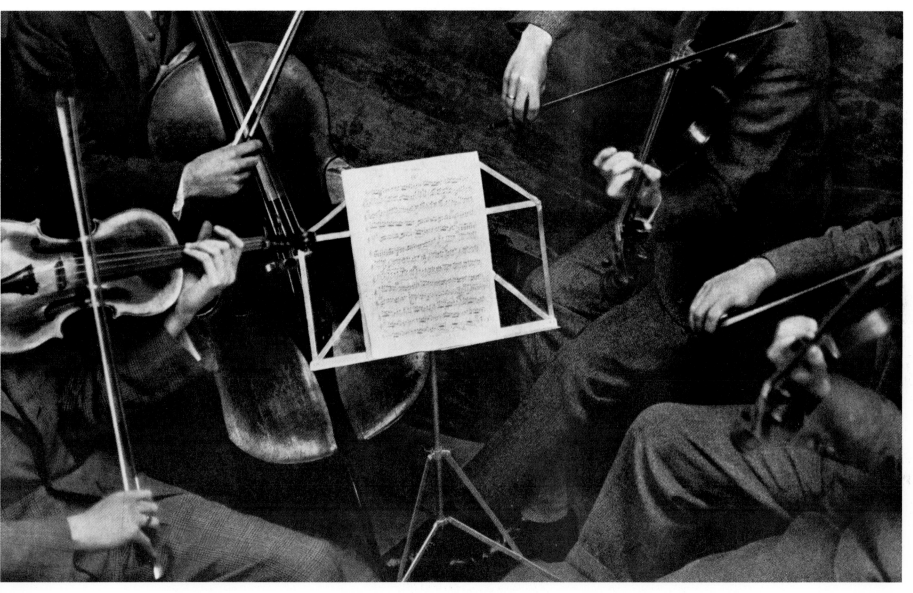

1926

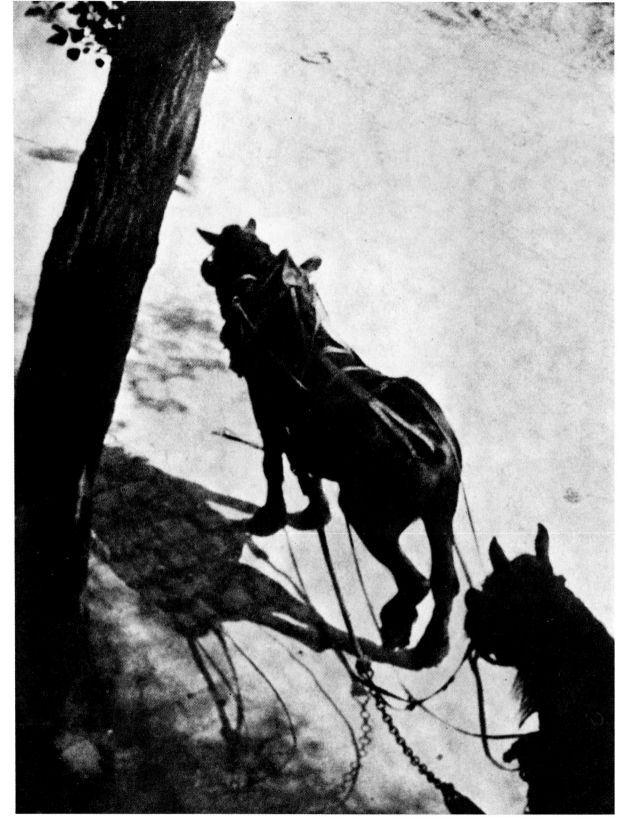

1925

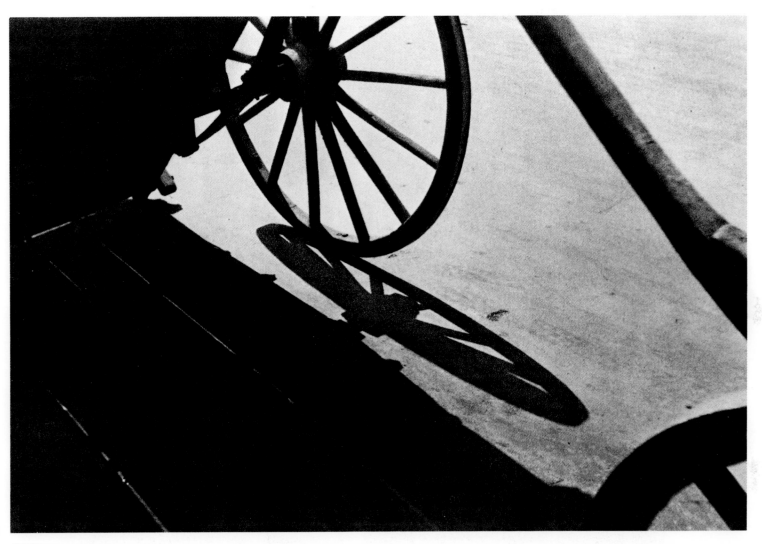

1928

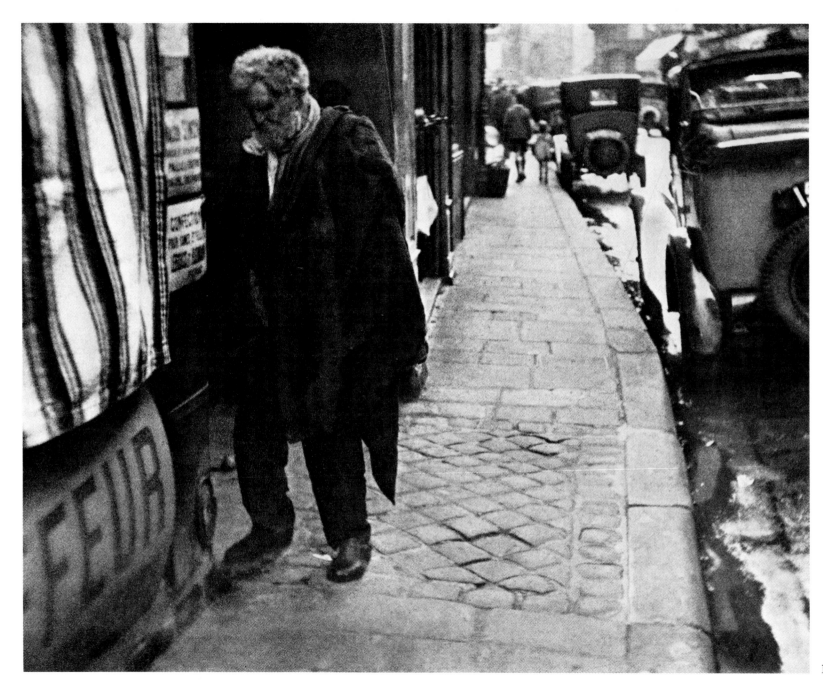

1928

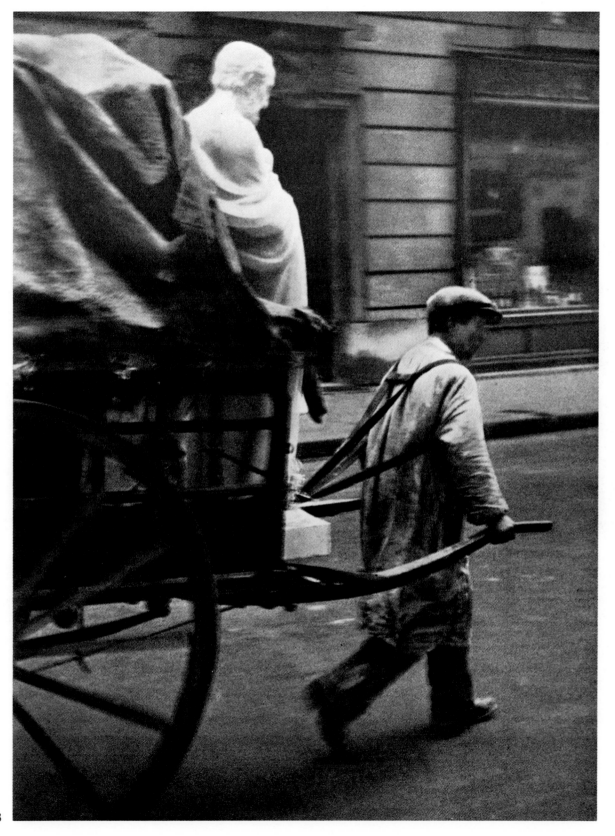

1928

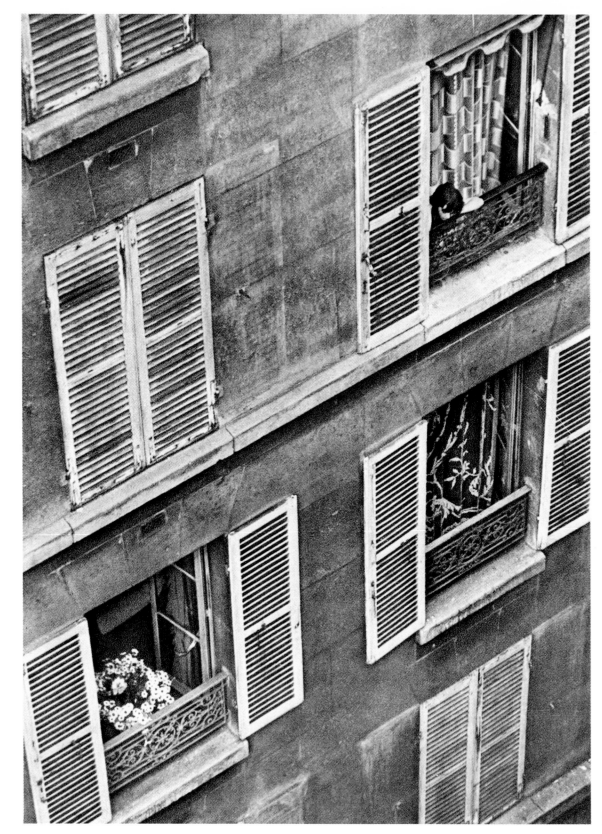

1925

126

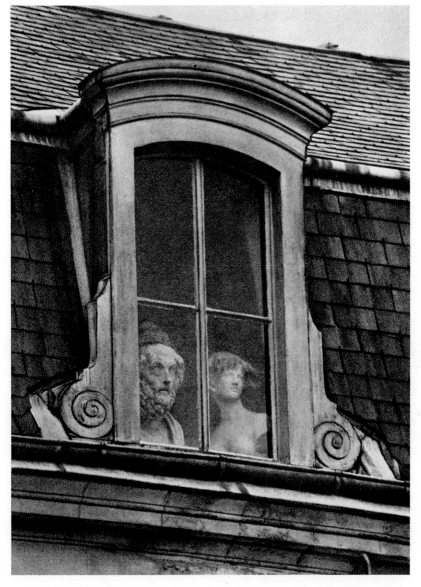

1928

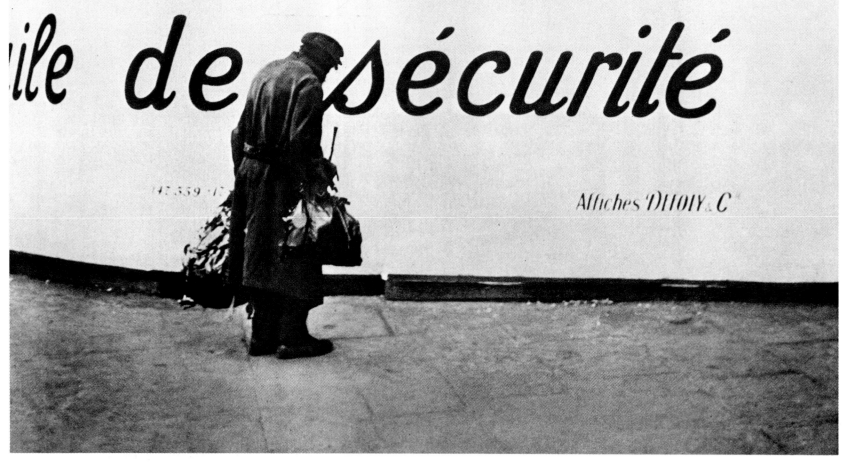

1927

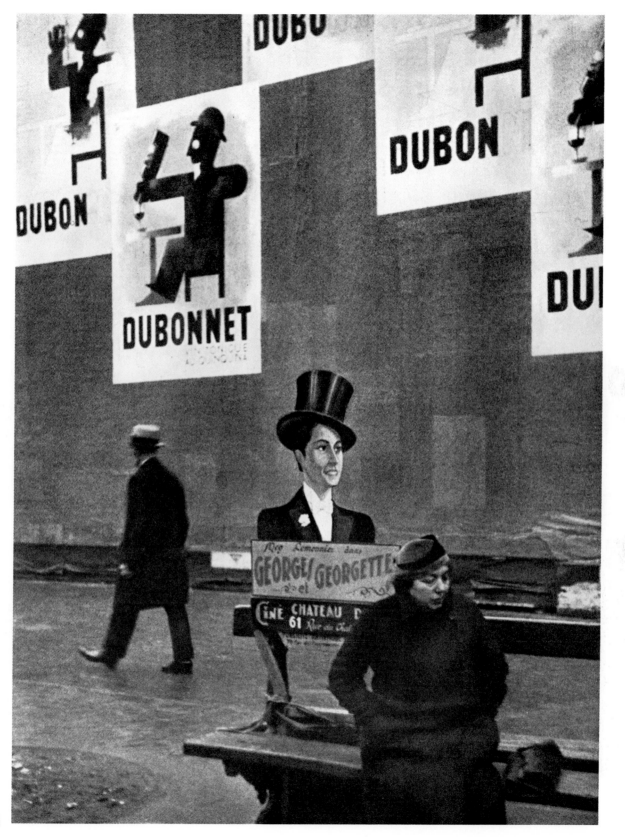

1934

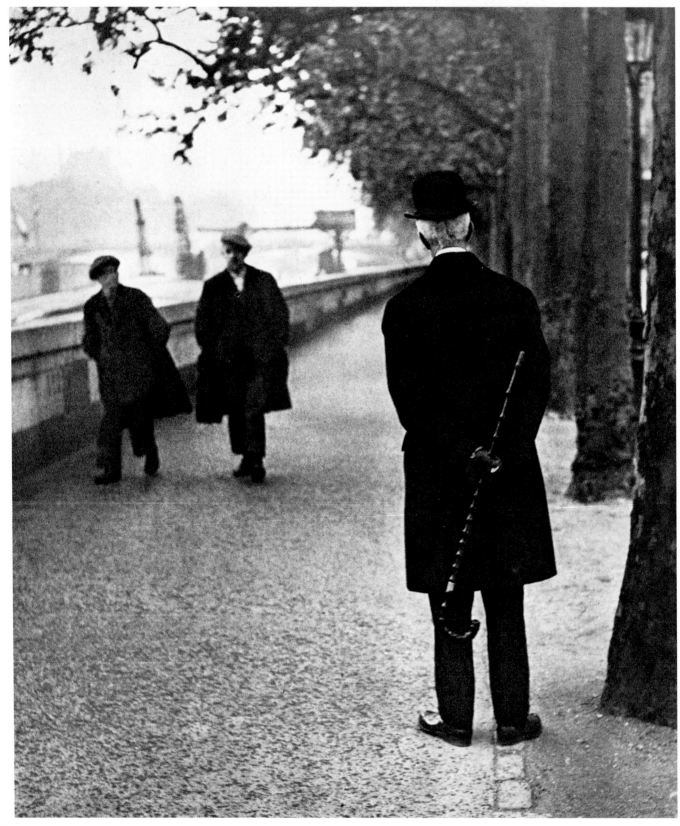

1926

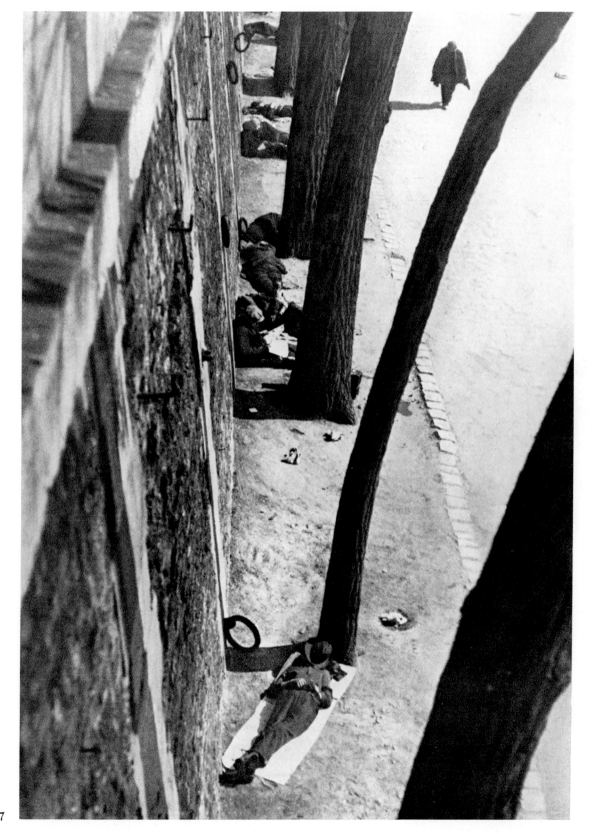

1927

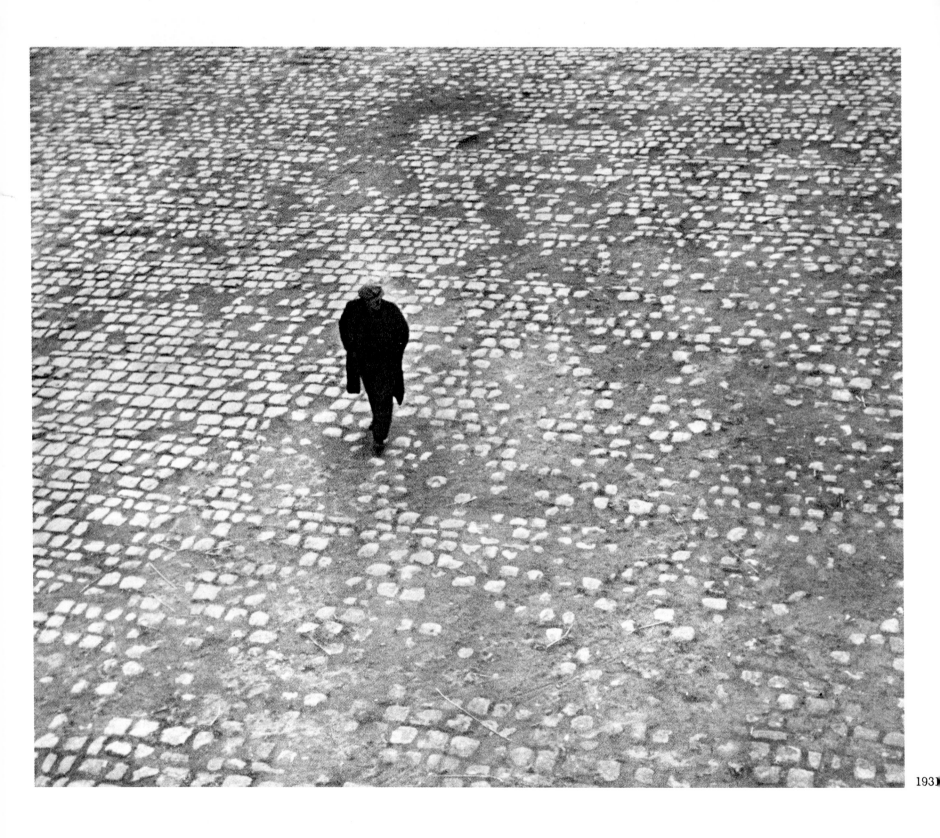

1931

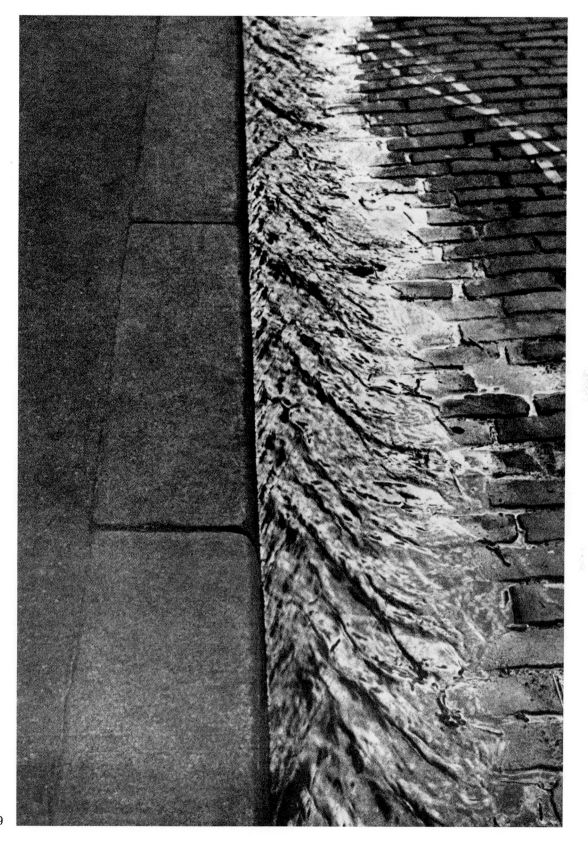

1929

133

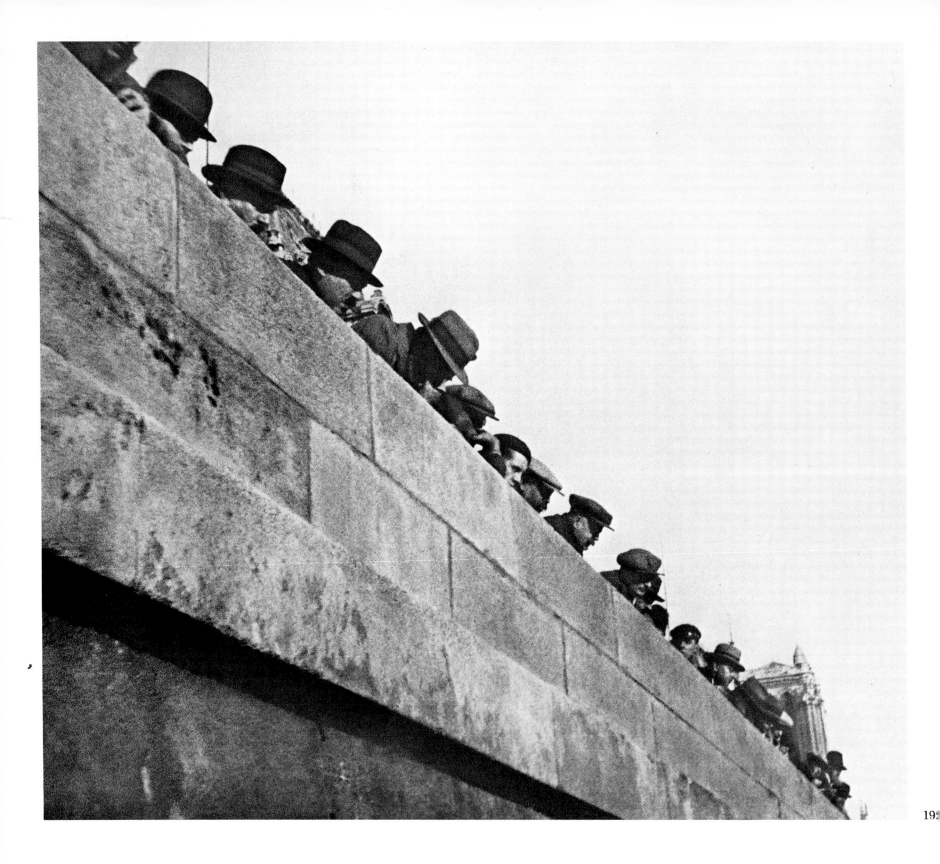

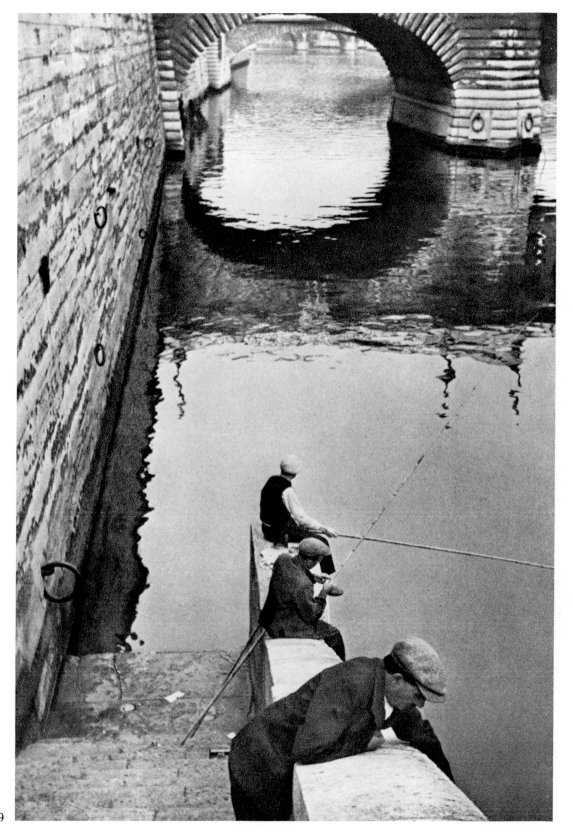

1929

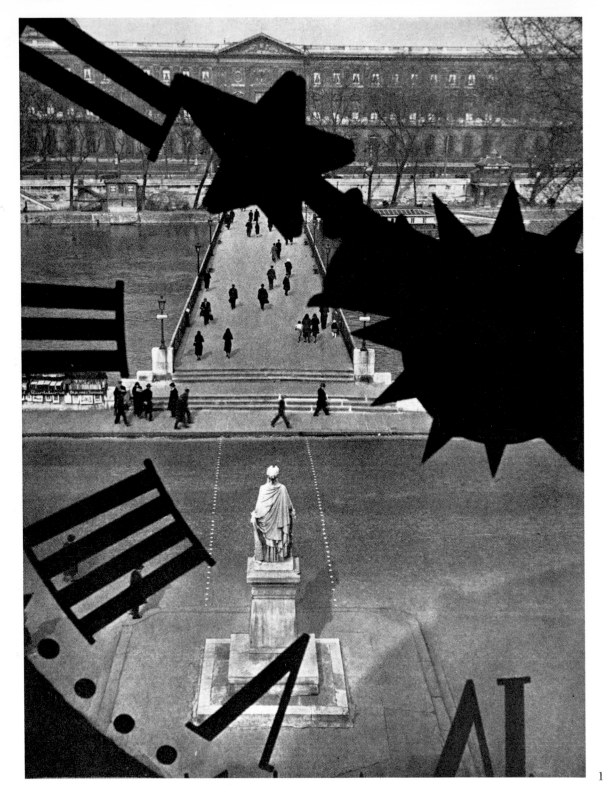

1932

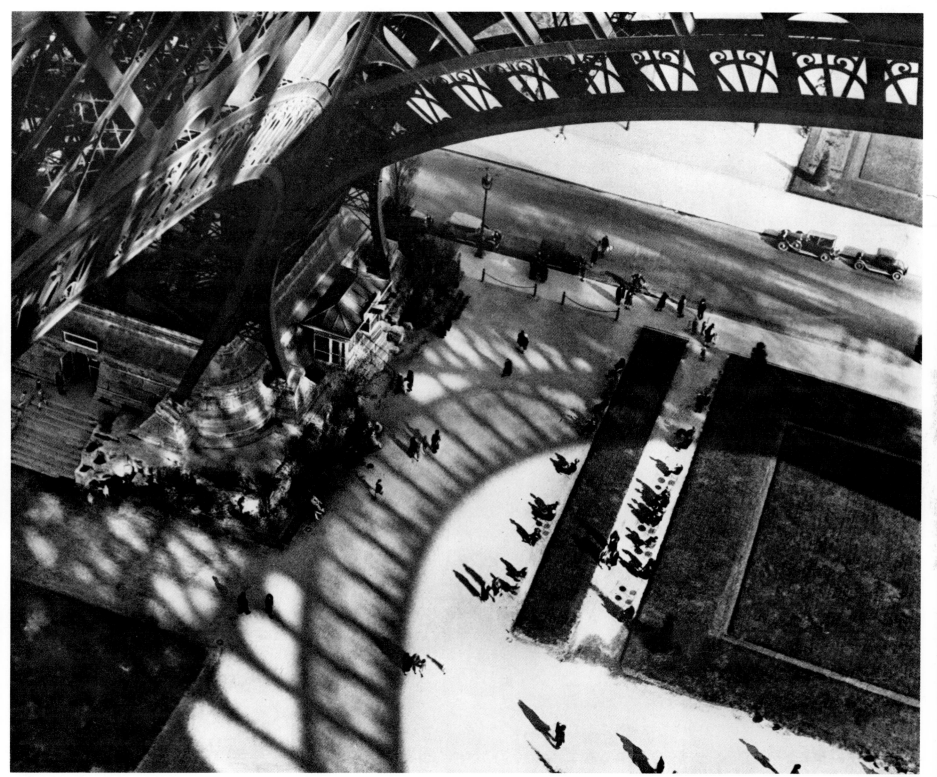

1929

137

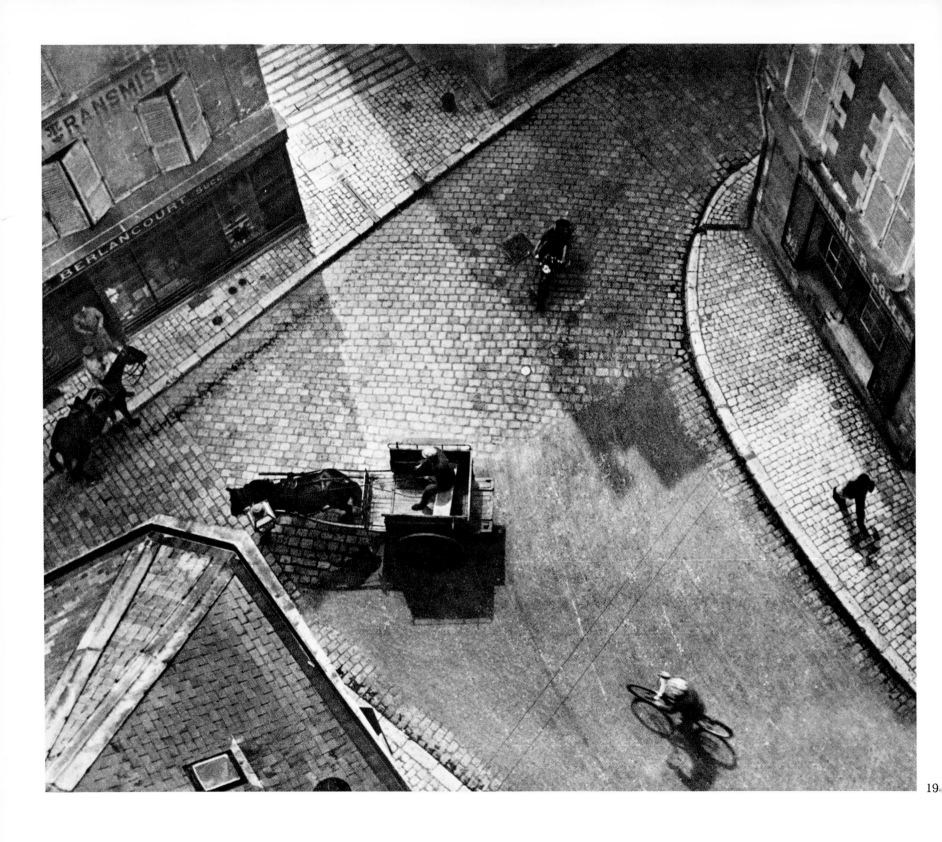

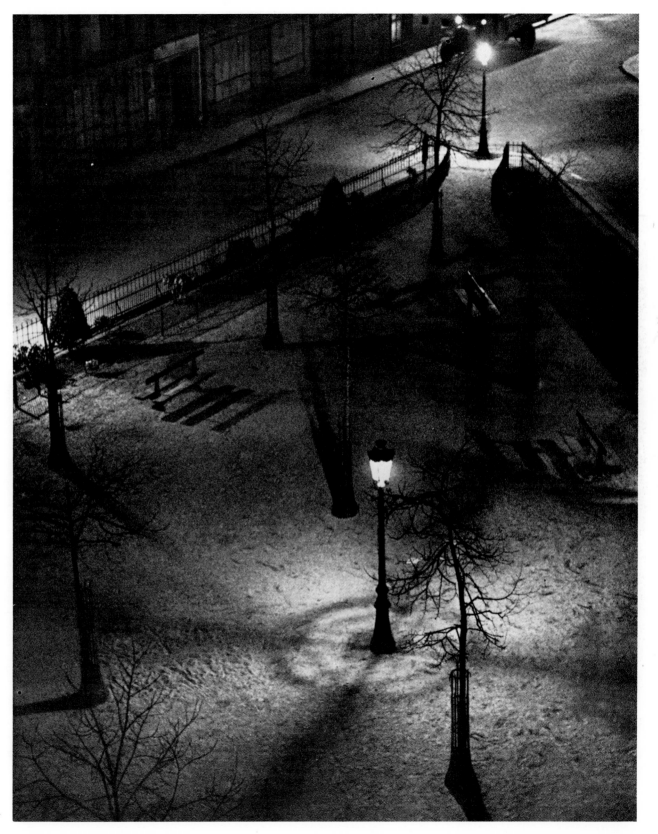

1927

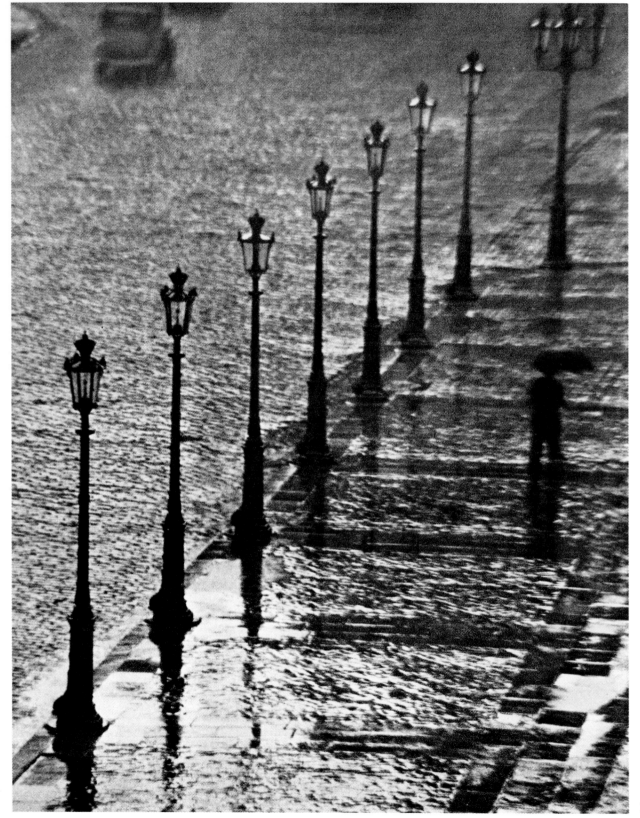

1929

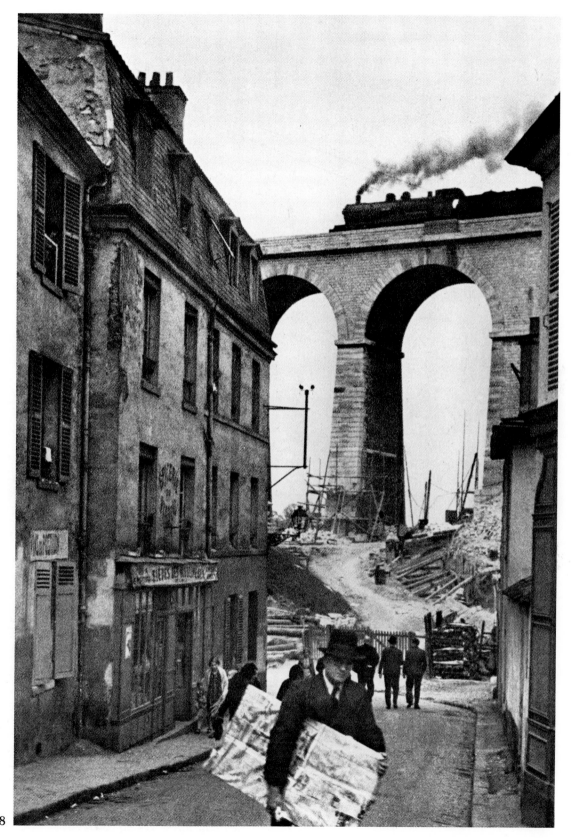

1928

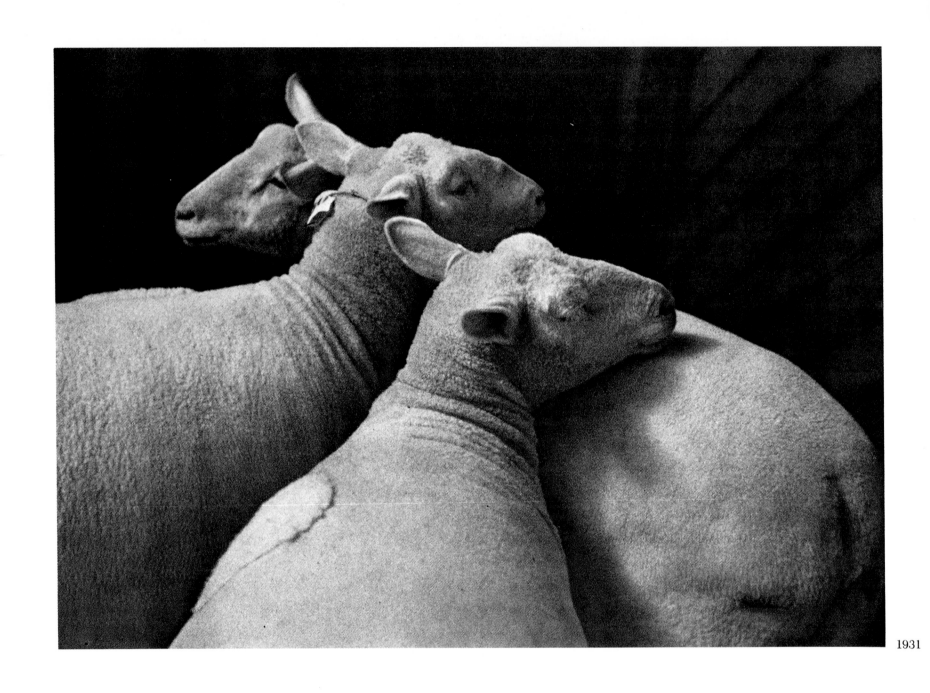

1931

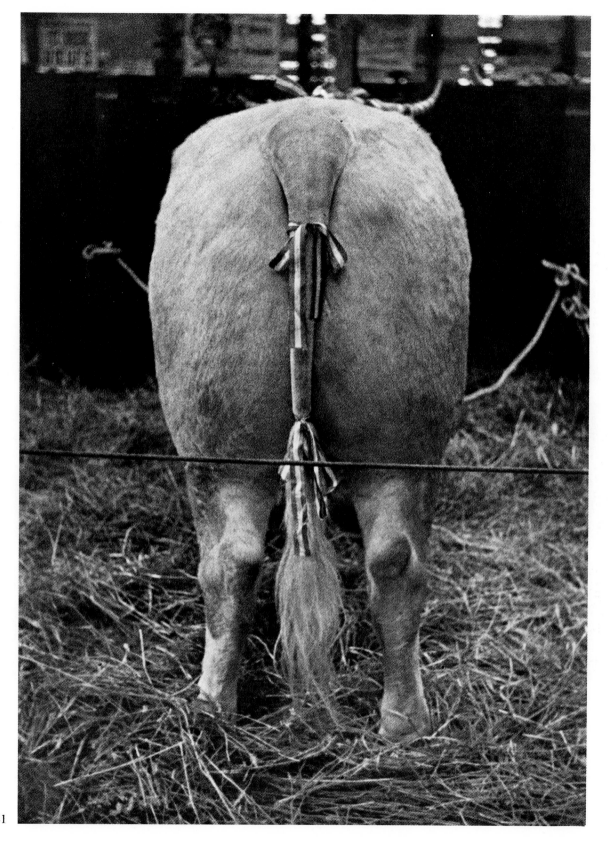

1931

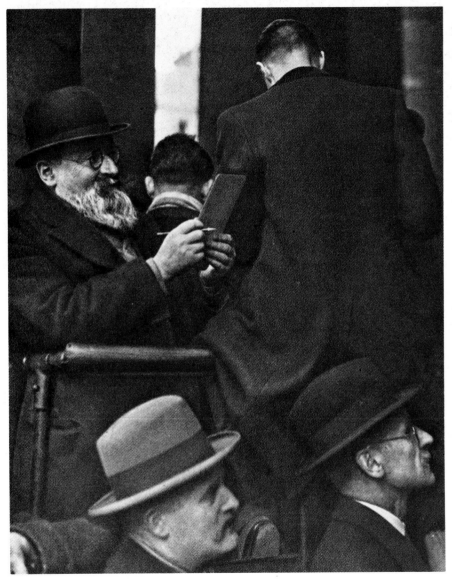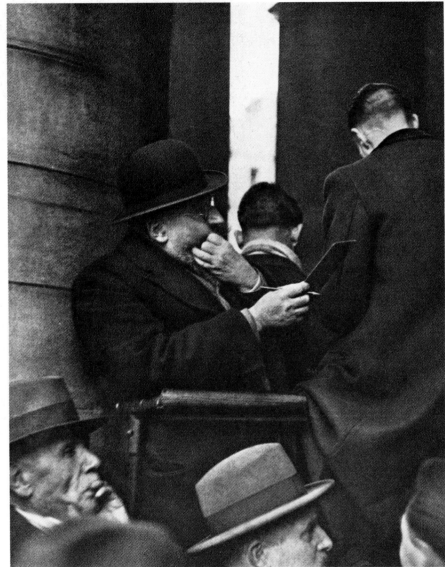

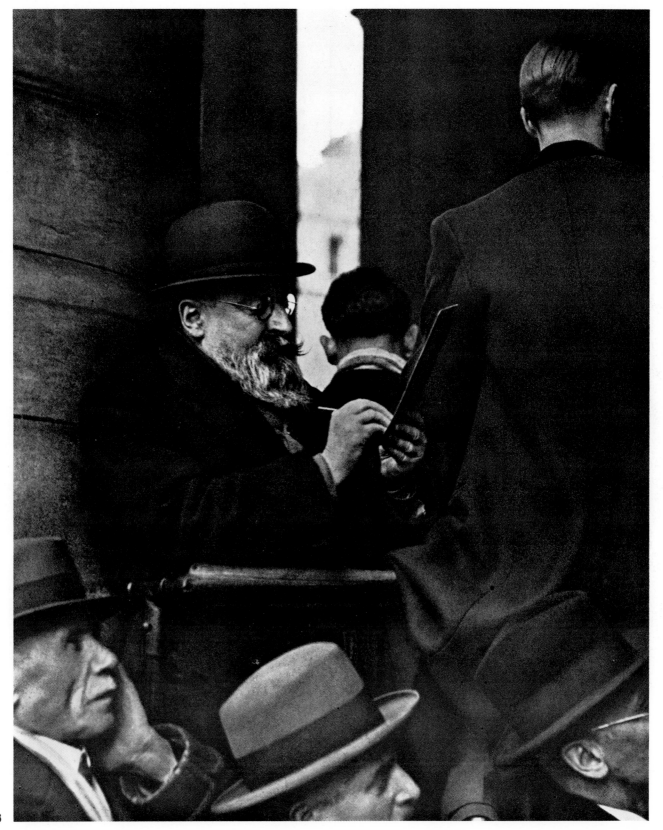

1926

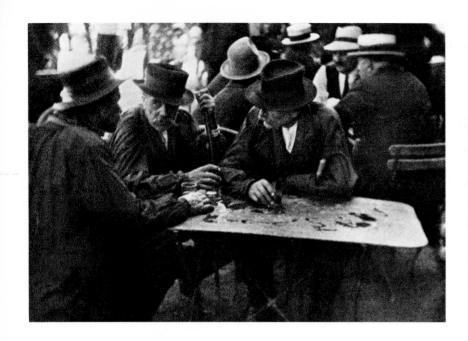

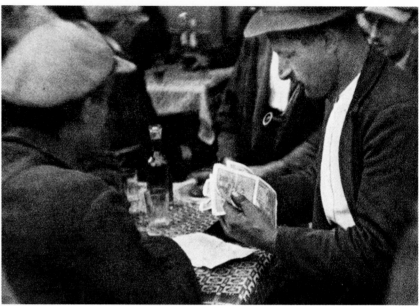

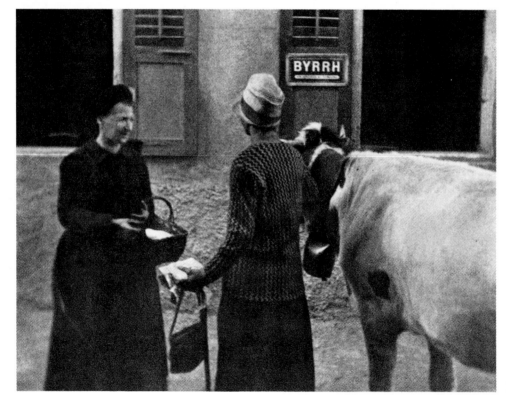

1928

146

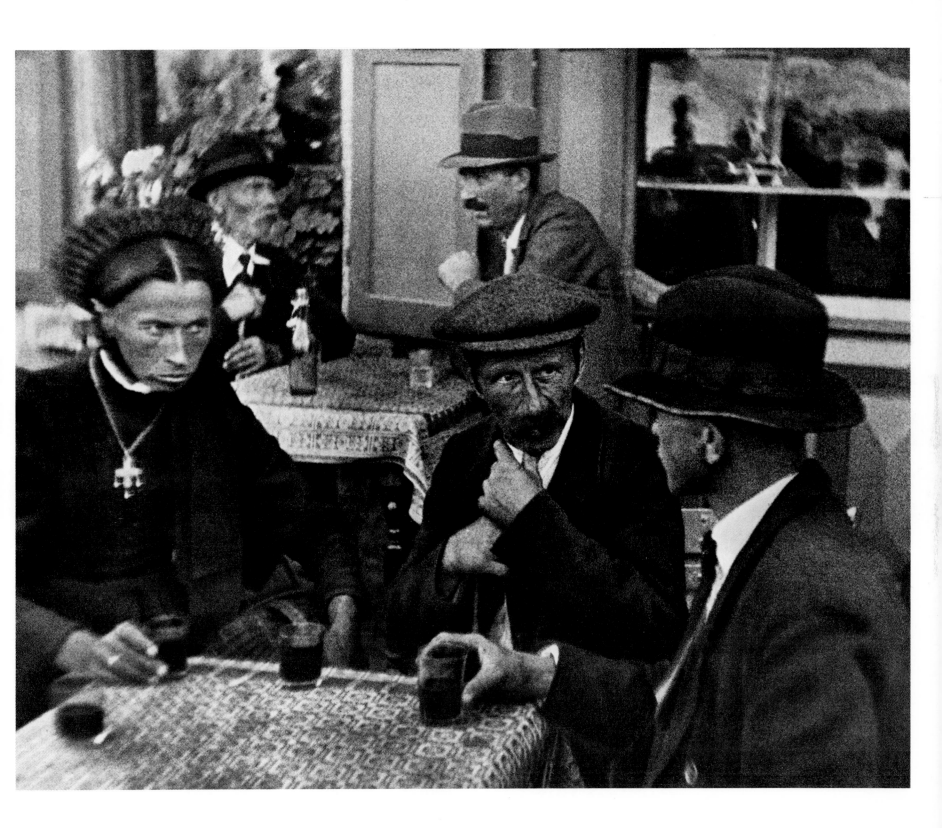

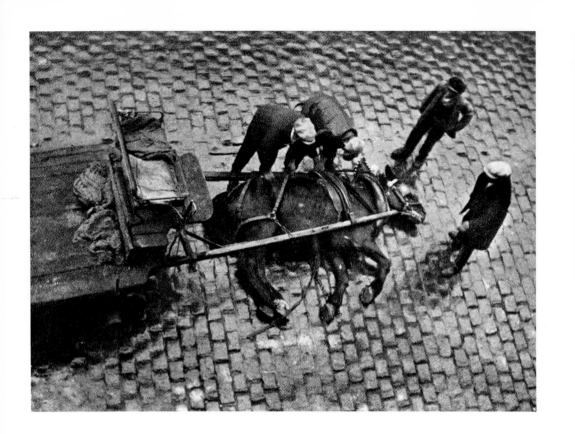

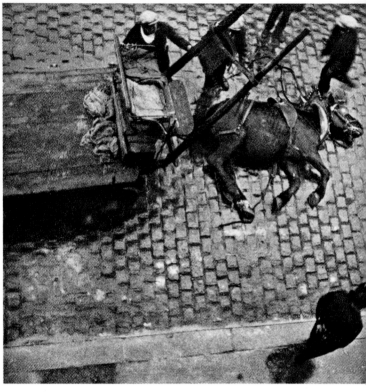

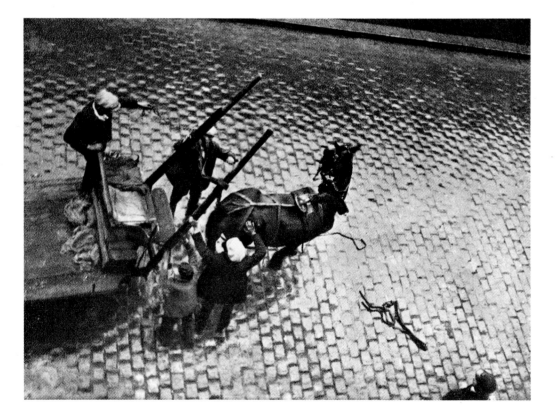

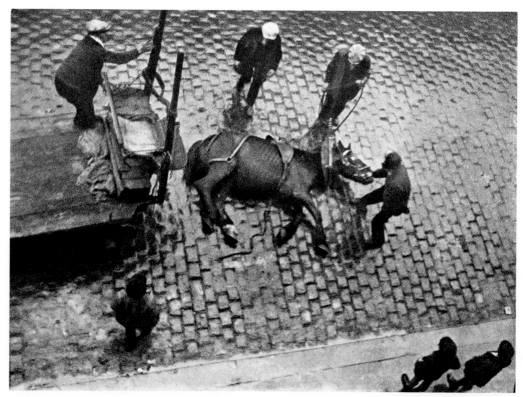

1927

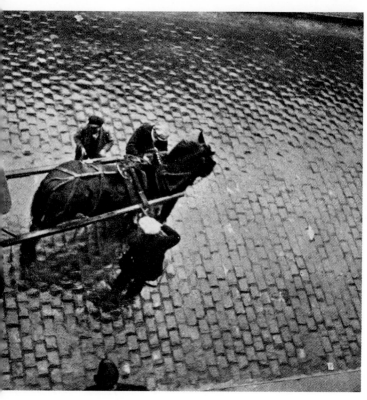
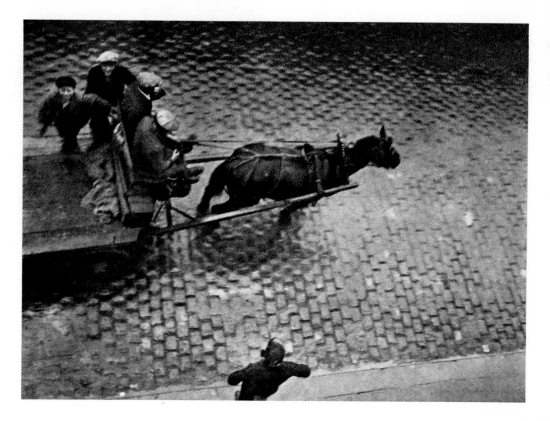

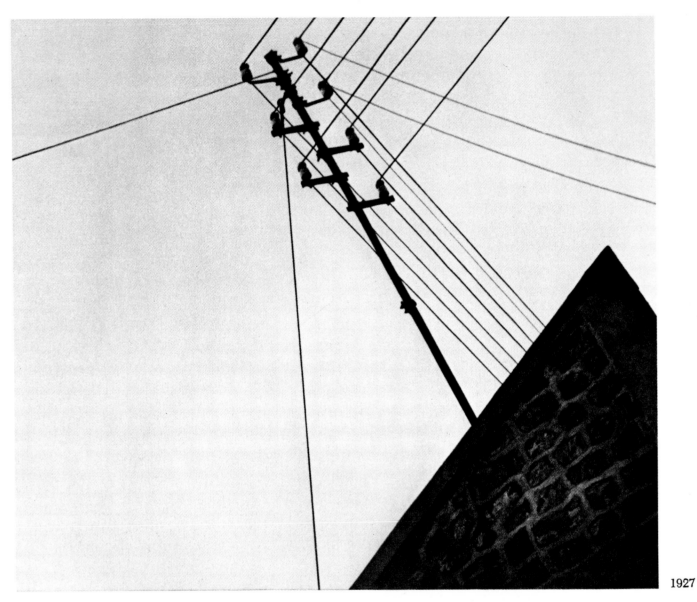

1927

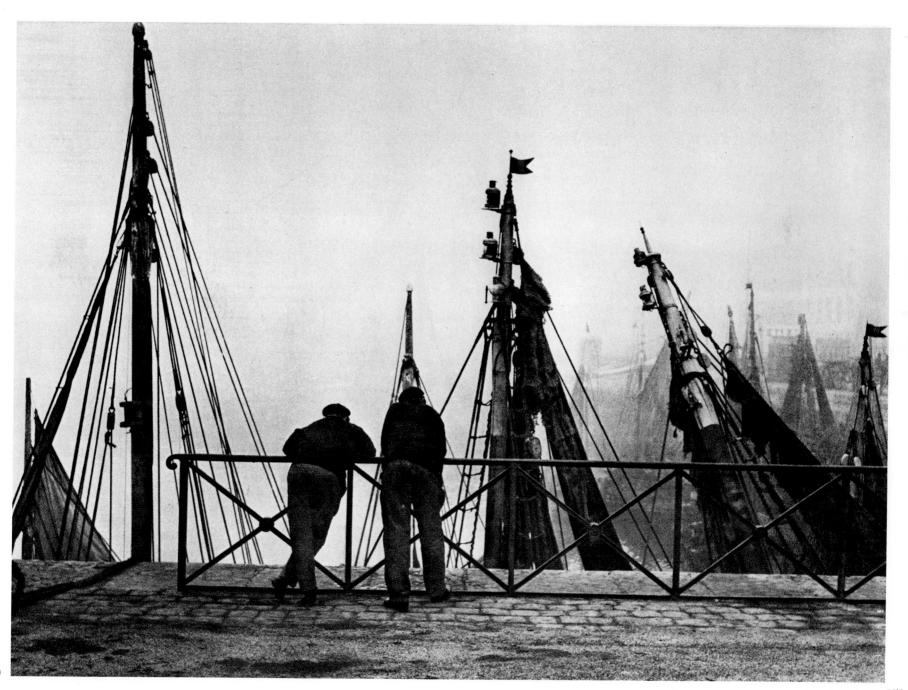

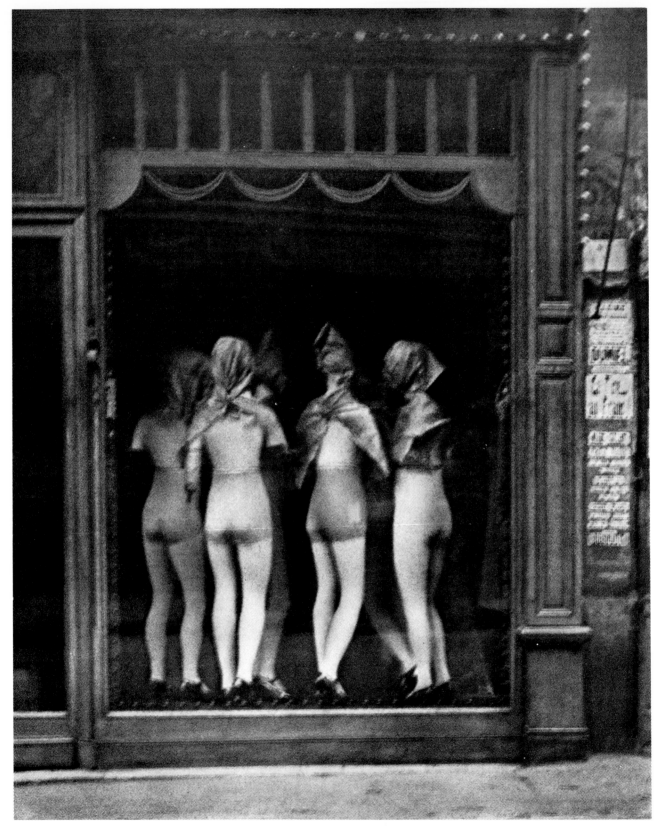

1925

152

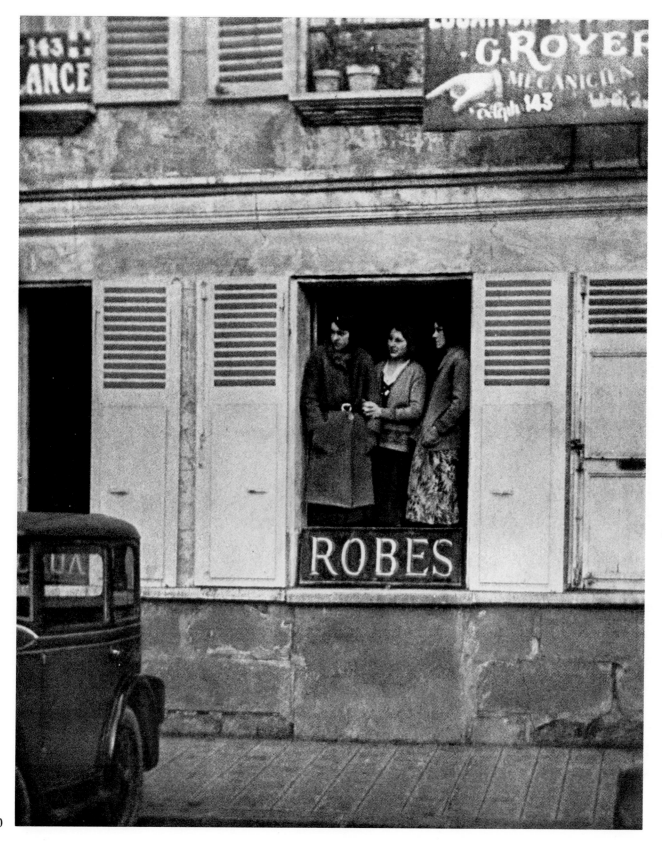

1930

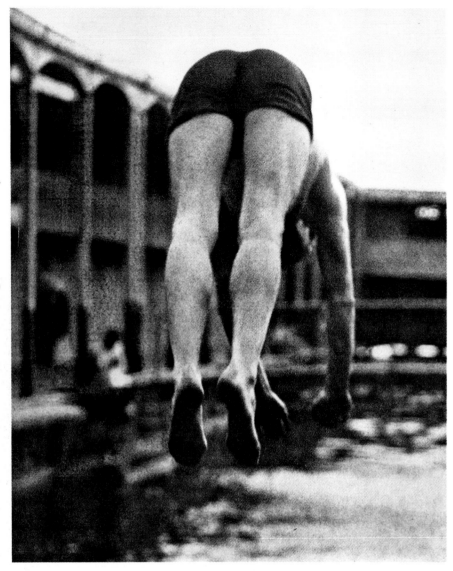

1928

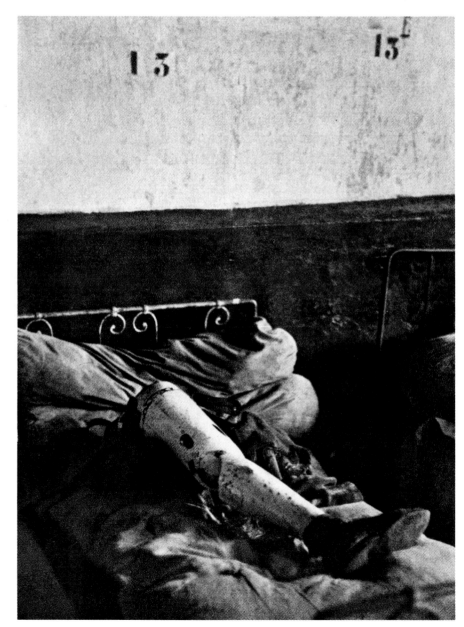

1927

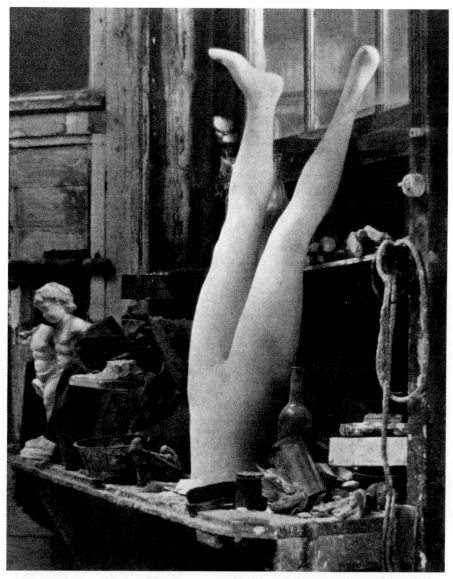

1925

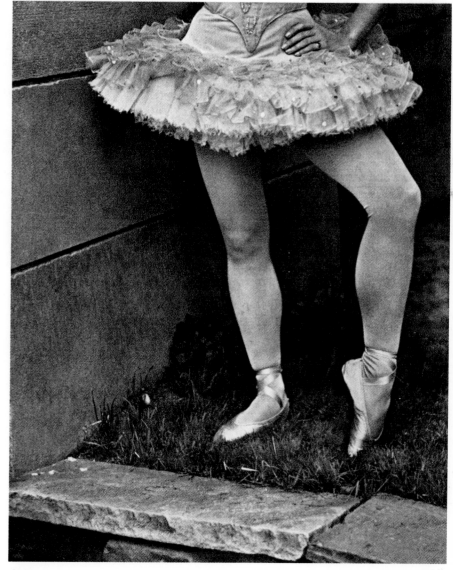

1939

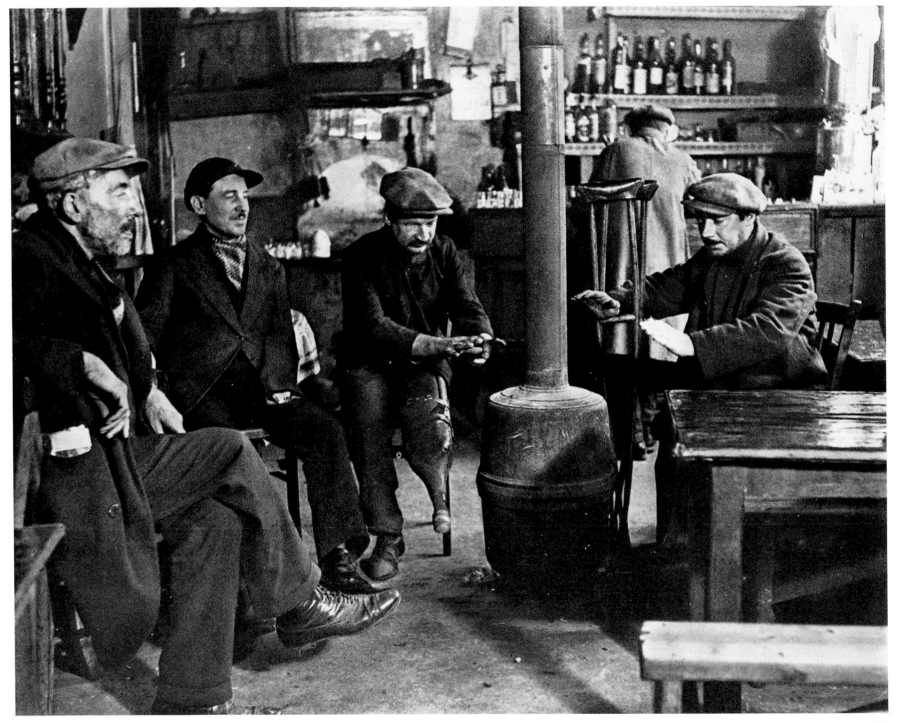

1927

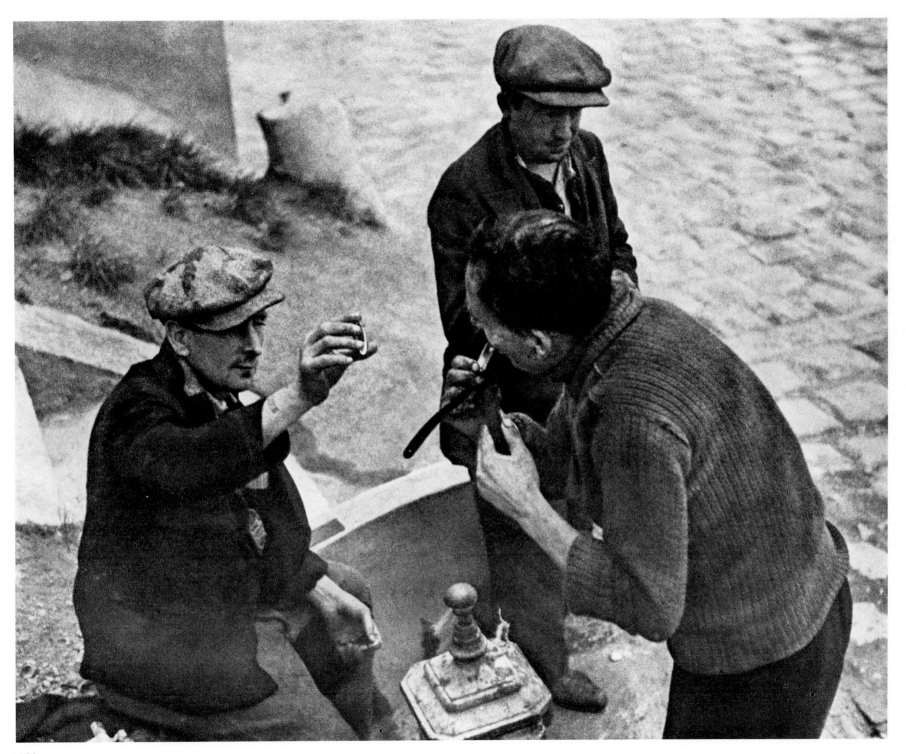

1930

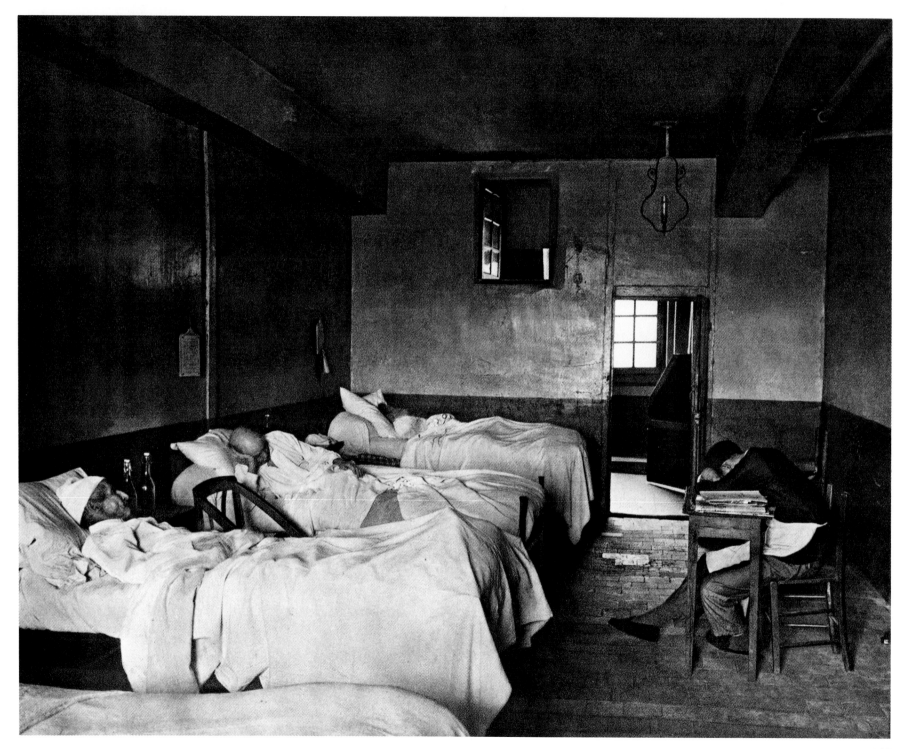

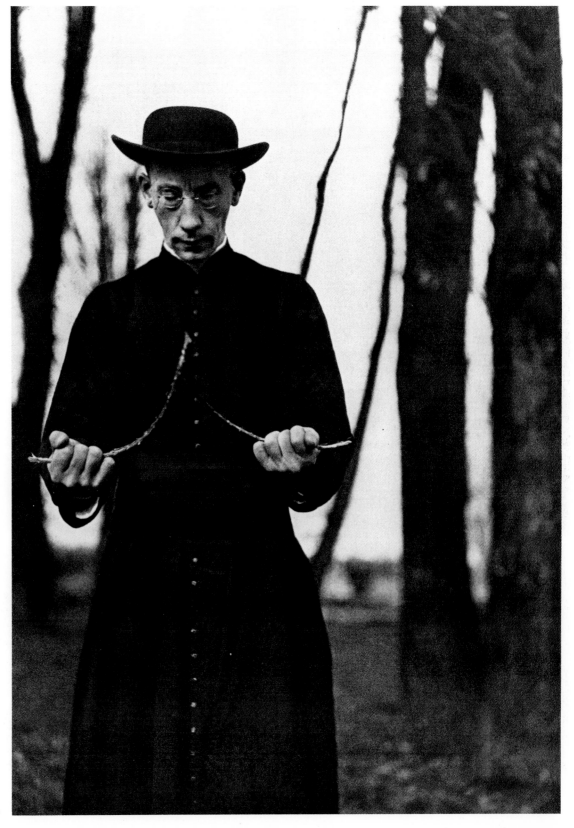

1928

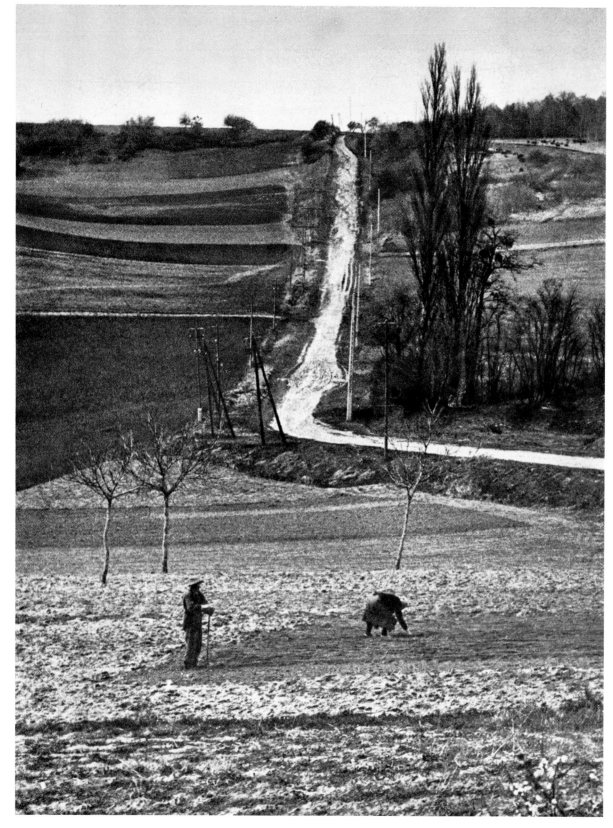

1931

160

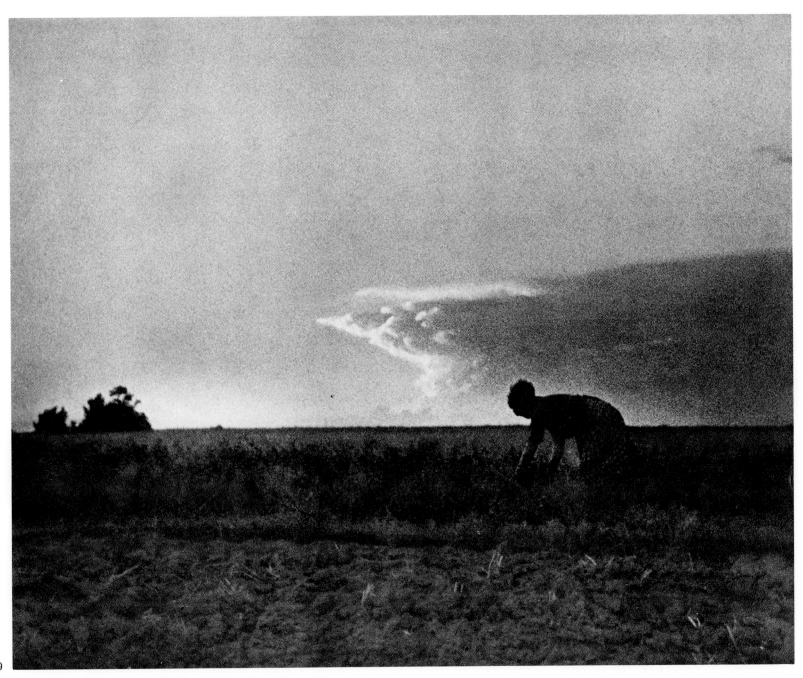

1929

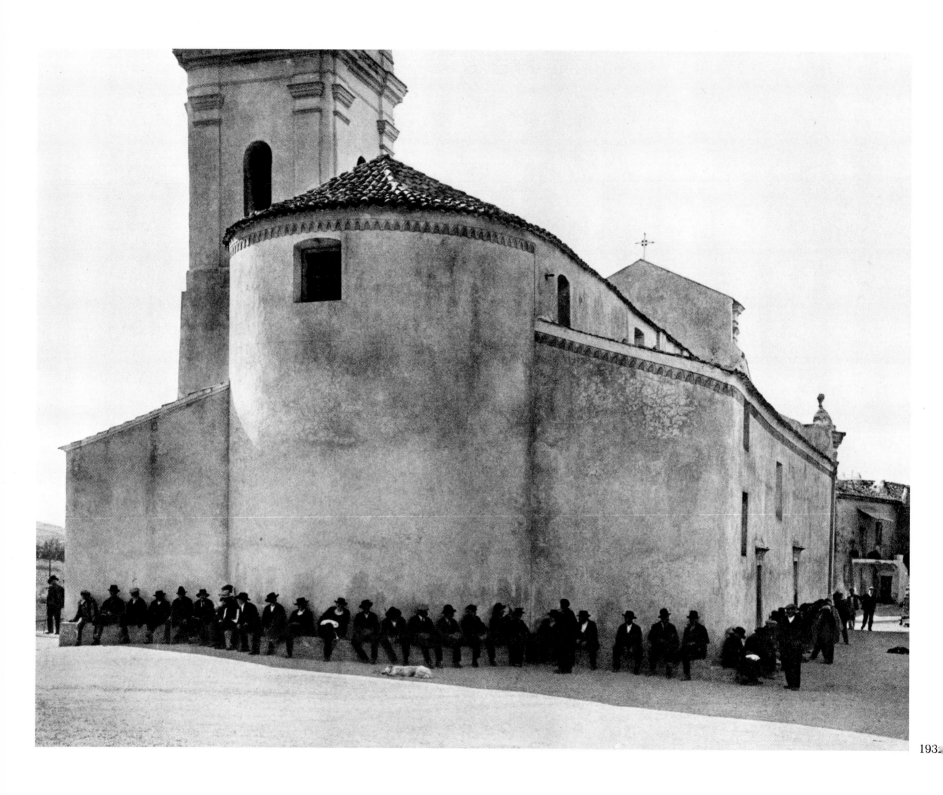

193

1928

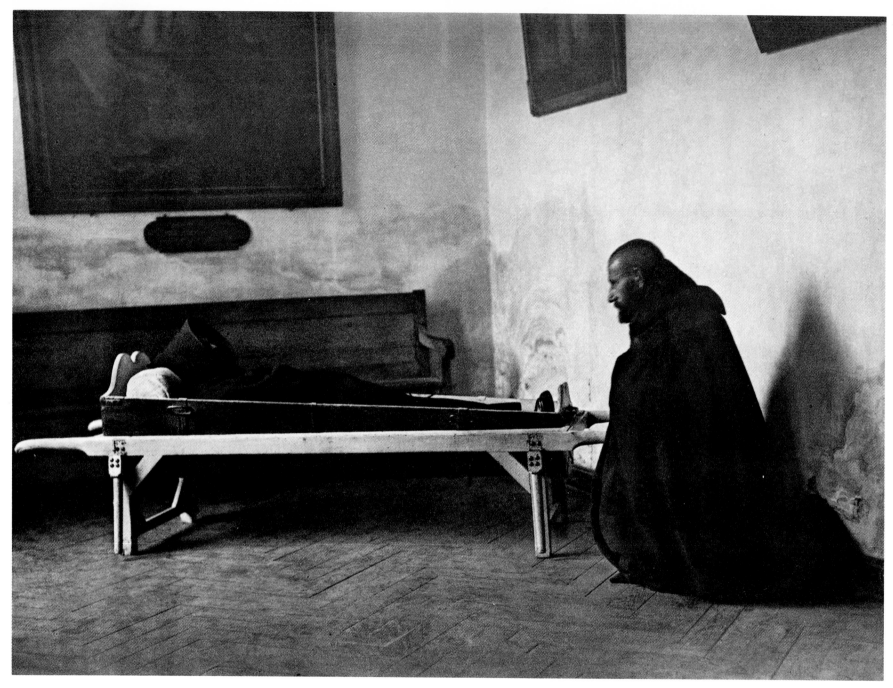

1928

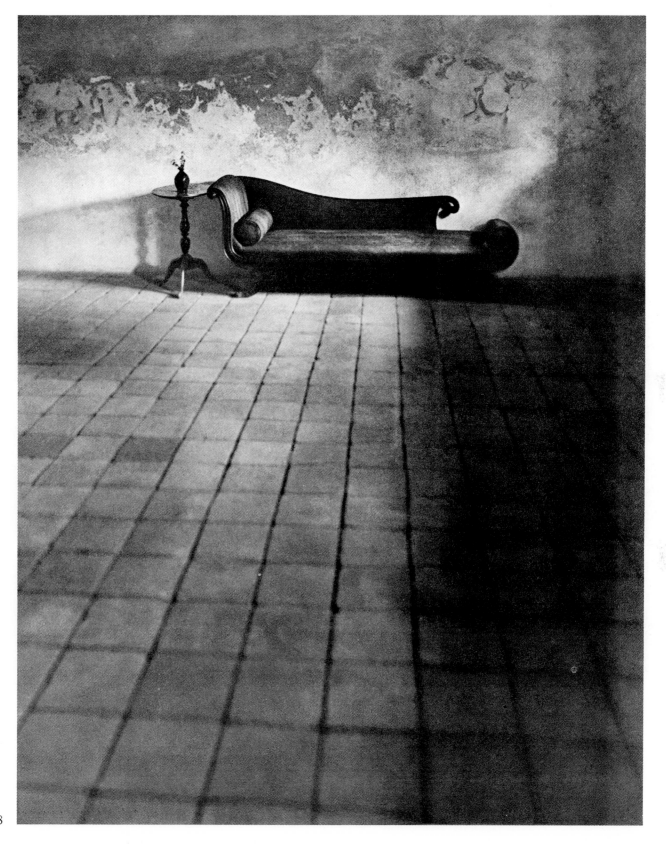

1948

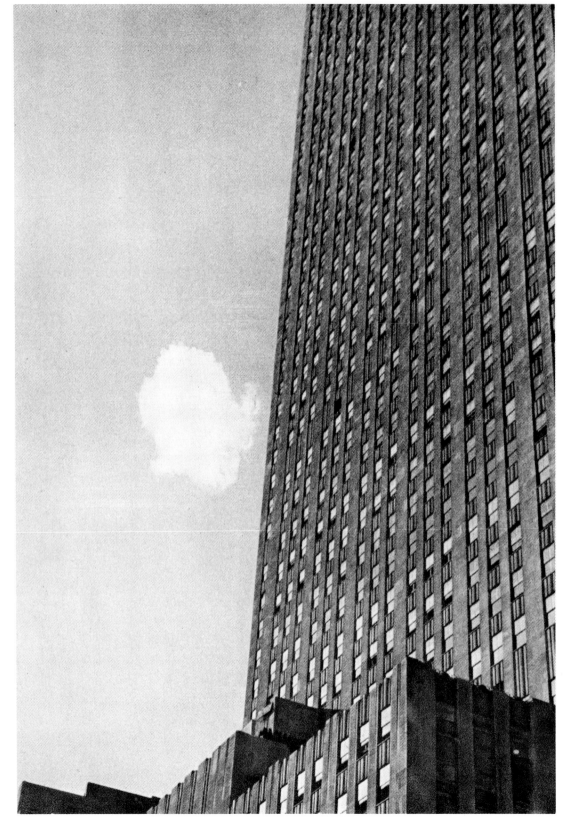

1937

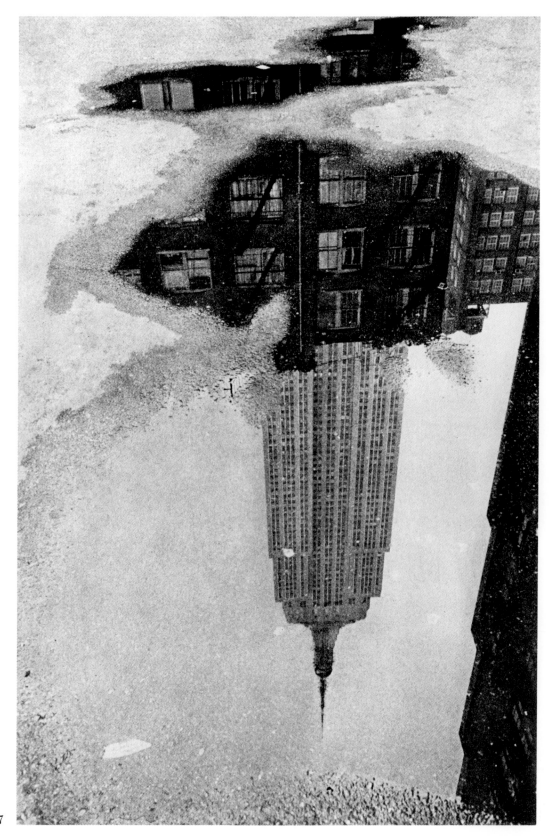

1967

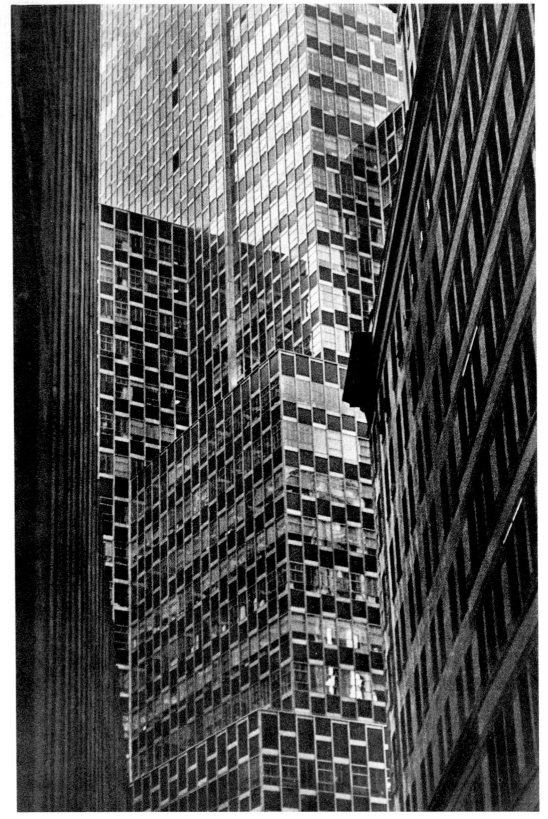

1965

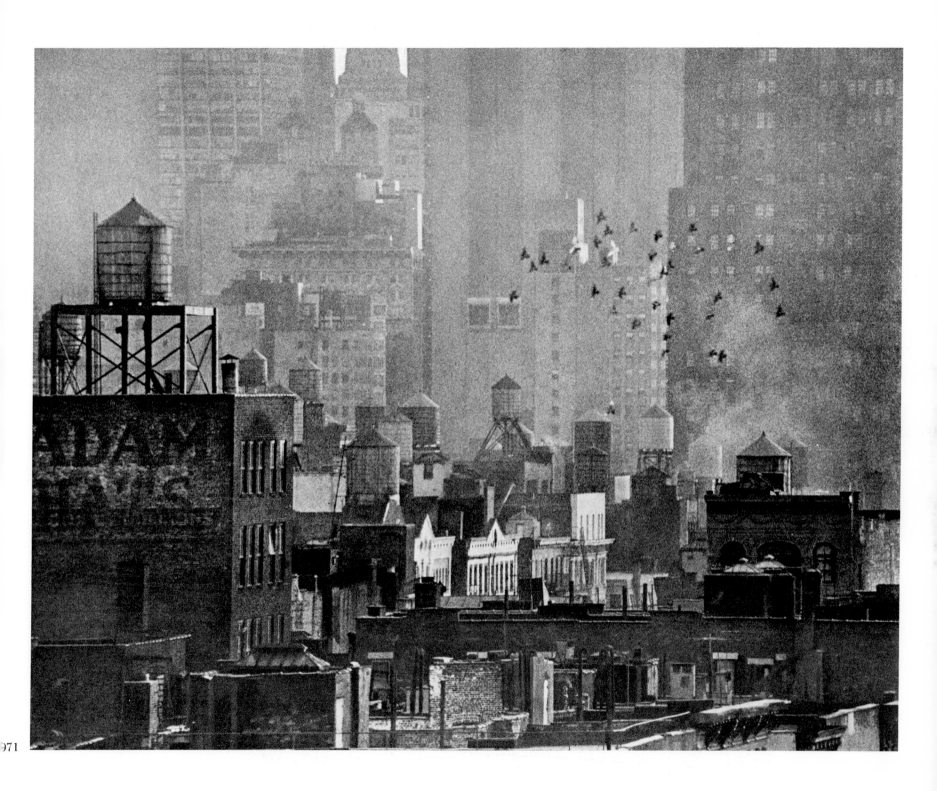

971

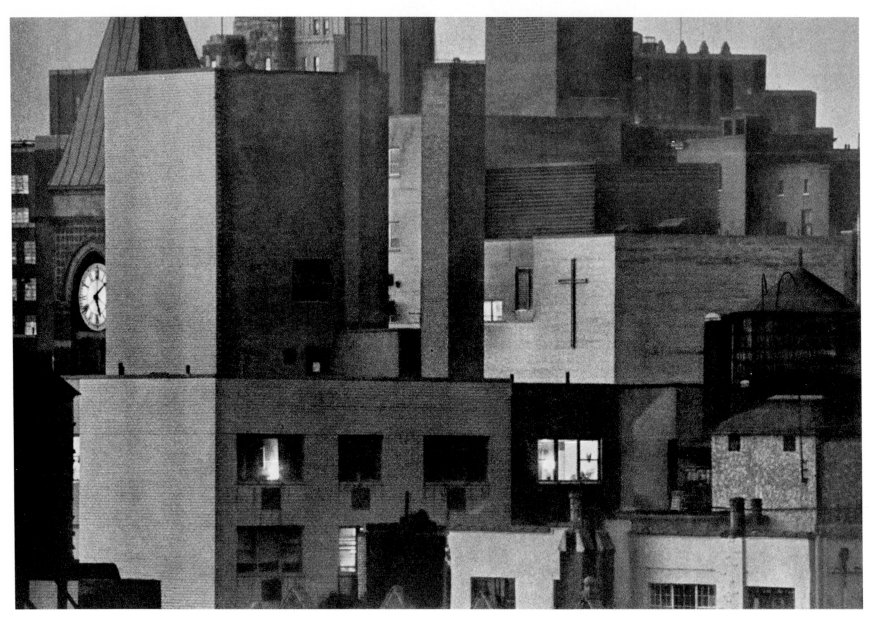

1971

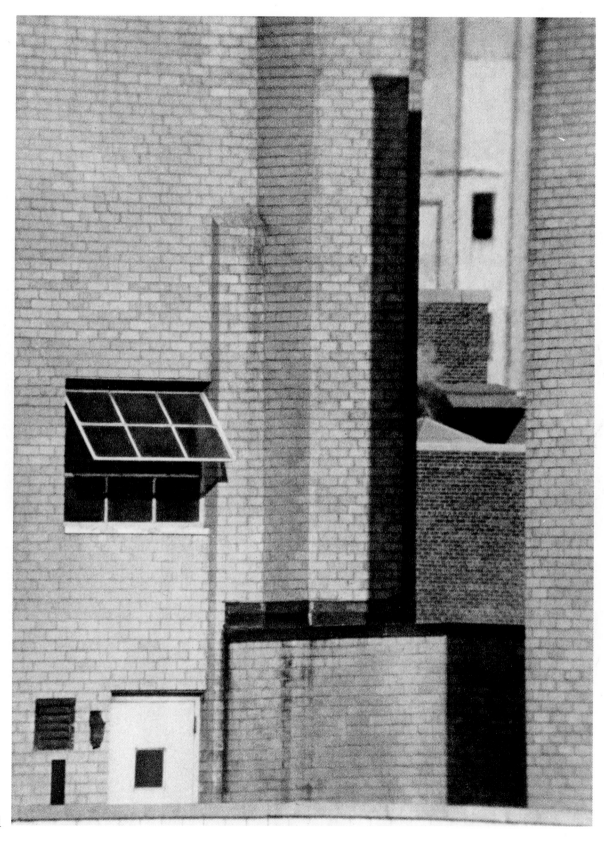

1961

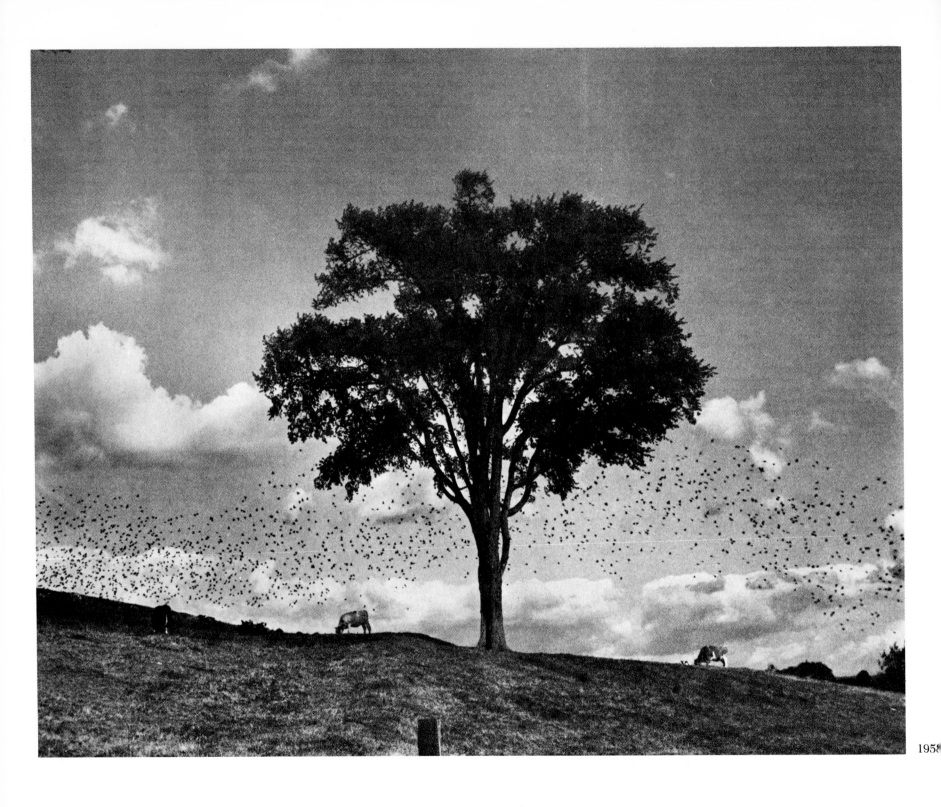

1958

172

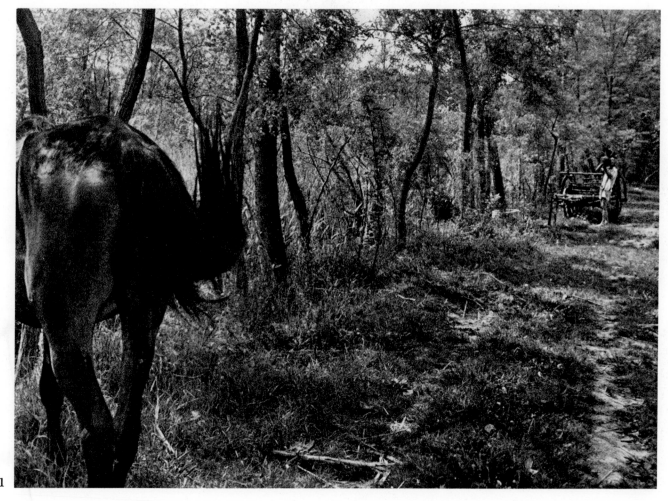

1971

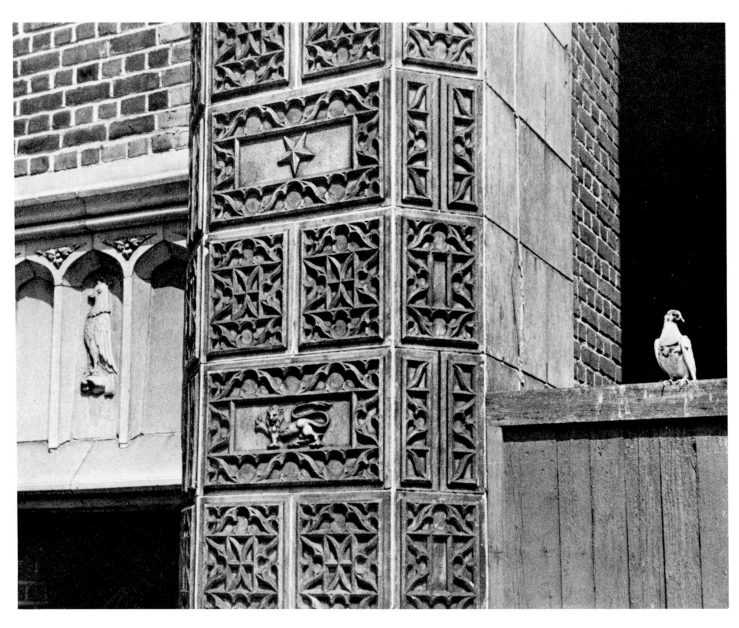

1962

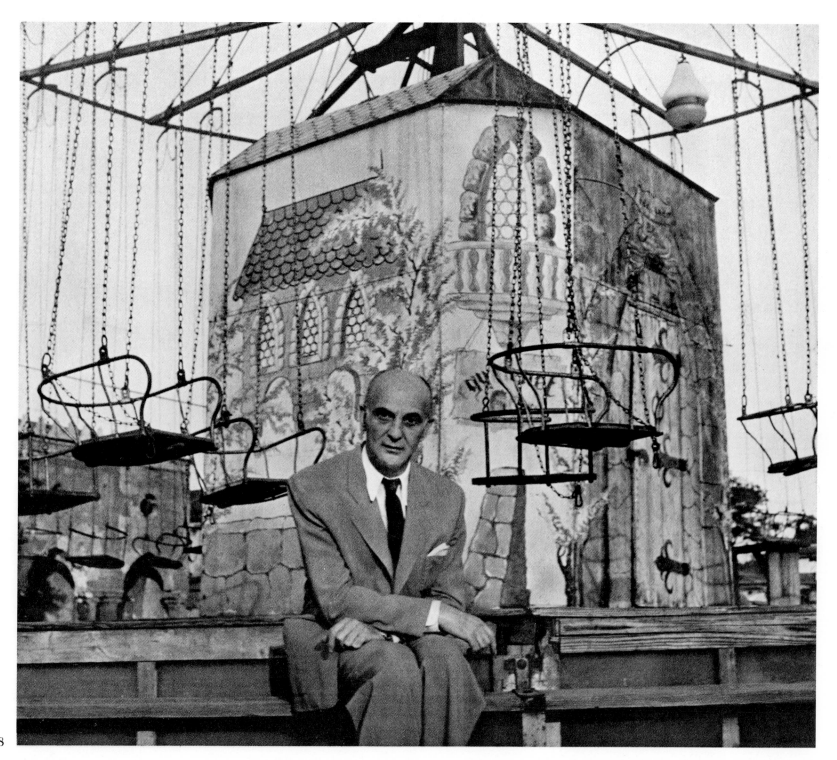

1948

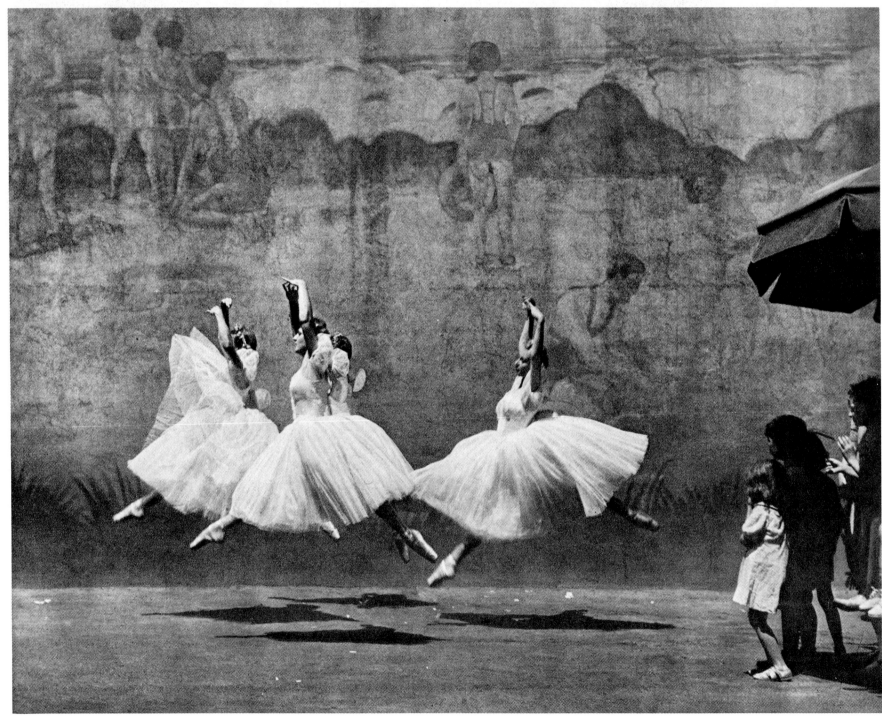

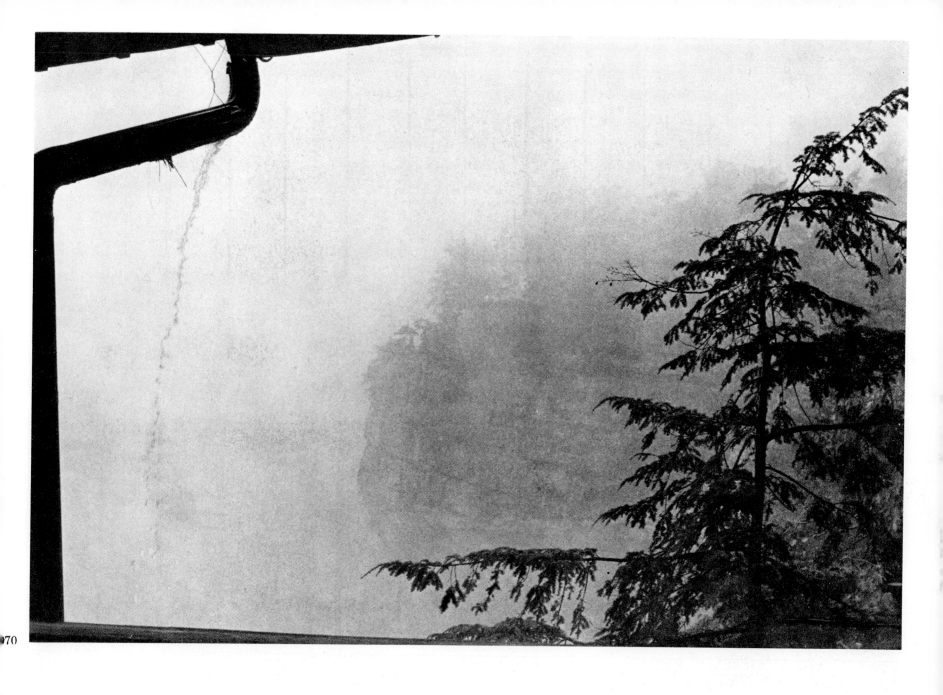

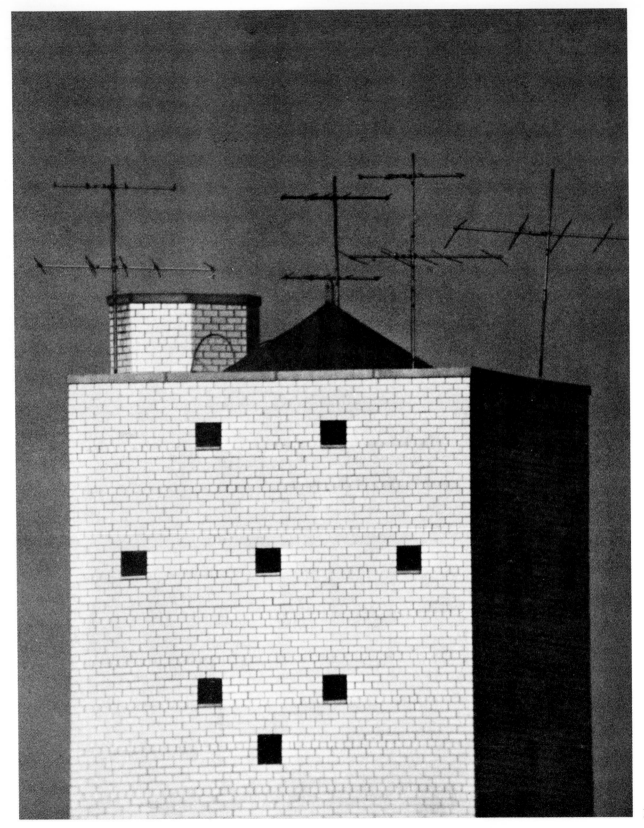

1962

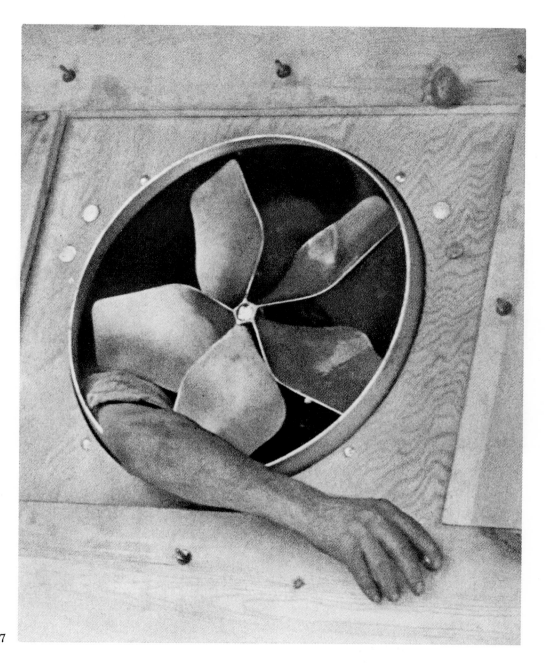

1937

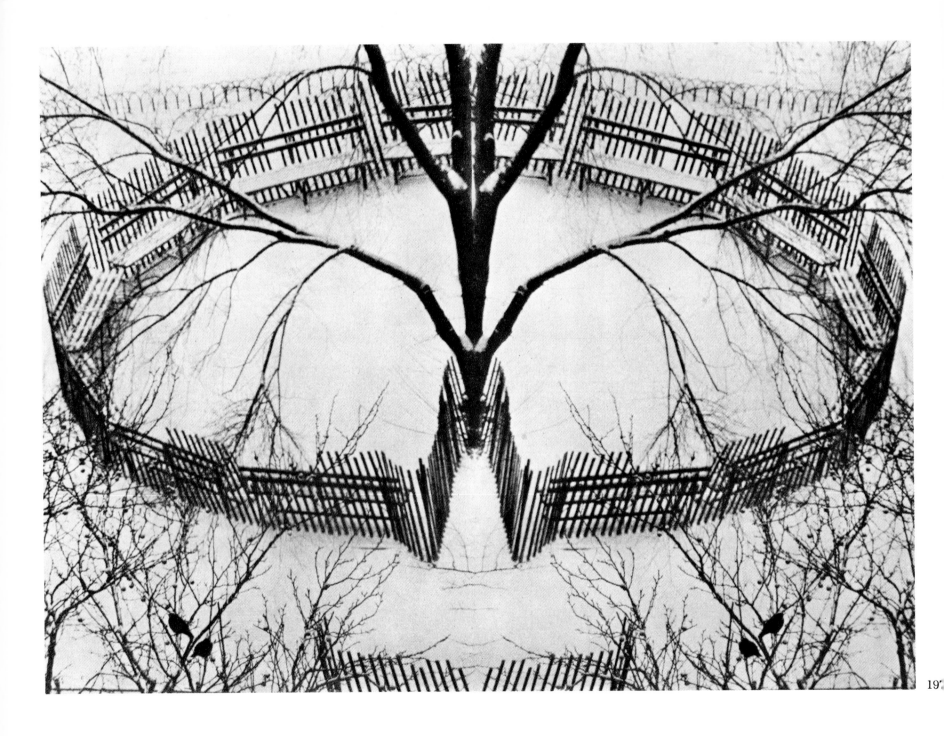

197

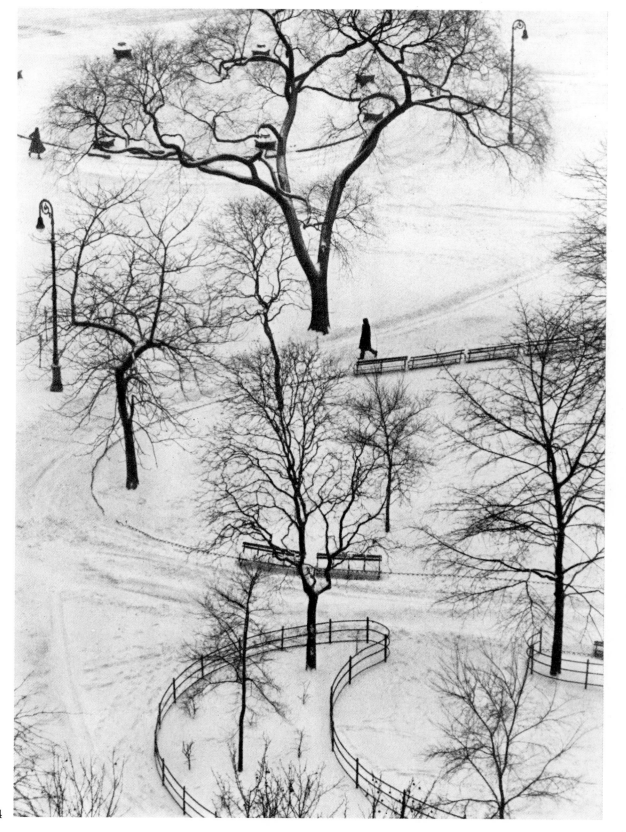

1954

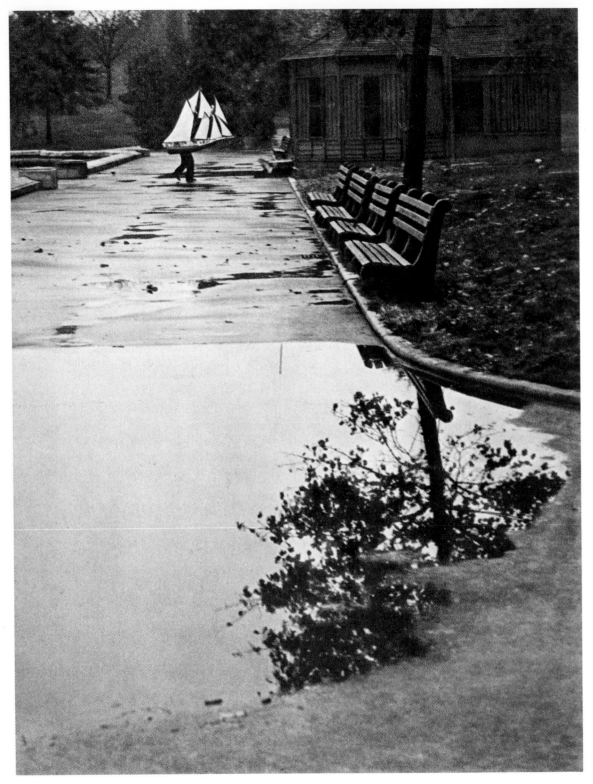

1944

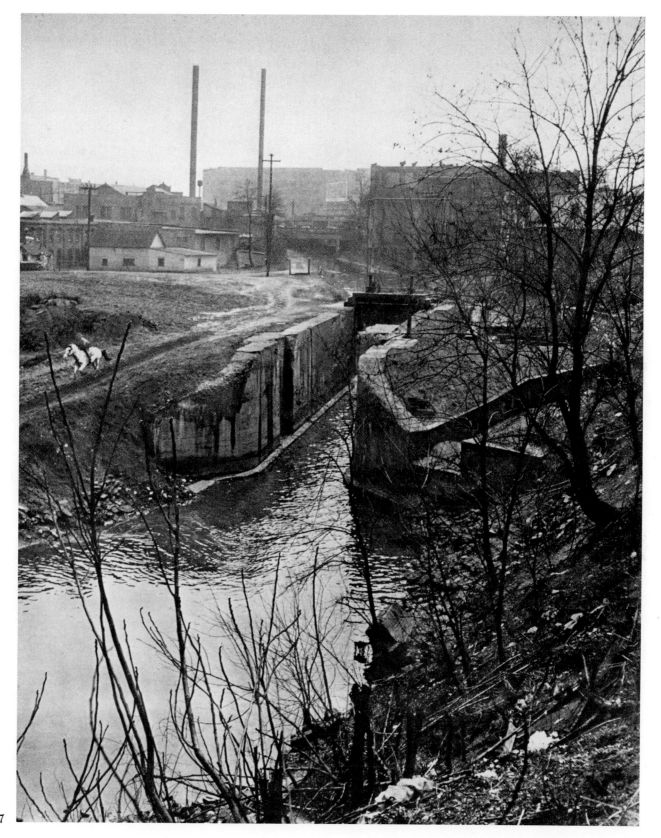

1947

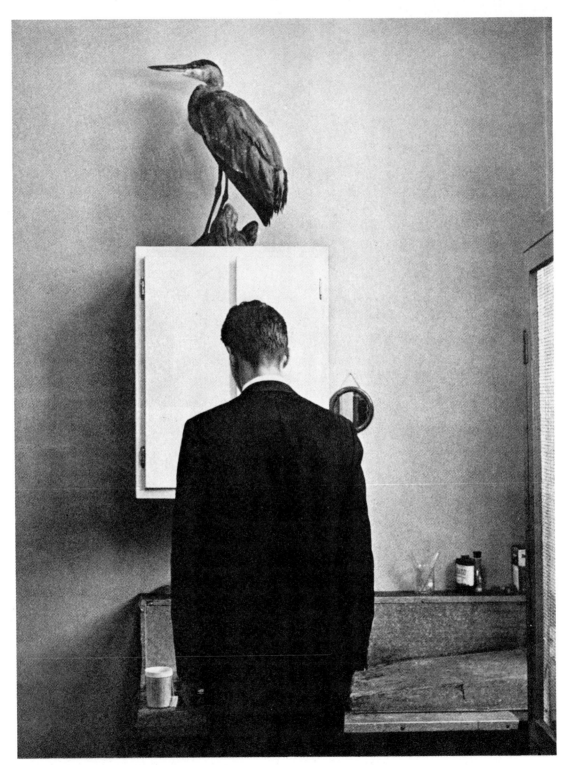

1969

184

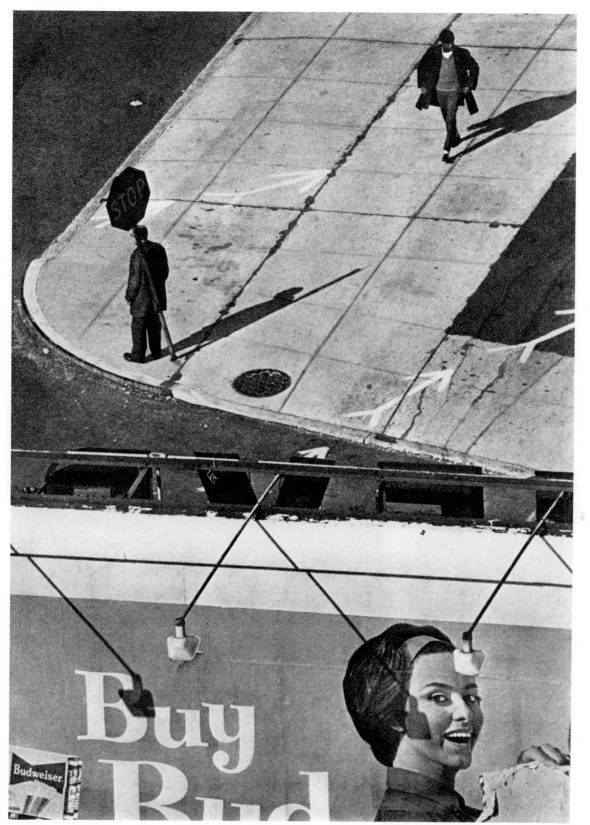

1962

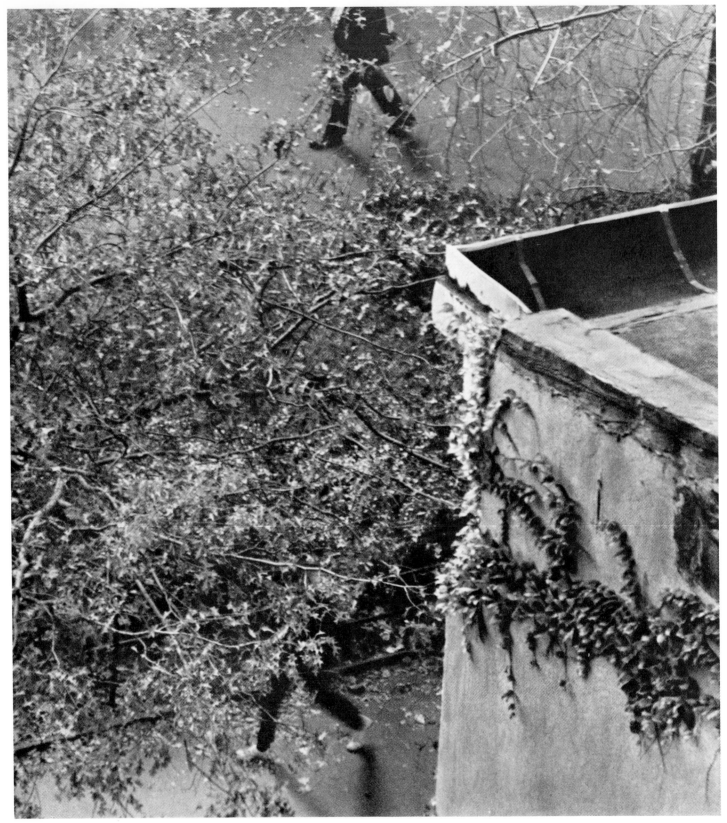

1962

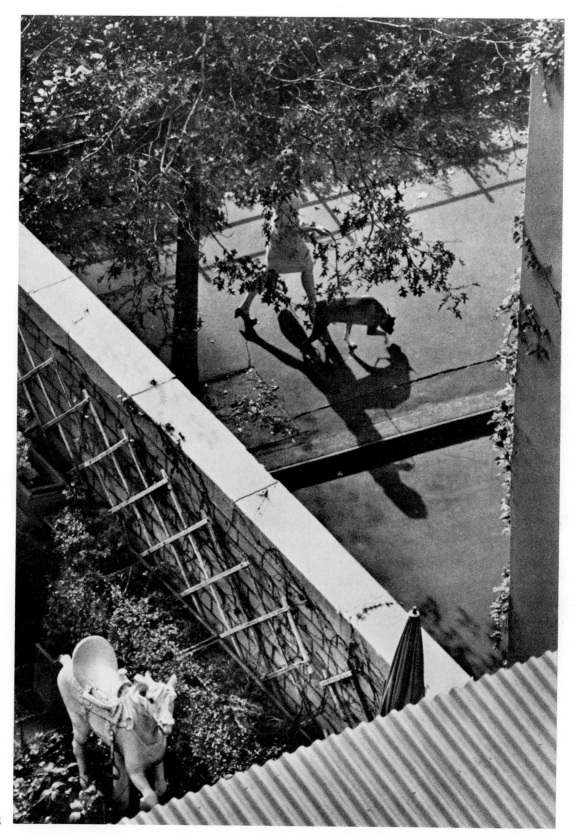

1962

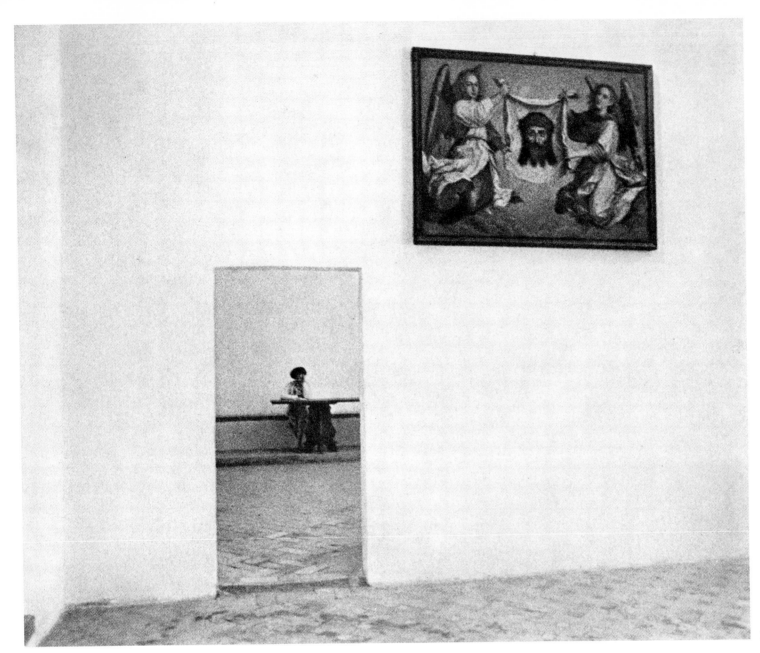

1971

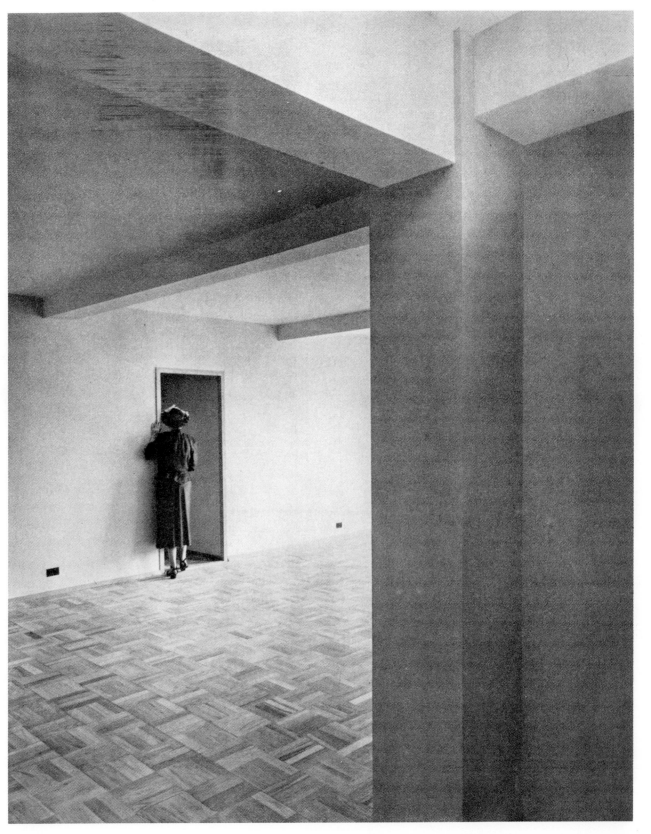

1948

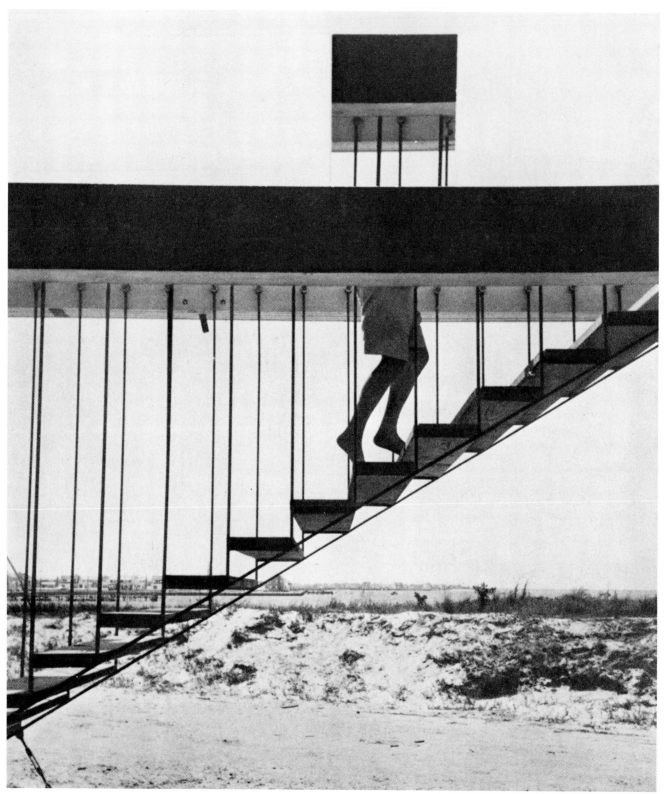

1955

190

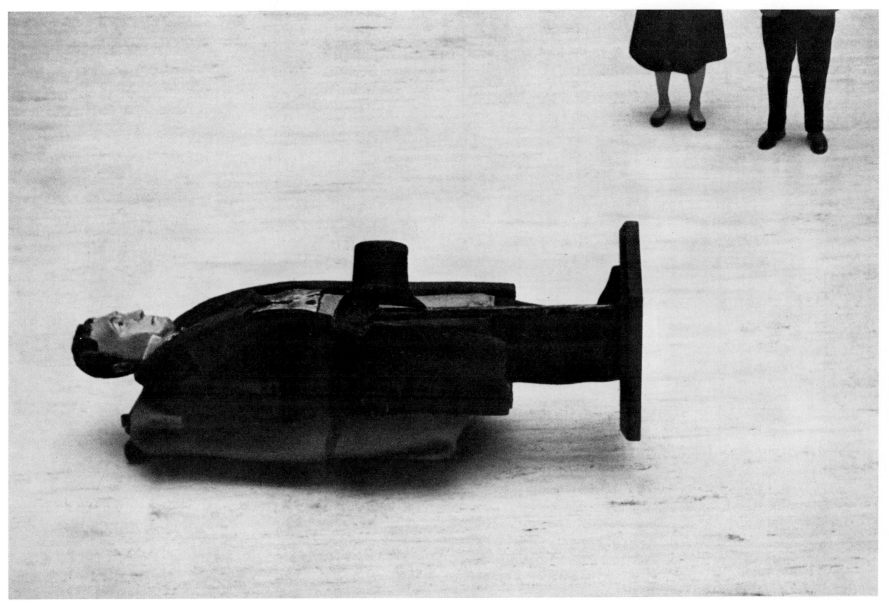

1961

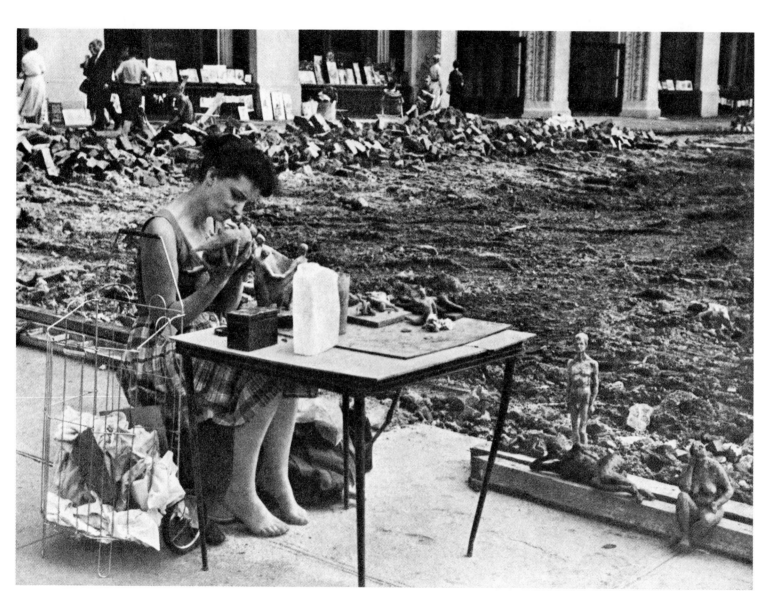

1959

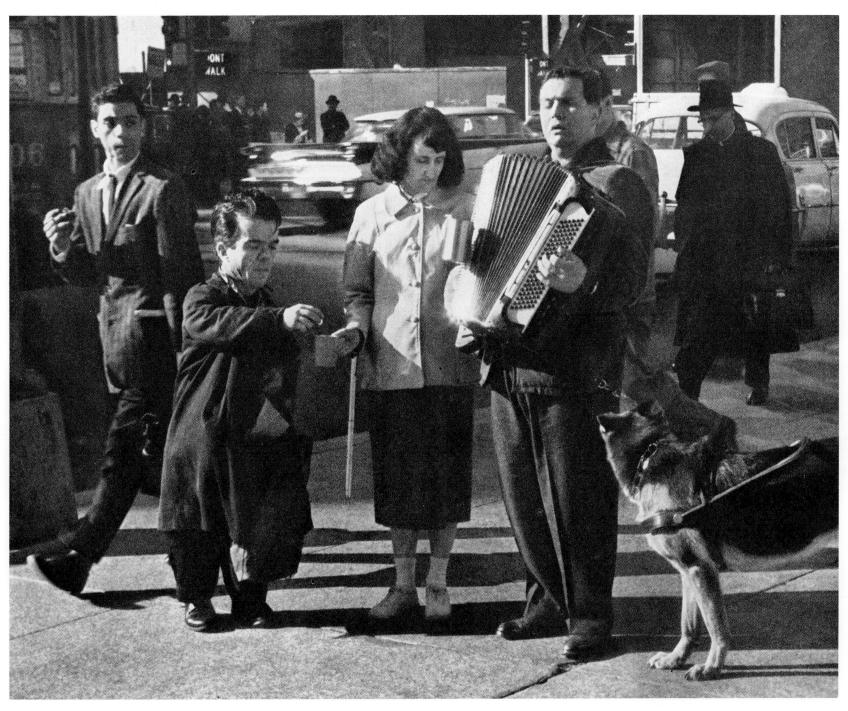

1959

193

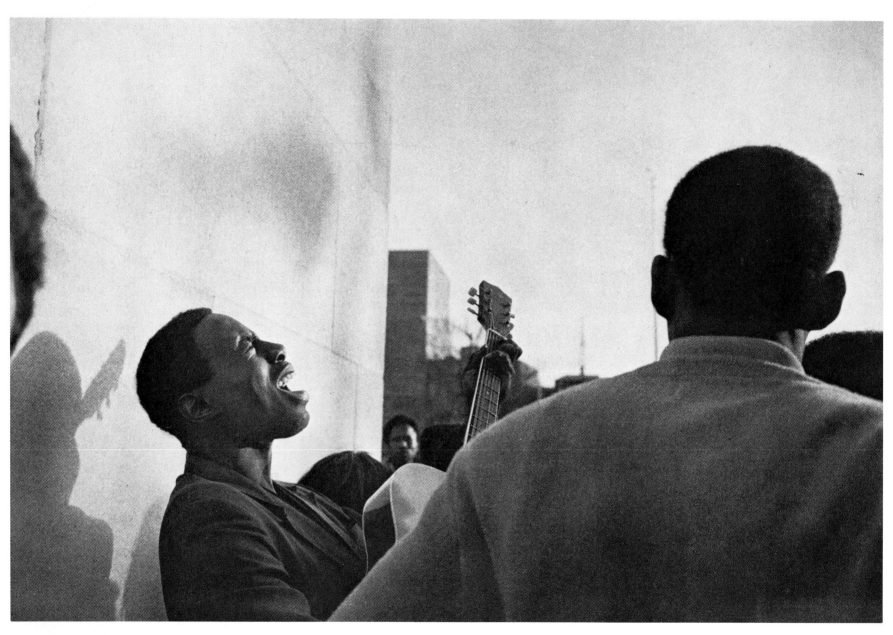

1969

194

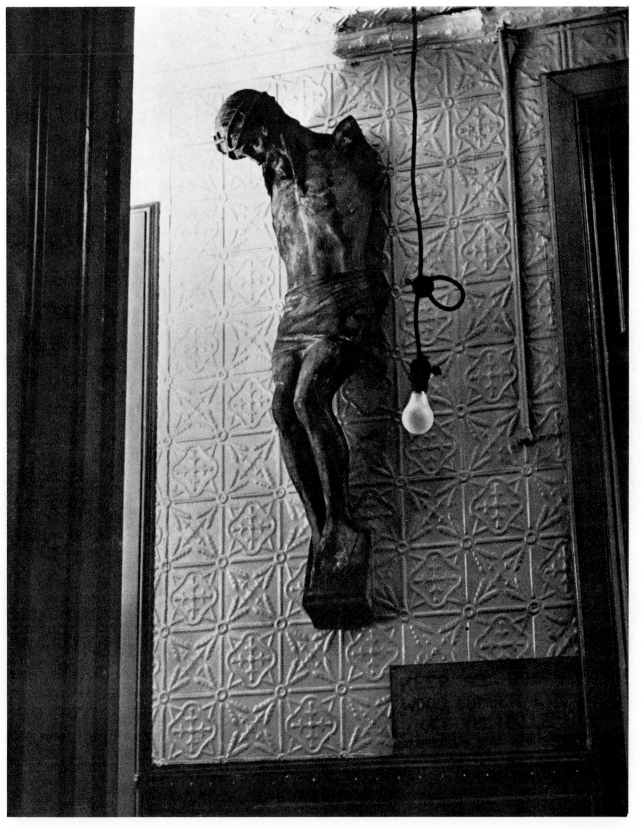

1947

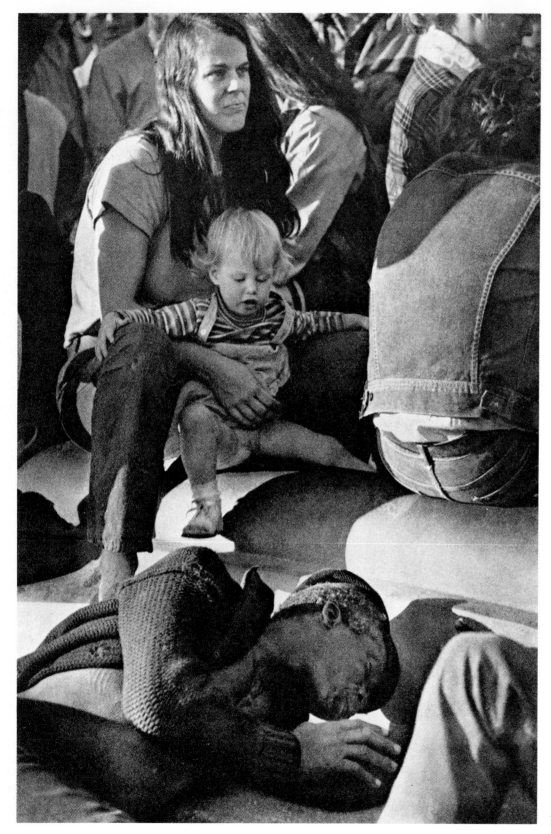

1969

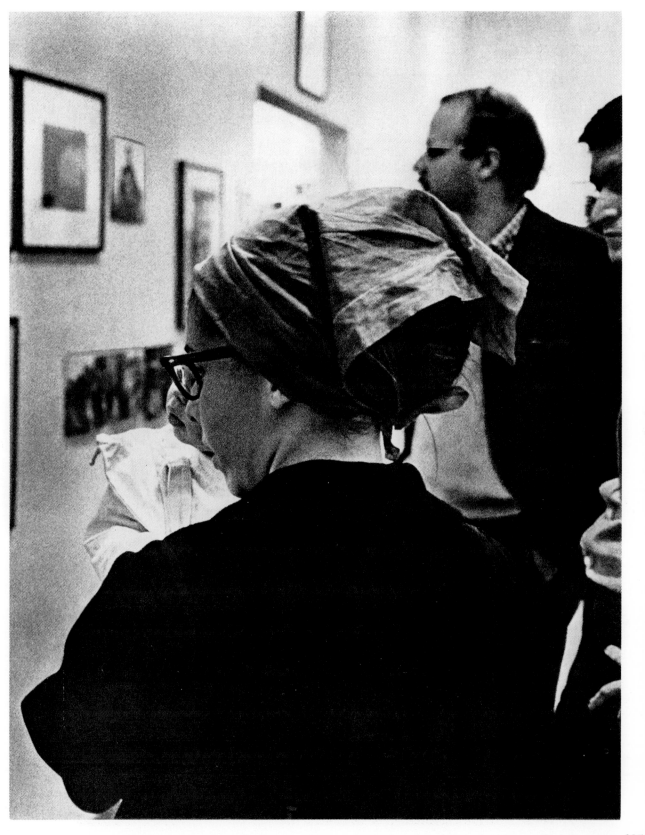

1967

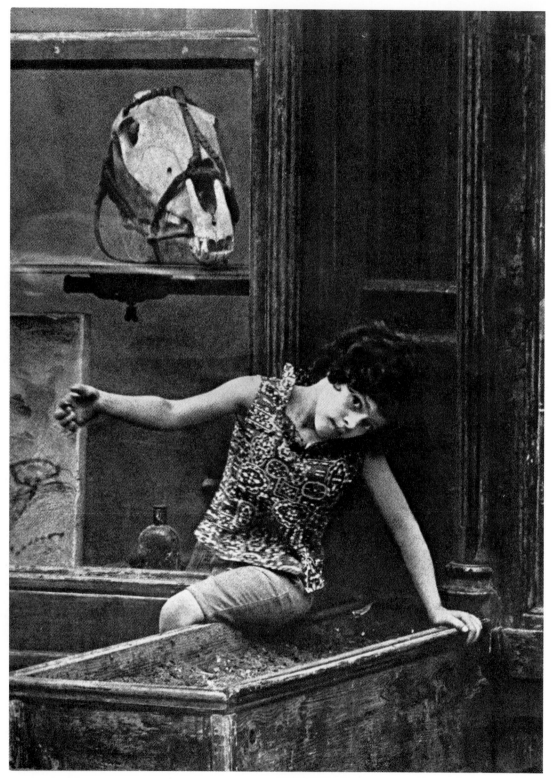

1966

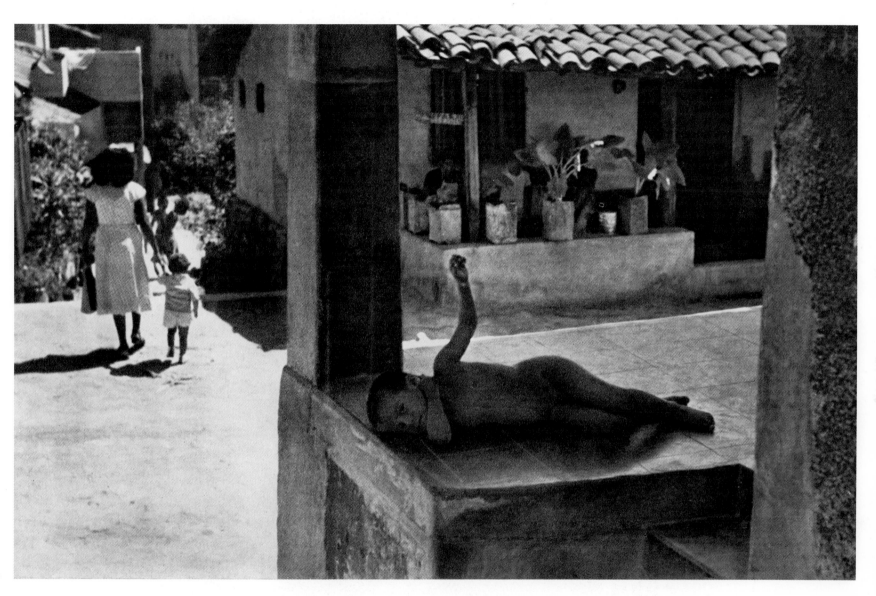

1952

199

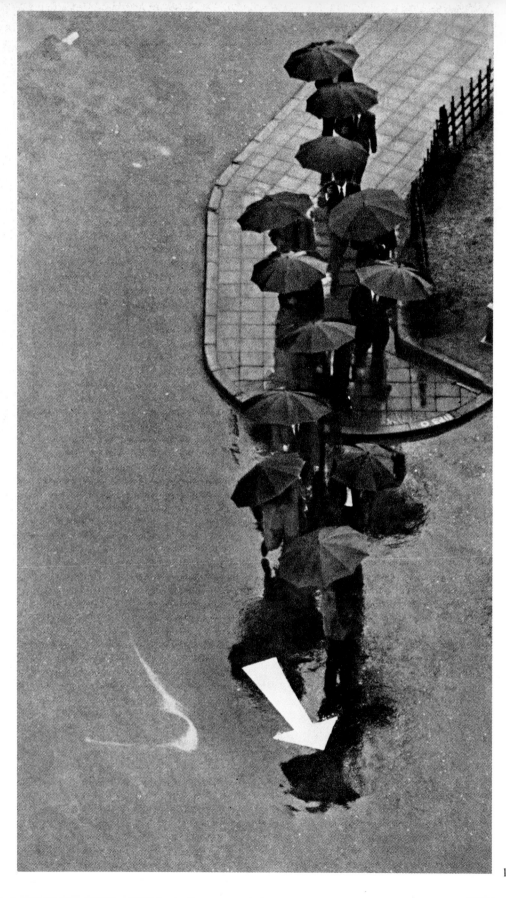

1968

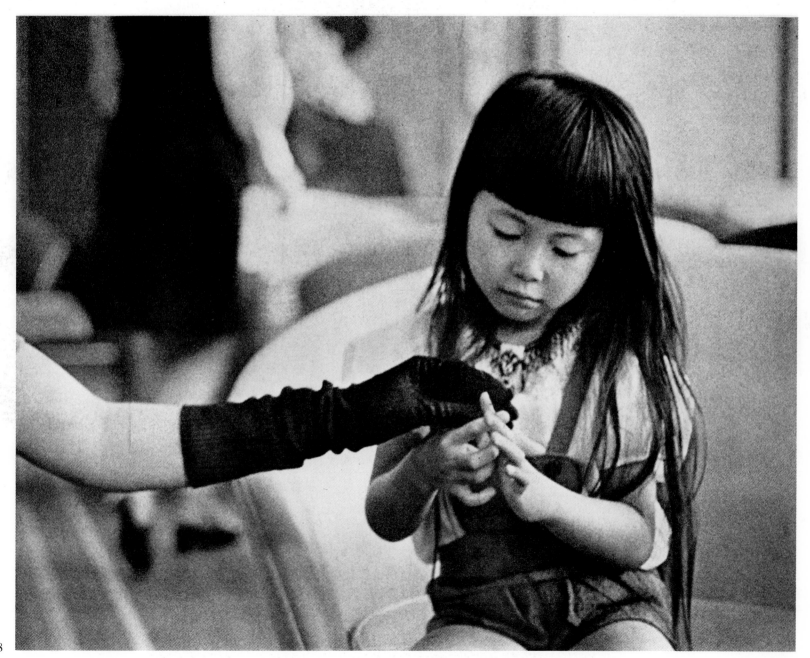

1968

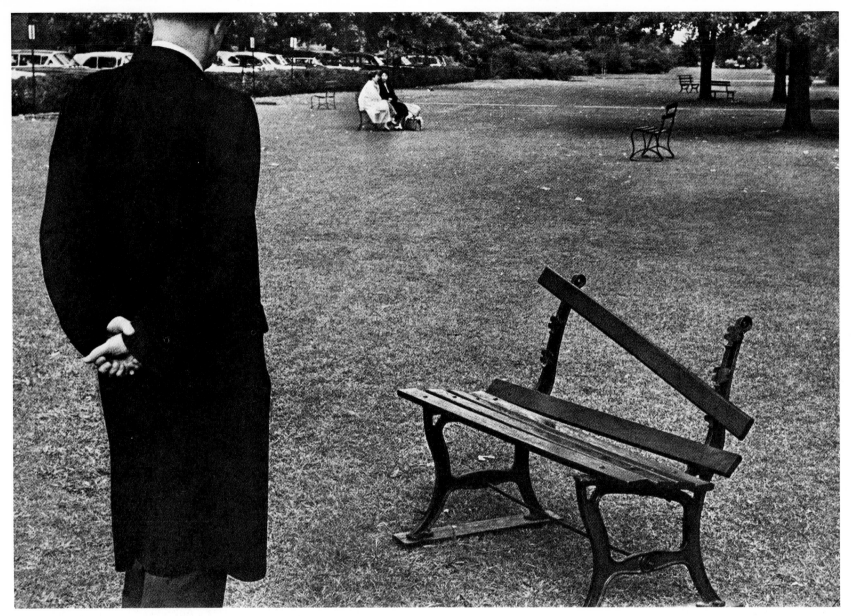

1962

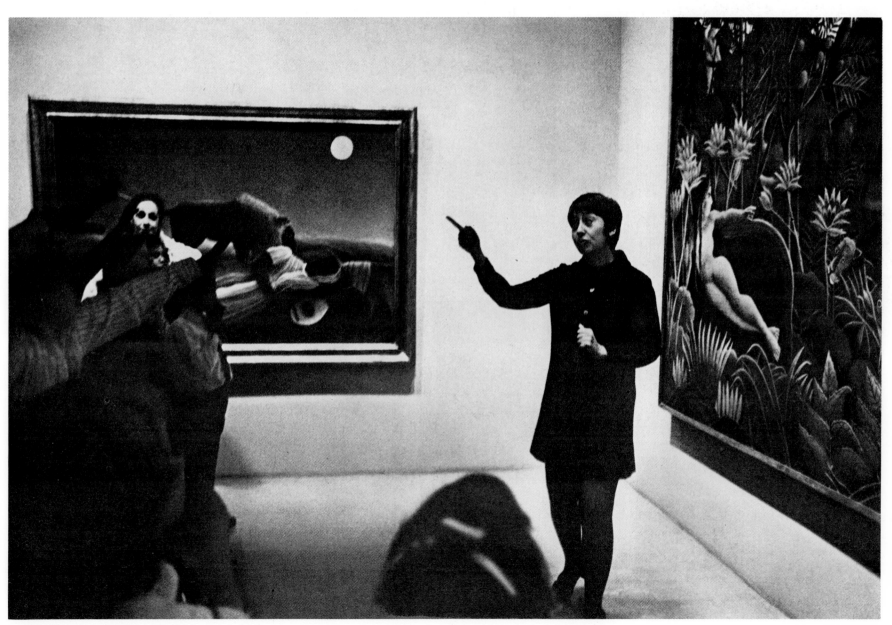

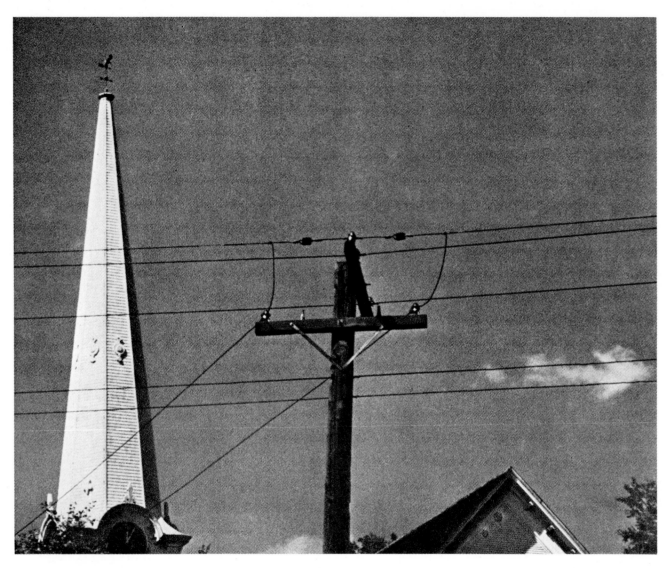

1946

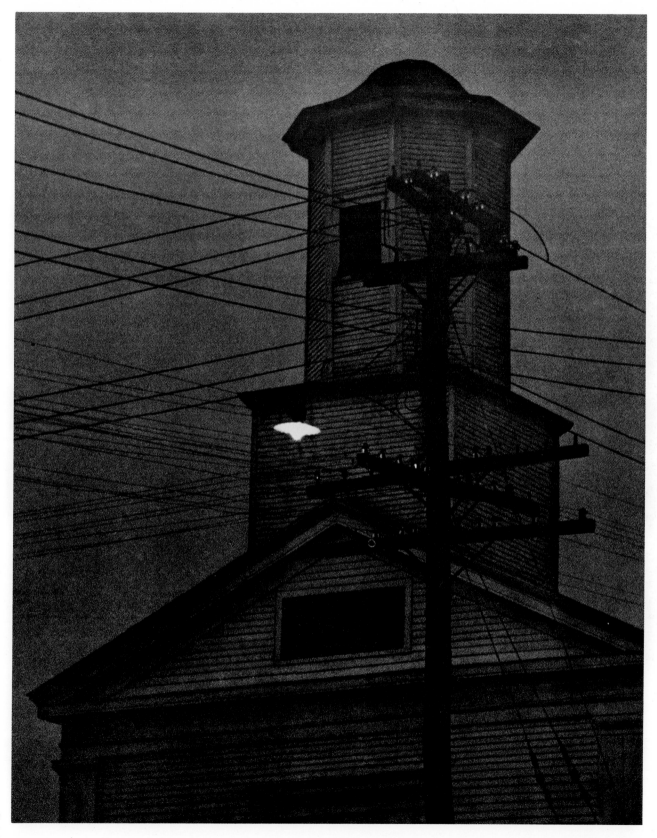

1937

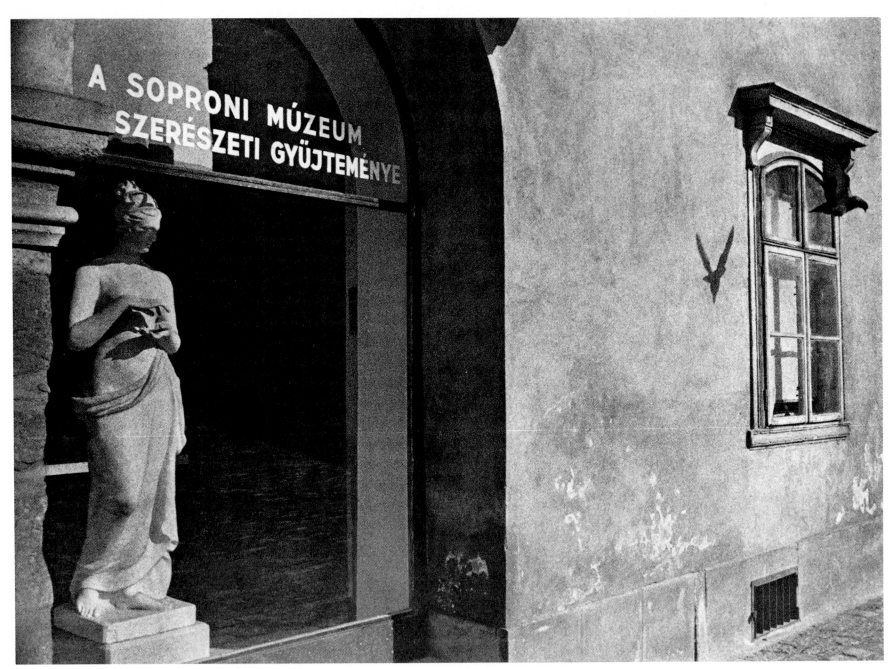

197

1960

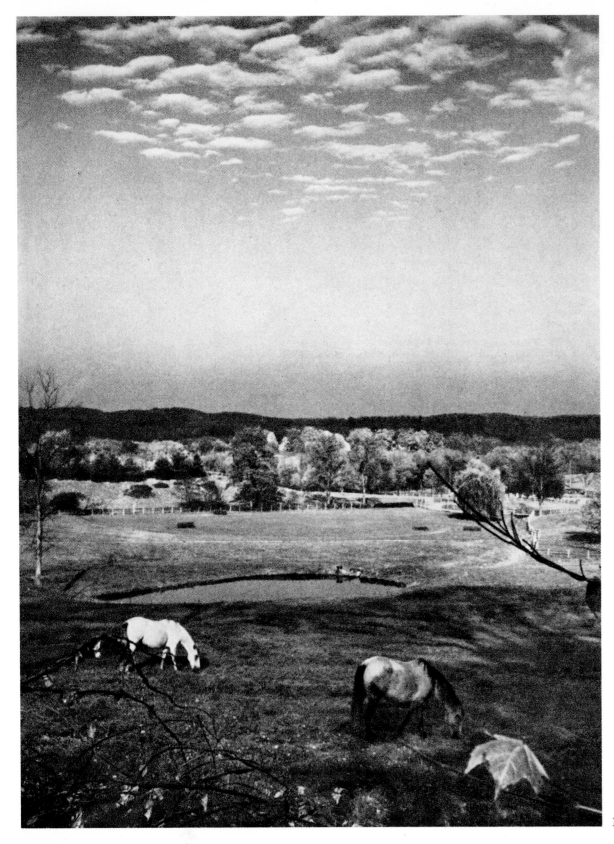

1959

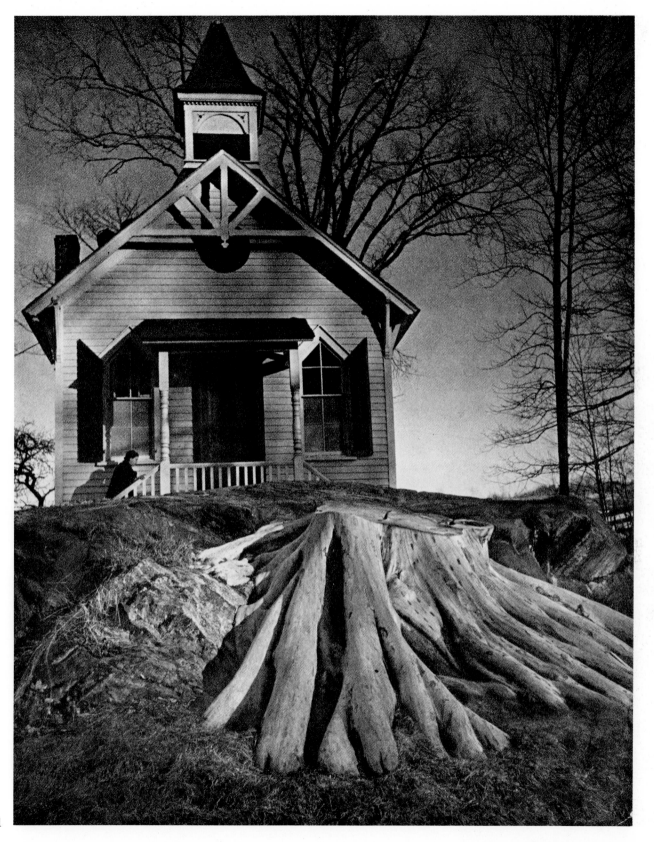

1941

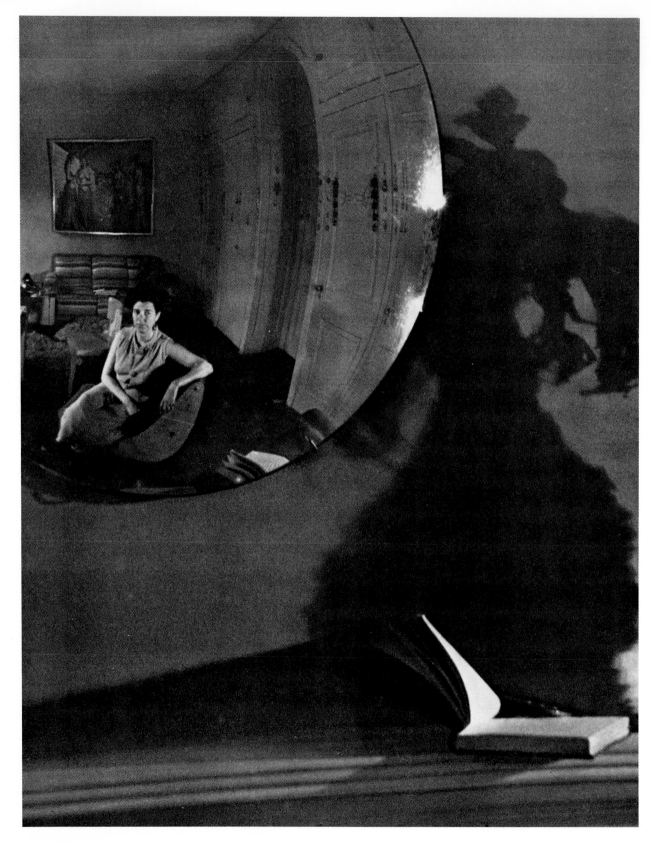

1945

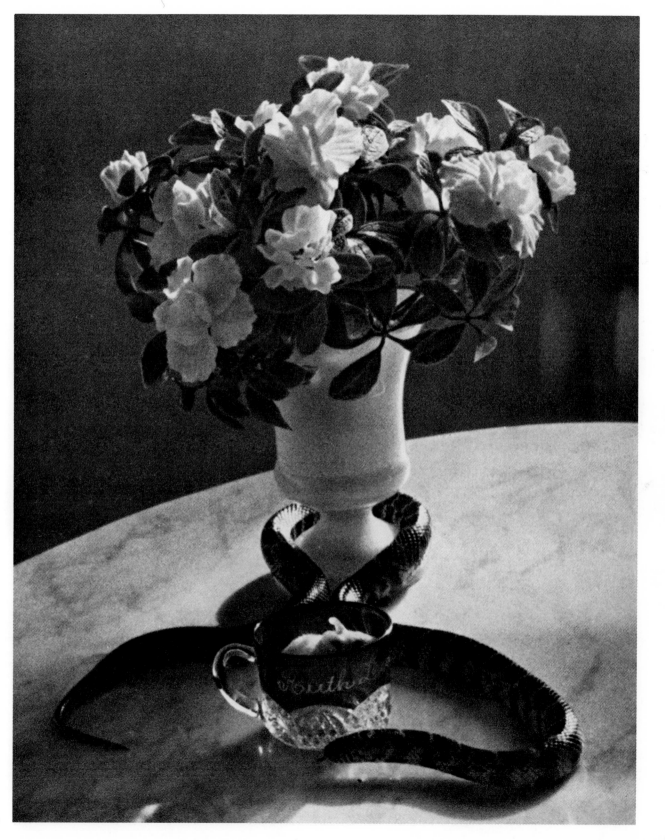

1960

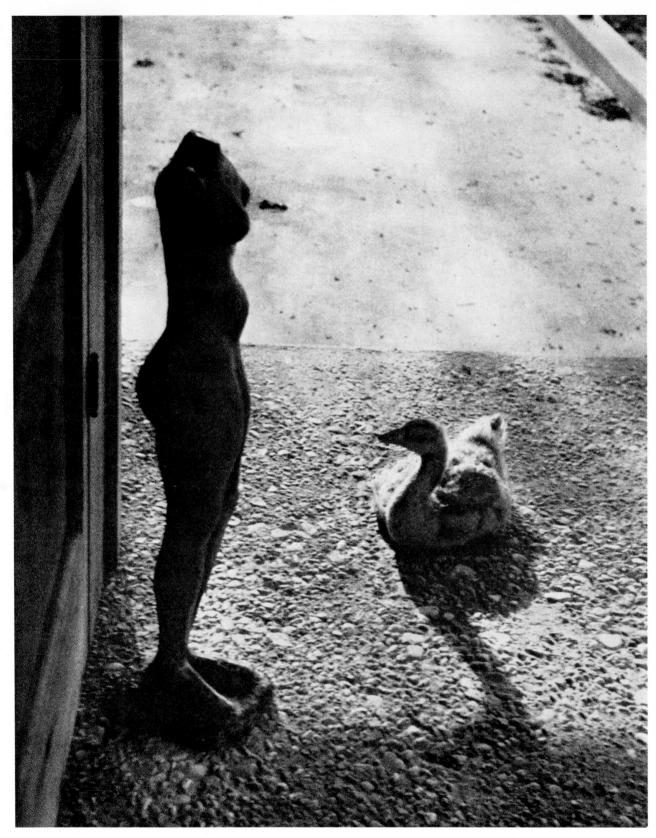

1959

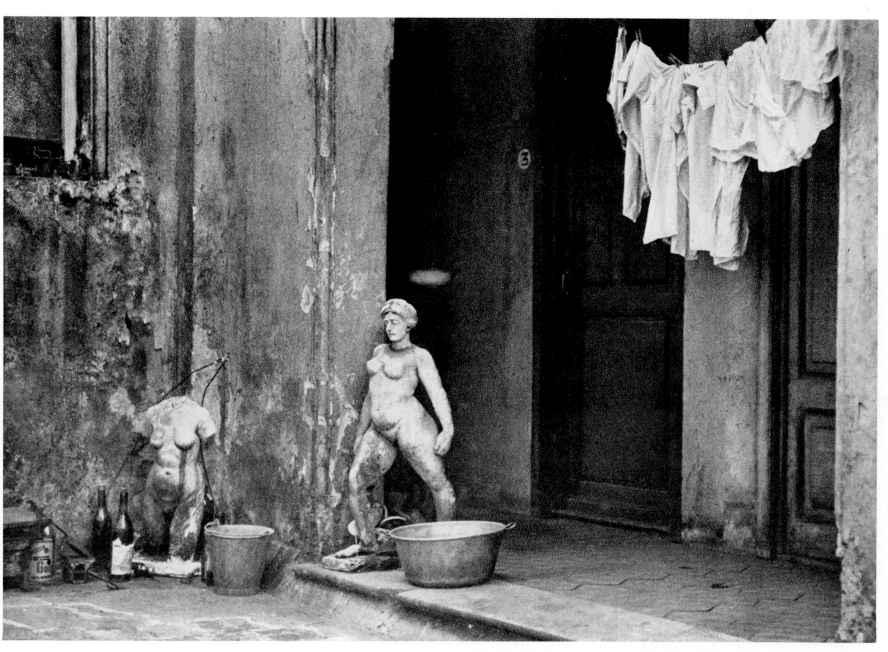

1962

213

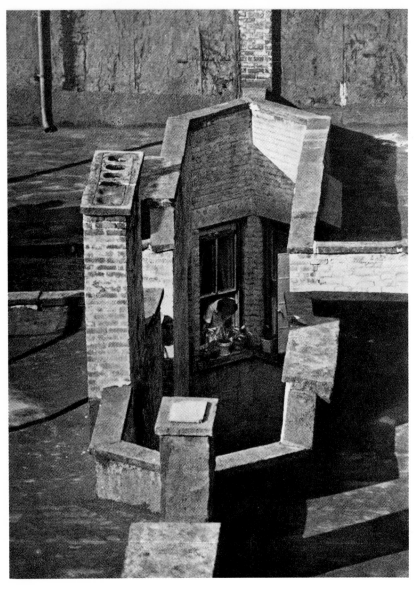

1970

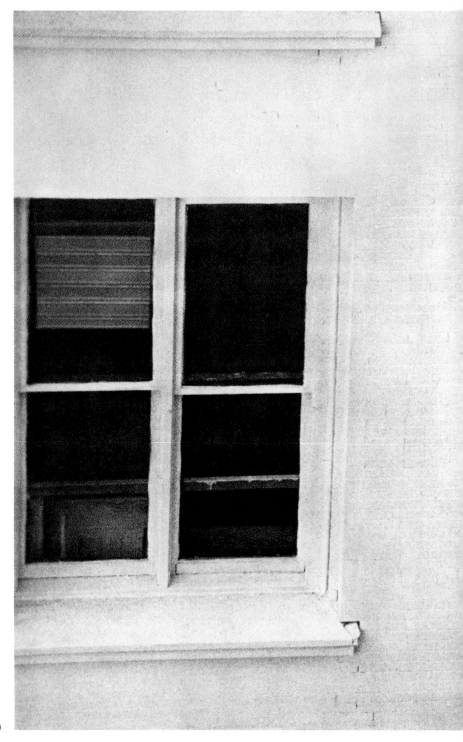

1970

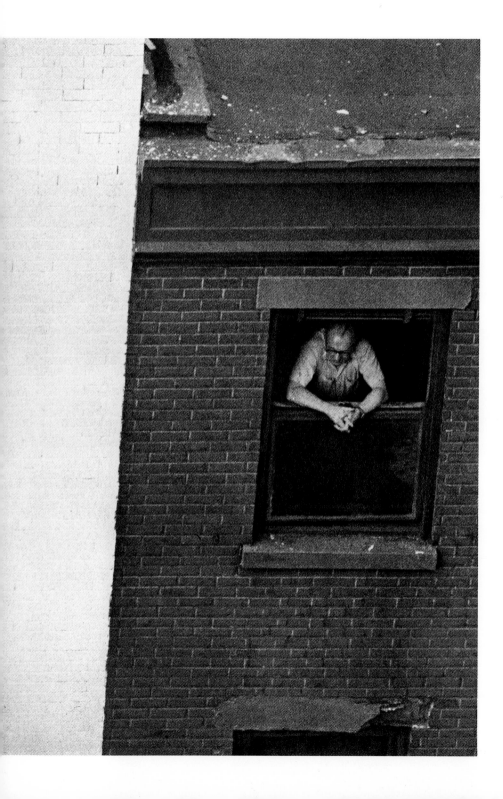

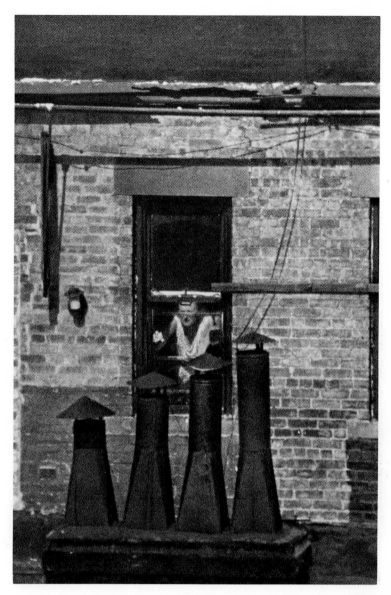

1970

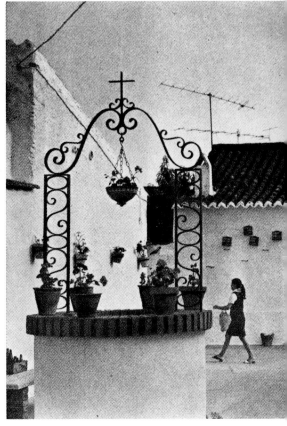

1971

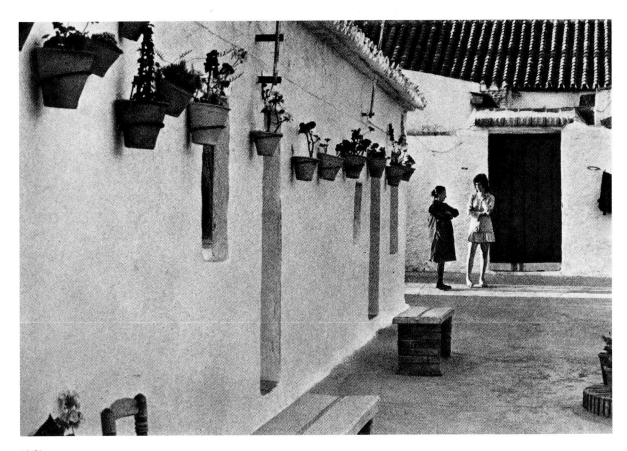

1971

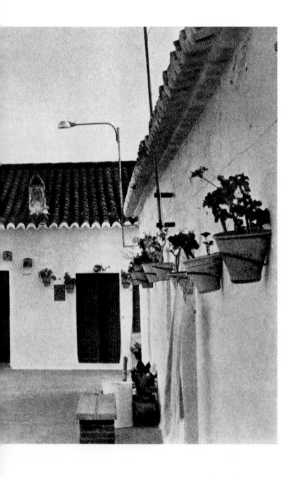

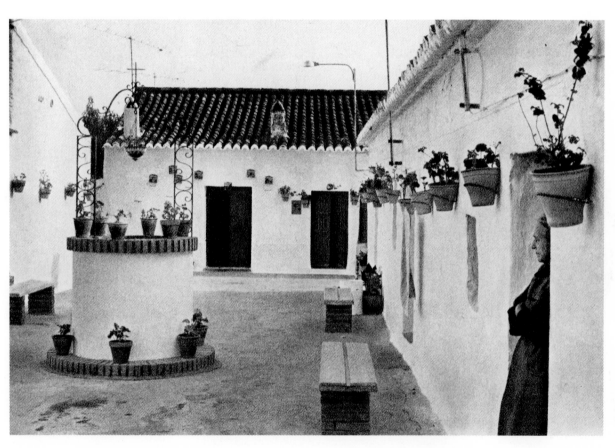

1971

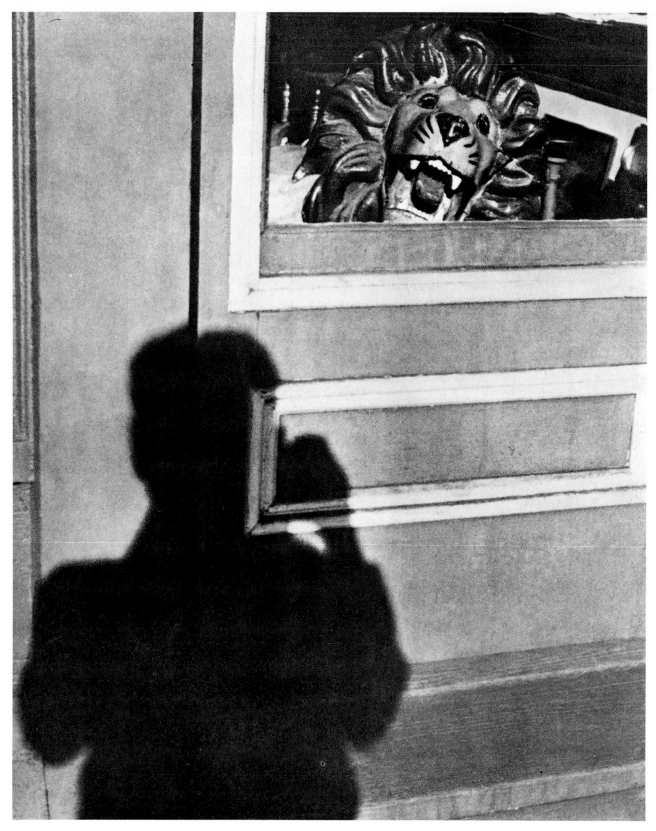

1949

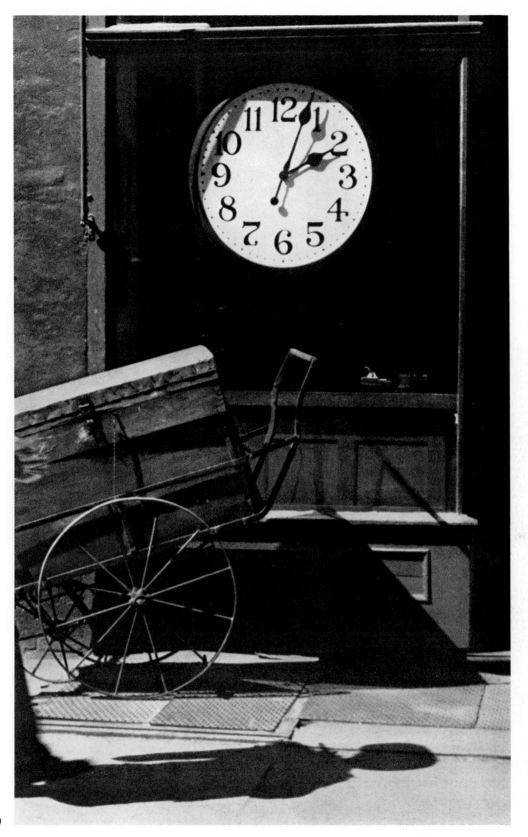

1950

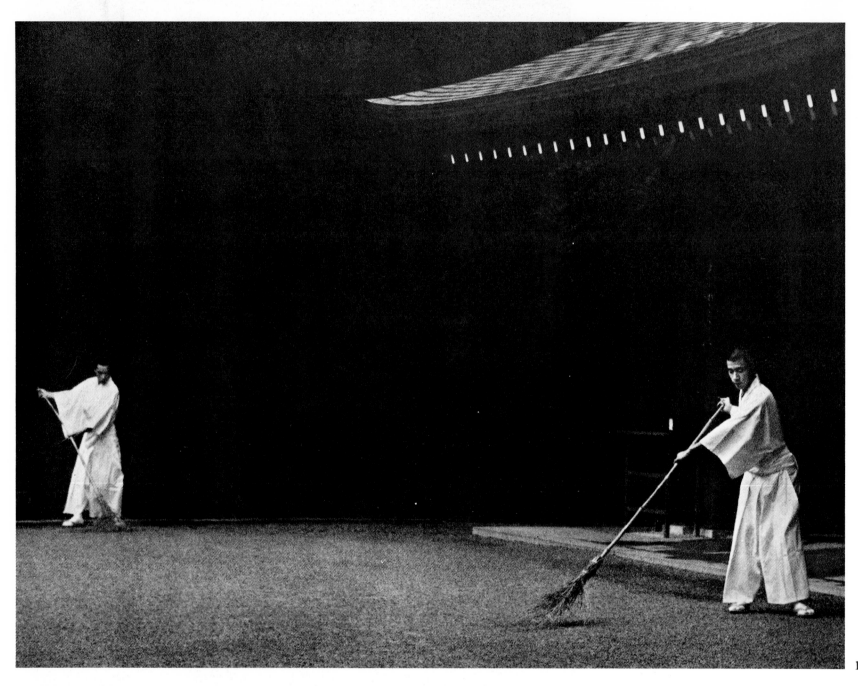

1968

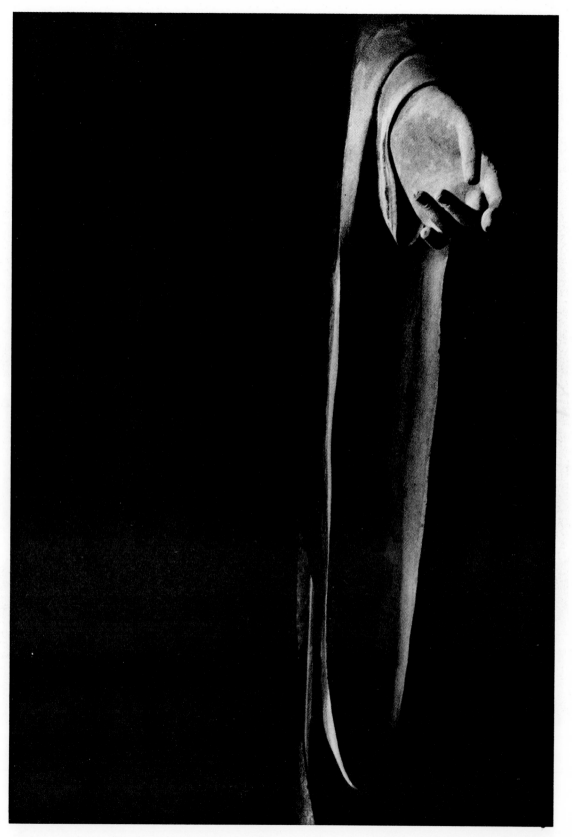

1968

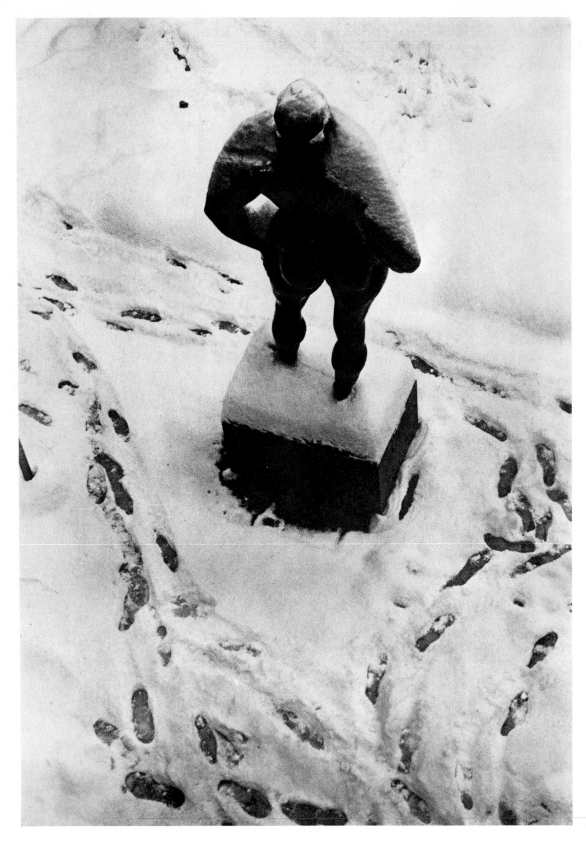

1964

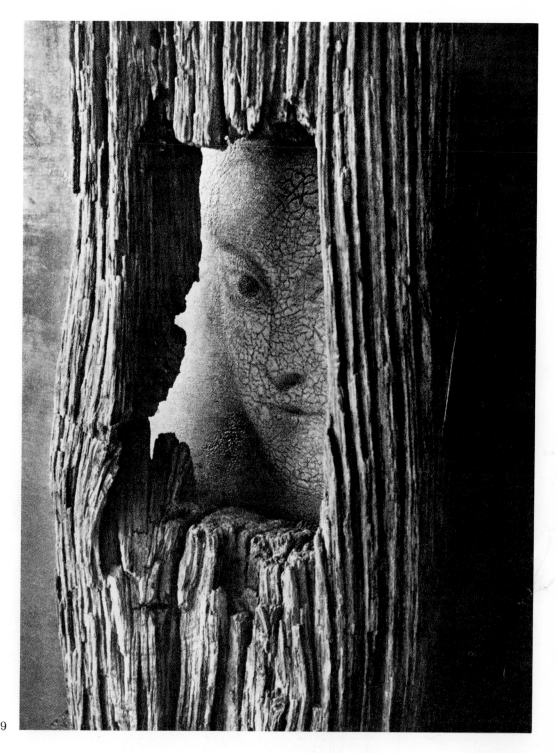

1959

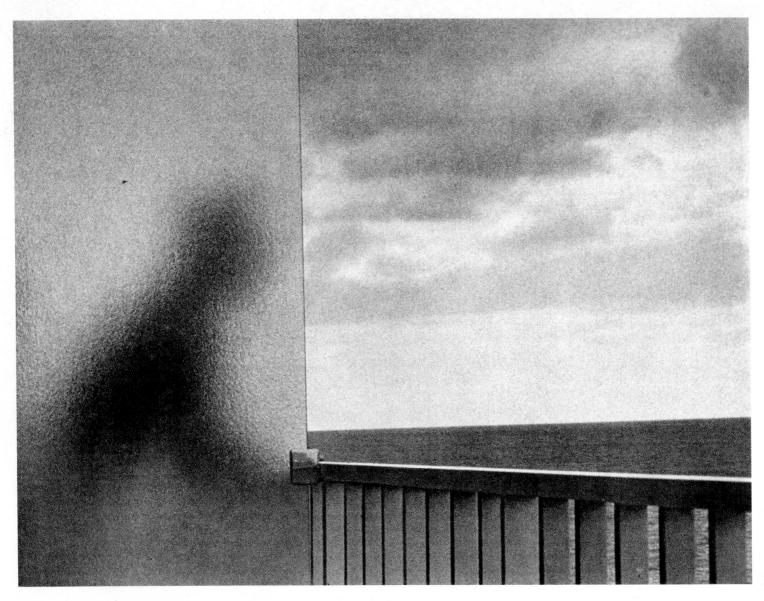

1972